ART DIRECTING PROJECTS FOR PRINT

A ROTOVISION BOOK
PUBLISHED AND DISTRIBUTED BY ROTOVISION SA
ROUTE SUISSE 9
CH-1295 MIES
SWITZERLAND

ROTOVISION SA
SALES AND EDITORIAL OFFICE
SHERIDAN HOUSE, 114 WESTERN ROAD
HOVE BN3 1DD, UK
TEL: +44 (0)1273 72 72 68
FAX: +44 (0)1273 72 72 69
WWW.ROTOVISION.COM

10 9 8 7 6 5 4 3 2 1

ISBN: 978-2-88893-020-4

ART DIRECTOR TONY SEDDON
DESIGN BY STUDIO INK

TYPESET IN ARNO PRO AND DIN

PRINTING AND BINDING IN SINGAPORE BY
STAR STANDARD INDUSTRIES (PTE.) LTD.

ART DIRECTING PROJECTS FOR PRINT

Tony Seddon &
Luke Herriot

Solutions and Strategies for Creative Success

RotoVision

CONTENTS

INTRODUCTION

As you progress through this book's 256 pages, you'll realize that it's full of contradictions. They're there because of the diversity of responses we received from the art directors and designers we spoke with while researching and planning our content. We found ourselves thinking "yes, that's what an art director is," or "that's the best way to work with freelancers," or "that's essential practice for quoting a new project," and so on. Then we would read another response and think, "actually, that's a completely different approach but is just as valid." This variety of approaches to the problems faced by art directors during every working day has been one of the most interesting things to come out of the writing process. It's not possible to attach one label to all when it comes to the running of creative projects, as each different job will demand a different approach in order to make it work. Every client is subtly different, every type of business will place different demands on the skills of an art director, and every combination of personalities within a creative team will generate different synergies that could either benefit or endanger a project. That's why being an art director is rarely boring.

As we hoped when embarking on this assignment, reexamining the knowledge that we have amassed during the course of our careers as art directors has prompted us both to reassess some of our own working methods. We hope that, through the insightful comments and viewpoints of the art directors who kindly contributed their knowledge and experience, this book will serve to demystify the world of art directing projects for print. Thank you for reading and we hope you enjoy what follows.

Tony Seddon and Luke Herriott

Fire Records' Embers series

Brand component for a back catalog
relaunch by indie record label Fire Records.
John Foster—Bad People Good Things

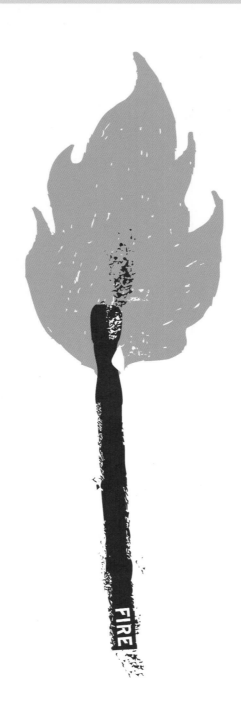

Meet the Art Director

WHAT IS AN ART DIRECTOR?

Good question! OK, here goes. An art director is someone who is accountable, calm, collaborative, communicative, confident, connected, consistent, creative, curious, decisive, demanding, disciplined, encouraging, enquiring, excited, flexible, holistic, humorous, informed, inspirational, inspired, interactive, levelheaded, lucid, motivated, measured, observant, organized, original, precise, principled, professional, receptive, responsible, responsive, ruthless, spontaneous, strategic, stubborn, sympathetic, tireless, and visionary.

Well, not necessarily all of those things of course, and certainly not all at the same time. The reality is that it's not easy to define exactly what an art director is because there are so many different but entirely relevant definitions for the role an art director might fulfill. It is possible to distill these down to a simple statement, as Sean Adams of AdamsMorioka manages with: "An art director is a leader who is able to guide, direct, listen, and advocate creative work." This definition works for me mainly because there are two important words included here: "guide" and "listen." I've always felt that in many ways an art director is a cross between a navigator and a politician. The navigator component steers the team through a project while ensuring that no mishaps occur during the journey, and the politician component listens to the questions posed by a brief and endeavors to deliver solutions that fulfill the requirements in a responsible and commercially-successful fashion. As for the creative part, it goes without saying that a good art director must be creative in their approach to problem solving, but creativity doesn't dwell exclusively within the realms of graphic design. You could say the same of any number of professionals from a variety of industries who have to resolve tasks through the application of a creative thought process. However, art directors must develop the ability to employ creative thought in a variety of ways that are both visual and managerial. This necessity poses a number of questions that need to be addressed before we can reach any kind of definitive answer to the question, "What is an art director?"

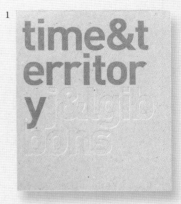

1

1. Time and Territory

The cover of a book published by landscape architect and urban design firm J&L Gibbons to celebrate their 21st anniversary.
Domenic Lippa—Pentagram

2. Do Hit Chair

Poster campaign for Droog Design's Do Hit Chair, a steel cube that ships with a sledgehammer so you can customize its shape yourself.
KesselsKramer

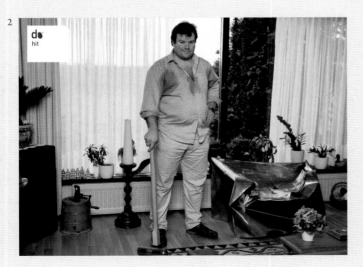

2

"The simplest way to describe an art director is to label them as the person responsible for the visual part of creative communication. Of course, they are more than this. On any given day, an art director must be a problem solver, an idea generator, a client liaison, a tireless researcher, a ruthless negotiator, a talent manager, a decision maker, an artist... A great art director is someone who does whatever it takes to bring an idea to life."

Erik Kessels—KesselsKramer

3

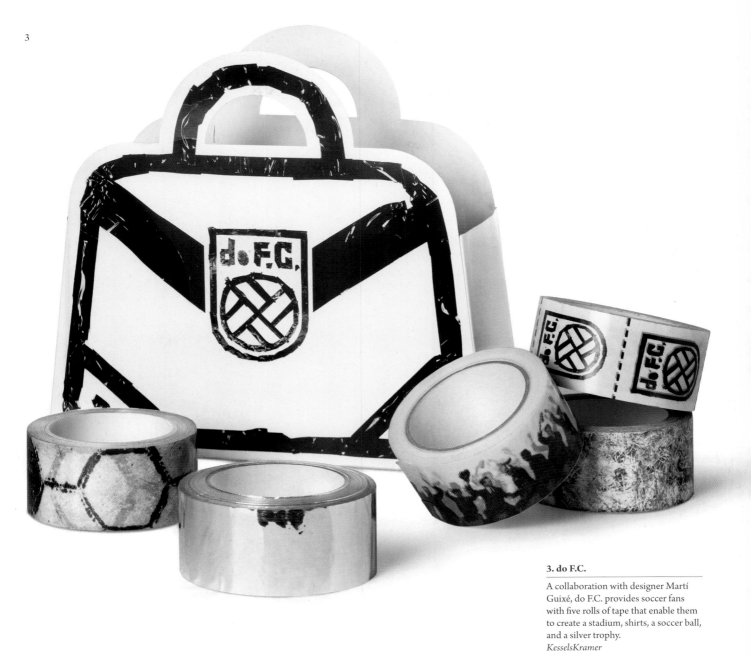

3. do F.C.

A collaboration with designer Martí Guixé, do F.C. provides soccer fans with five rolls of tape that enable them to create a stadium, shirts, a soccer ball, and a silver trophy.
KesselsKramer

"An art director is a leader who is able to guide, direct, listen, and advocate creative work."

Sean Adams—AdamsMorioka

"It is about assuming accountability for the success of the project being designed."

Neal Ashby—Ashby Design

"An art director is the leader of a creative team who knows when to be directing and when not to. They understand the business and creative aspects of the project, studio, and client. They are able to inspire, direct, stand back, and push the creative process when necessary. They are the conceptual leader and guiding collaborator."

Justin Ahrens—Rule 29

"....for me it's about having a 360-degree overview. It's about learning to instinctively know what's right and being able to see the overall picture."

Paul West—Form

Values Day identity

Brand tool kit for Values Day, a motivational training day for the staff of a global management consultancy.
Crush

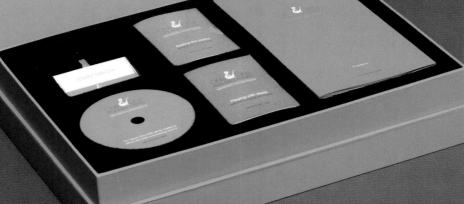

How do you become an art director?

There's one thing you can be sure of—you can't enroll on an "art director" course in order to learn how to be one. At least there are none that exist in any college I've ever heard of, which is pretty remarkable given that there are so many art directors working in the design profession. Every single publisher, advertising agency, and design consultancy is likely to have at least one art director working for them, whether they use this exact job title or not. So what's the answer? Can art direction be taught?

Greig Stevens, art director of the *International Herald Tribune*'s advertising supplements, states that "My art directing skills were acquired by working with other art directors. I learned the basics of magazine design and how to art direct photo shoots and commission illustration from one. Another taught me how to work well with my editorial teammates in a collaborative manner. Another insisted on speedy working practices which was a painful but necessary lesson. Pulling that experience together and having an overview of the bigger picture is how it came about for me."

Erik Kessels of KesselsKramer had a somewhat similar experience. "After art school I took a job at Ogilvy & Mather, an advertising agency in Eindhoven, the Netherlands. I had a slow start, sketching other people's ideas as a graphic visualizer, but eventually started to bring my own ideas to life as an art director working with a copywriter. This slow evolution was good for me because it gave me time to learn and make mistakes." He goes on to say, "I don't think anyone is born to be an art director. A natural talent for design obviously helps, but creative thinking and organizational talent are also very important. It's really a job that can only be learned through training. It was clear to me from the beginning that the good art directors had not just strong individual skills, but also the ability to work well in a group. Unlike when I was starting out, creative people are now expected to be art directors straightaway. I believe it's better to train art directors and allow them time to develop their taste, organization, and communication skills, and some strong opinions."

1–3. Absolut Label

Items created for the annual fashion collection from Swedish vodka brand Absolut.
KesselsKramer

4–5. 2 kilo of KesselsKramer

An anthology of work produced by KesselsKramer that actually weighs in at two kilos.
KesselsKramer

1

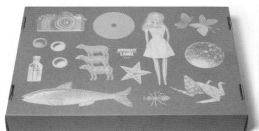

2

3

4

5

Both these viewpoints help to confirm that, for all but the very gifted, the role of an art director is something you evolve into. If you have the right combination of talents and skills (and the inclination, of course) at some point in your career as a designer you'll find that you've become an art director. On the other hand, you could simply get hired into the role by responding to appropriate job ads, which to be honest is the way that many designers gain promotions, but I believe that success will only be forthcoming if you've put the hours in beforehand in order to gain the necessary experience. This leads us to another question—what are the key skills you should try to learn?

"I don't think anyone is born to be an art director. A natural talent for design obviously helps, but creative thinking and organizational talent are also very important. It's really a job that can only be learned through training."

Erik Kessels—KesselsKramer

The art director's key skill set

Sean Adams is clear on several important skills he learned from three different art directors he was fortunate to work with during the earlier part of his career. "I learned that compassion, integrity, and true grit not only enable design to be strong and wonderfully executed, but also help the morale of a team to band together when projects become difficult and problematic. [Each art director] also had a wonderful sense of humor and a life outside the office that they were ready to share with everyone." He adds that, "Time management and managerial skills are important for designers as well as art directors, and it shouldn't only be the art director that dictates workflow. I feel that an art director that overmanages a project makes designers into pairs of hands rather than creatives."

This is interesting in that these are not traditional graphic design skills, they're *people* skills. Skills of this type are fundamentally important and an art director should always display an ability and willingness to empathize with the team of designers they're leading if the creative process is going to work. In my experience, designers don't respond well if they're dictated to in an overly prescriptive way—prima donnas are rarely respected, and we are after all a committed lot when it comes to standing up for our own ideas and viewpoints. Designers must be given the chance to contribute to the process of managing their part of a project to create a sense of ownership over the end result, and perfecting the people skills that allow you to make that happen is extremely important.

"I learned that compassion, integrity, and true grit not only enable design to be strong and wonderfully executed, but also help the morale of a team to band together when projects become difficult and problematic."

Sean Adams—AdamsMorioka

1

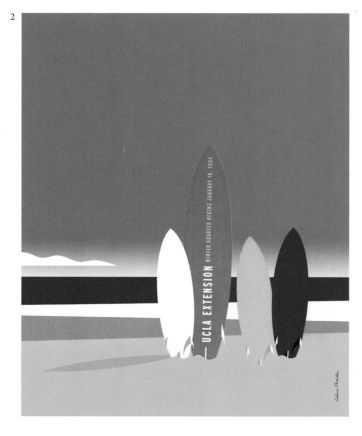

2

3

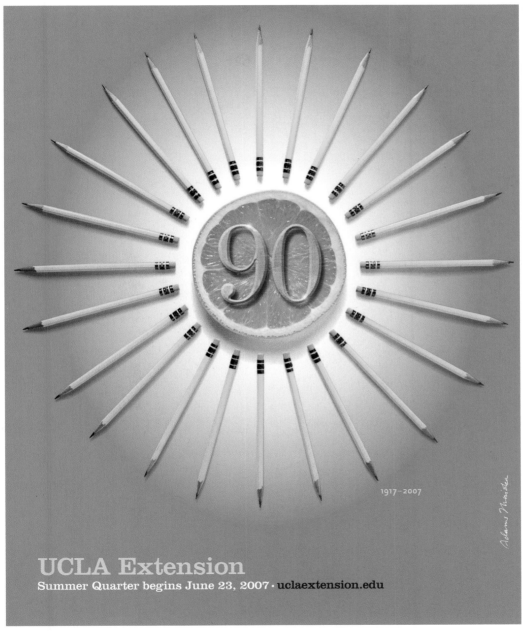

UCLA Extension
Summer Quarter begins June 23, 2007 · uclaextension.edu

1917–2007

1. AIGA Salt Lake City

Lecture poster for the Salt Lake City chapter of AIGA.
AdamsMorioka

2. UCLA Extension Winter 2004 Quarter

UCLA catalog cover suggesting an ideal Los Angeles winter.
AdamsMorioka

3. UCLA Extension 90th Anniversary

UCLA summer quarter catalog cover fusing a "sun" icon with an orange, a recognized symbol for southern California.
AdamsMorioka

It's also vital to learn how to locate and identify the best people with the appropriate skills to get the job done. In other words, art directors should strive to acquire the ability to delegate. One of the things I found hardest to deal with when I first became an art director was "letting go" and delegating work that I would previously have enjoyed doing myself. I'm not talking about illustration or photography work here as my own talents in both of these areas are limited, but rather the preparation of material and the design and layout of a project. It's actually quite liberating to finally get the hang of delegation as it frees up time that is better spent on understanding the bigger picture—a key part of any art director's role—and more often

than not produces a creatively diverse and superior result. Joshua Berger of Plazm sums this up well: "The most important thing I learned is to give people space to be creative—to do what they do best. At the same time you need to have high standards of quality and be able to encourage the best work from the people you are collaborating with. Know when to push for more, to suggest ideas and directions that may have been missed, when to say something is done, and when to pull the plug." Learning to feel good about being a conduit for other designers' creative talents, finding that you can enjoy doing just that, and that you're able to champion another designer's creative idea to the point that you'll stridently argue for its

> "The most important thing I learned is to give people space to be creative—to do what they do best."
>
> *Joshua Berger—Plazm*

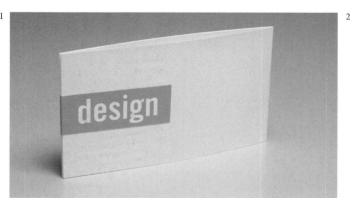

1

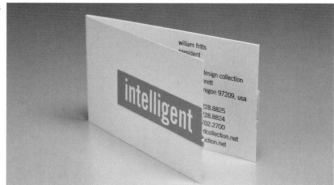

2

1–5. Intelligent Design identity

Business cards for a company distributing high-end furniture to both homes and offices.
Joshua Berger and Pete McCracken—Plazm

3

william fritts
president

intelligent design collection
733 nw everett
portland, oregon 97209, usa

p 503.228.8825
f 503.228.8824
m 503.702.2700
 bill@idcollection.net
 idcollection.net

implementation as though it were your own work, marks a key point in the process of becoming an art director.

A further important art direction skill is the ability to gauge the appropriateness of a design solution in terms of its identifiable market. This is particularly pertinent in areas such as publishing or packaging, where a particular demographic is the intended audience for a magazine, a series of books, a can of beans, and so on. Different designers will interpret a brief in different ways, that's what's great about working with a range of people. However, on occasion a designer's aesthetic approach may not be entirely appropriate for its market. It could be that the

concept of a piece is fine but the color palette isn't quite right, or perhaps the images are perfect but the chosen fonts broadcast the wrong message. This is where the art director's ability to see the bigger picture kicks in, providing an opportunity to advise the designer of the potential pitfalls of the proposed solution when it goes into production. Once again I would advise that, if possible, this is done in a way that isn't overly prescriptive in order to avoid alienating the designer from their original concept.

4

5

"I worked with an amazing art director for about six years, and the most important lesson he taught me was the art of diplomacy."

Carl Rush—Crush

SKILLS

"Being a curious person about your world is the best education for being an art director. And, ultimately, the most important thing an art director does is to edit information, filtering out everything that is nonessential, so that the message is as simple and clear as possible."

Neal Ashby—Ashby Design

"In no particular order:
- the ability to share ideas, to collaborate, and to let your collaborators run with ideas that take you somewhere new
- the ability to see opportunities or ideas when they arise
- to have the confidence to wander into the unknown
- to have the confidence to see the project through, even when it's in its most fragile state
- to be able to research well and inspire
- to be able to edit cultural references and filter them into something cohesive and fresh
- to be able to pay attention to the little things—details, moments, or subtleties—that are the difference between good and great."

Simon Dixon—DixonBaxi

"For me, it's having a strategic sense and a collaborative approach. Technically I'm pretty hopeless but I know what's out there, I can see what's good, and have been lucky enough to work with teams of very skilled people. I just glue it all together, so the whole is greater than the sum of its parts by seeking the big idea."

Mark Stevens—M-A-R-C

"Calmness under pressure has to be one of the most important skills you can develop. The more you stress, the more everyone stresses ... and when everyone is flapping, nothing gets done. You have to be decisive, but even if your decision is that you can't decide, you should say so, buy some time, and go work it out. Probably the biggest two skills required to be an art director are firstly the ability to step back and see the bigger picture, whether that's on a specific project or running the whole team, and secondly common sense. Surprisingly simple in theory, but not always that easy for people."

Paul Burgess—art director

"Firstly you should have an enquiring mind about all visual culture—past, present, and future—across many fields. Research is very important but should not be limited to specific jobs—you should be constantly learning. I hope to be surprised and amazed by new ideas every day. Secondly you need good social and interpersonal skills. An art director will collaborate with many people in different areas such as photography, illustration, and editorial, as well as clients, of course. You need to attract these people to work with you and also be able to explain your vision and persuade them of your ideas. It's also very important to have an open mind to accept the ideas and potential of others. You should also be flexible as some of the best ideas come unexpectedly."

Peter Stitson—Peter Stitson Ltd

Guardian Society

Illustration supporting a newspaper article about students and graduates moving to a public sector working environment.
Carl Rush and John McColloch—Crush

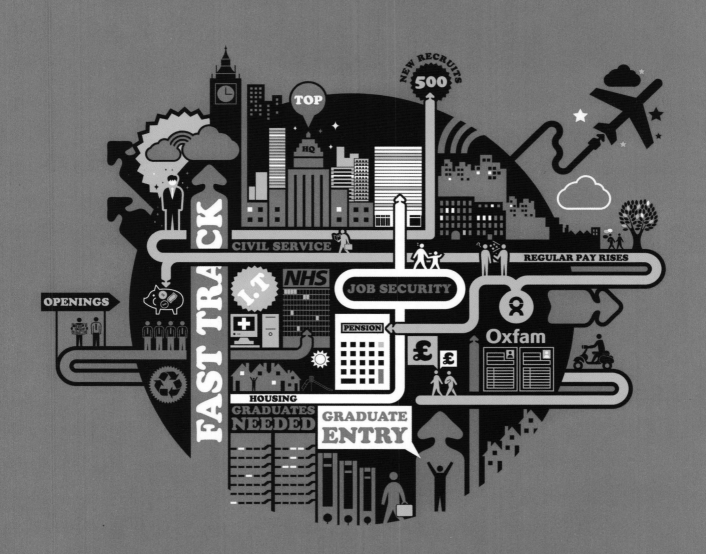

Is an art director a creative or a manager?

Every budding art director should decide how they would answer this question before they begin to mold their approach to their future career. Is an art director a creative with good management skills, or a manager with good creative skills? Which is more important, expert project management abilities or creative governance over your team? I think the answer to this important point is that you should work at developing skills in both these areas in order to succeed, but ultimately it's up to the individual to decide whether or not one should be seen as more important than the other in the context of their particular situation. Aslan Kilinger of Amsterdam-based design and advertising firm Maestro backs this view: "In my opinion an art director must be driven by creativity, therefore they are not 'managers with creative skills' but the other way around. But as an art director you do need managerial skills because you need to get the best out of people. Excite them, inspire them, and motivate them!"

2

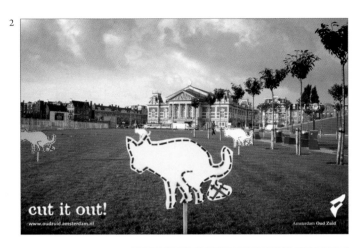

1

3

4

1. Love

Wedding gift designed as an alternative to a traditional book.
Aslan Kilinger—Maestro

2. Cut it out!

Publicity stunt to generate public awareness of the problems generated by irresponsible dog owners.
Sharon Kilinger and Aslan Kilinger—Maestro

I think the percentage split between the two areas depends very much on the makeup of an art director's creative team and the particular strengths they bring to the table. Joshua Berger contributes to this point by saying, "Art directors are like filmmakers, chefs, or general contractors. Without our crews—our designers, producers, sous chefs, and roofers—we are not complete. Yet our crews count on us to make the experience happen. Creative autonomy doesn't happen 'over' a team, it happens with their assent and their talent. Project management skills are essential, but they are only one piece of the puzzle." For me this answers the point well, highlighting the fact that there is no end product without the people to make it, but also no progress without someone to take the lead and make decisions.

7
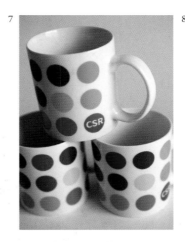

8
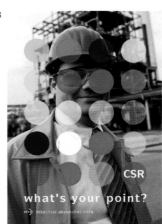

5

9
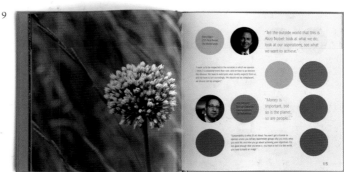

6

3–4. Self-promotional brochure

Promotional mailout brochure.
Aslan Kilinger—Maestro

5–9. AkzoNobel

A range of corporate and promotional items for Dutch decorative coatings and chemical manufacturer AkzoNobel.
Maestro

"In my opinion an art director must be driven by creativity, therefore they are not 'managers with creative skills' but the other way around. But as an art director you do need managerial skills because you need to get the best out of people. Excite them, inspire them, and motivate them!"

Aslan Kilinger—Maestro

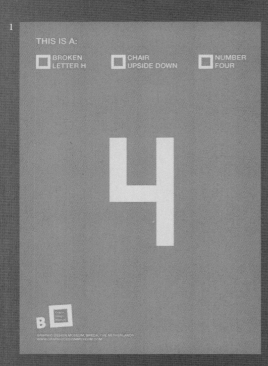

1

THIS IS A:

☐ BROKEN
 LETTER H

☐ CHAIR
 UPSIDE DOWN

☐ NUMBER
 FOUR

CREATIVE OR MANAGER?

"In 1996 when my partner, Johan Kramer, and I started KesselsKramer in Amsterdam, some people wondered how this could be possible. After all, we were used to creating ideas, not managing people. But because we took the leap, we just had to figure it out. We helped crush the myth that a creative person can't be a manager. In reality, every art director is already a manager."

Erik Kessels—KesselsKramer

"An art director is definitely a creative with management skills. This is why many designers fail to become art directors. They've trained in creativity, they love creativity, they are passionate about it, so when you ask them to do something different, such as manage, they aren't really that interested. But after a while you learn that inspiring others to do great work is just as rewarding as doing it yourself."

Paul Burgess—art director

"Good ideas, clear vision, and intelligent execution are most important. If you're even half good you'll be able to manage a project."

Simon Dixon—DixonBaxi

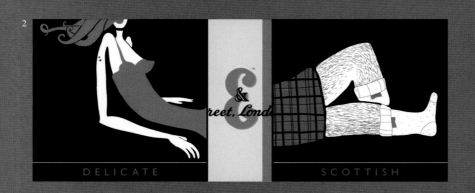

2

DELICATE SCOTTISH

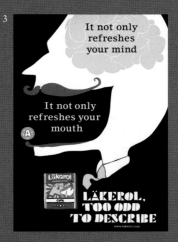

3

4

5

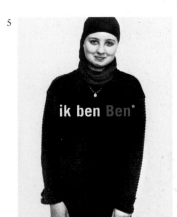

1. Graphic Design Museum, Beyerd Breda

Promotional poster for the Dutch Graphic Design Museum.
KesselsKramer

2. Delicate & Scottish

Billboard designed for J&B Whisky, Spain.
KesselsKramer

3. Läkerol pastilles

Promotional poster for international candy brand Läkerol.
KesselsKramer

4–5. Ben®

Promotional material for Dutch cell phone company Ben®.
KesselsKramer

Can an art director have a signature style?

In my opinion, most designers do have a signature style that will at times manifest itself in their work. Designers and art directors aren't always prepared to accept this when asked, and will offer the retort that every project has to be approached with a clear mind, a clean slate, and without reference to personal design sensibilities. That's quite true of course, but if you take a look at the body of work of any number of well-known designers and art directors, you'll realize that many of them have at least a hint of a signature style that they've used to great effect to produce memorable work. It's an important part of the process by which art directors are retained by their employers, are offered more work by their clients, and how new clients are drawn to approach individual art directors or their companies.

"Art directors should develop their own styles, but there is a fine line here because you can't give all your different clients the same look," says Erik Kessels. "The style that I'm talking about is not necessarily about aesthetics—it's more of a specific approach or mentality that is applied to different briefs and jobs. My own personal style is influenced by many different factors. I think it's important to not draw inspiration from other campaigns, but instead to find inspiration from the world outside. You can find inspiration in conversation, on the street, in art, in music, and on the toilet." Aslan Kilinger adds to this point when he says, "There is a difference between a signature style and repeating yourself. I believe an art director is likely to have some kind of signature style, which is not a hindrance to creativity, but it gives the art director a unique character. At the same time, a good art director should stay sharp, reinvent himself continuously, and not just try to surprise the client, but also himself."

Bringing all of these points together paints a pretty good overall picture of what an art director is, but as I said at the beginning of this chapter, it's not easy to define exactly what an art director is. There will always be some new way of defining the art director's role because, fortunately for those of us that are art directors or designers, we work in an industry that is ever changing. That's what makes it all so rewarding, what keeps it interesting, and what makes it fun.

1. Save Yourself/Drink Urine

Advertising campaign for fashion brand Diesel.
KesselsKramer

2–3. Hans Brinker Budget Hotel

Promotional material for the Hans Brinker Budget Hotel in Amsterdam.
KesselsKramer

4. In Almost Every Picture 1

A collection, edited by Erik Kessels, of hundreds of photos of a woman taken by her husband during the years 1956 to 1968, which were found in a flea market in Barcelona, Spain.
KesselsKramer

5. In Almost Every Picture 3

A collection, edited by Erik Kessels, of photos of deer and other small animals captured by a camera that was rigged with a motion detector.
KesselsKramer

6. MTV Japan

MTV Japan promotion for the Video Music Awards 2005.
KesselsKramer

7. I Amsterdam®

Promotional poster for the City of Amsterdam, the Netherlands.
KesselsKramer

8. Action!

Promotional material for Diesel.
KesselsKramer

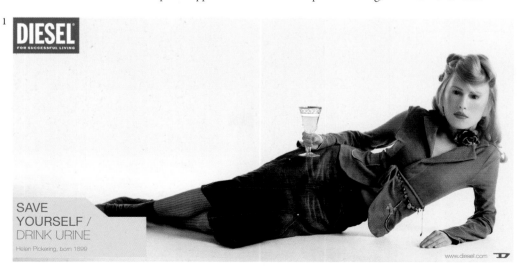

1

DIESEL
FOR SUCCESSFUL LIVING

SAVE YOURSELF / DRINK URINE
Helen Pickering, born 1899

www.diesel.com

2

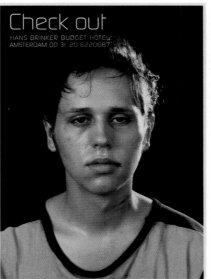

Check in
HANS BRINKER BUDGET HOTEL
AMSTERDAM 00 31 20 6220687

Check out
HANS BRINKER BUDGET HOTEL
AMSTERDAM 00 31 20 6220687

6

7

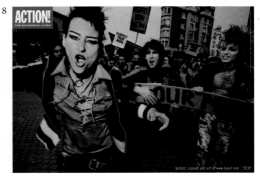

I amsterdam

3

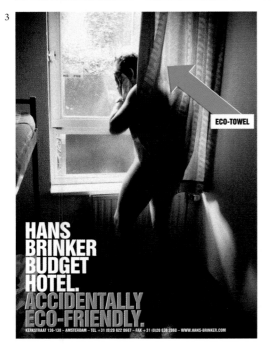

ECO-TOWEL

**HANS BRINKER BUDGET HOTEL.
ACCIDENTALLY ECO-FRIENDLY.**

KERKSTRAAT 136-138 – AMSTERDAM – TEL +31 (0)20 622 0687 – FAX +31 (0)20 638 2060 – WWW.HANS-BRINKER.COM

4

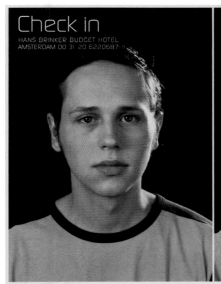

5

8

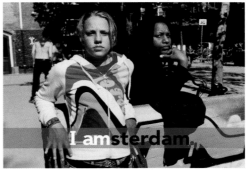

ACTION!
FOR SUCCESSFUL LIVING

"Art directors should develop their own styles, but there is a fine line here because you can't give all your different clients the same look."

Erik Kessels—KesselsKramer

SIGNATURE STYLE

"Instead of saying signature style, I think it's more precise to say that great art directors have a signature way of thinking and problem solving. This is part of the learning process of our profession and not a hindrance to creativity. I can emulate my past art directors' 'styles' and, by doing so, have come to create my own way of thinking and problem solving."

Sean Adams—AdamsMorioka

"An art director can have a signature style. But that style should always be at the service of the art director's problem solving and conceptualizing skill set. Style is not a solution in graphic design, it is a tool to achieve a better solution."

Neal Ashby—Ashby Design

"I think an art director can have a signature philosophy, but not a style. I think that starts to hinder uniqueness to the client."

Justin Ahrens—Rule 29

1

2

3

1–4. Nike Premium Performance

Custom media pack designed for a
campaign focused on innovation.
Joshua Berger and Todd Houlette—
Plazm

4

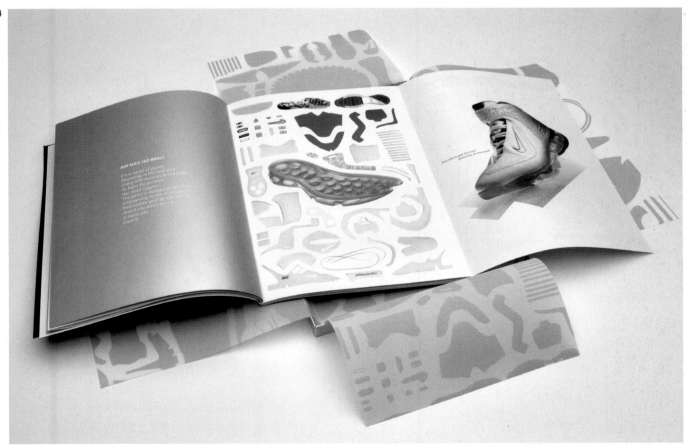

1

2

1–2. Nike Sisters Women's Training

Media kit designed specifically for the Asian market.
Joshua Berger, Ian Lynam, and Thomas Bradley—Plazm

3–9. Nike Sisters Women's Training

Media kit designed for the US market.
Joshua Berger and Thomas Bradley—Plazm

3

5

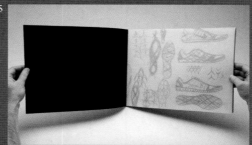

7

8

9

4

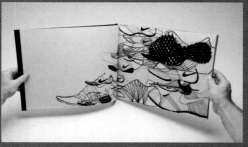

6

1. Nike Beautiful

A 60-page case-bound book with slip case and bound-in CD rom promoting the newest Nike women's products. *Joshua Berger, Todd Houlette, and Eric Mast—Plazm*

"Good art directors absolutely have a signature style and take on every project with their own unique approach. The best art directors are open to the potential of an unexpected solution. Sometimes the accidents are the most successful part of an exploration."

Joshua Berger—Plazm

ANGUS HYLAND
PENTAGRAM

Profile

After graduating from the Royal College of Art in 1988, Angus ran his own studio in Soho in the heart of London's West End for 10 years, where his portfolio of work included book publishing, identities, fashion campaigns, commercials, record sleeves, and information design. In 1998 he was invited to become a partner at Pentagram's London office.

Interview

Tony Seddon: We're beginning all our interviews with the same question—what is an art director?

Angus Hyland: I guess the answer expressed as a term is a bit like geography lessons at school in that art direction encompasses so many things. You have advertising, where art direction is visualizing the concept, then you have magazines, where art direction is different again because it's more about the layout. The role of art directors in publishing houses is sometimes seen as more of a managerial position, where you're working with your in-house team or outsourcing the design work and keeping an overview of the whole thing. For example, there's what I do with Laurence King. For want of a job title, I'm their art director, at least, that's what they call me, but I work on a consultancy basis. I actually call myself creative director because the role is twofold. I get involved in pushing books around to various designers and agencies because all Laurence King's design work is outsourced, and I provide a sort of arbitration service between the designers and the publishers and commissioning editors when the design work is completed. It's a bit like being a translator too actually, helping the people at Laurence King to see what the designers have done with the material.

Luke Herriott: So do you personally commission the designers?

AH: Yeah, sometimes, but often one of the commissioning editors will say they'd really like to work with someone they've come across, which is fine. Because I'm not there every day, the time available only allows me to advise rather than actually do, so I can't get fully involved in all of the commissioning. I also work with the Laurence King brand as well, we talk about ongoing and new ideas, how the brand is promoted, and so on.

TS: It's interesting that you brought up the job title of creative director, because the difference between a creative director and an art director can be a bit of a gray area.

AH: Yes, but I think both roles are actually about choosing people whose skills can be tasked into certain types of activity and then managing them properly. I suppose it really depends on which title you or the company you're working for chooses. It doesn't really matter, you could just as easily use the term brand consultant and it would mean the same thing in context.

LH: How does it work here at Pentagram?

AH: Well, firstly I'm a director of the company, so we lose the art bit for that. I'm also a practicing designer and I run a team of six or seven people, and I oversee everything they do. Part of that is managerial, part of that is client liaison, and a lot of it is actually working at the coal face. I don't really sit and push a mouse around any more although I probably could if I had to, but I've never really done too much of that. I used to do more when I started out because I only had one assistant back then.

TS: Do you miss the hands-on stuff at all?

AH: Not really, I can't remember what there is to miss! I think that when you change from being a designer to being an art director you eventually end up—not deliberately I should say—sort of rendering yourself obsolete as a hands-on designer because everything now involves newer versions of software and so on. There's not enough time to keep up with all the changes. What I'm saying is, I am a designer, but in the broadest sense of the term, I'm first and foremost an art director.

TS: I like that as an answer to the original question actually—an art director is a designer who doesn't sit in front of a computer all day.

AH: Yeah, think of the word directing, which obviously means telling people what they should do. If you're working on a computer producing the work you're telling the machine what to do, so there's no directing involved. Art directing therefore requires another layer, where the art director is working through a human interface, which is another designer sitting in front of the computer. That's it!

LH: How is your team structured?

AH: I have four designers who are full-time, and one temporary intern who is treated pretty much the same as the other designers. I've also got a project manager whose role is, as much as anything else, trafficking the various projects.

TS: Is that a design management role rather than a creative role?

AH: Yes, and she also does a lot of the day-to-day client liaison, mainly on the larger projects that need Gantt charts, lots of forward planning, all that kind of thing. She and I also work on fee proposals and

1. Quantum of Solace

Hardback edition of Penguin Books' <u>Quantum of Solace: The Complete James Bond Short Stories</u>.
Angus Hyland and Fabian Herrmann—Pentagram

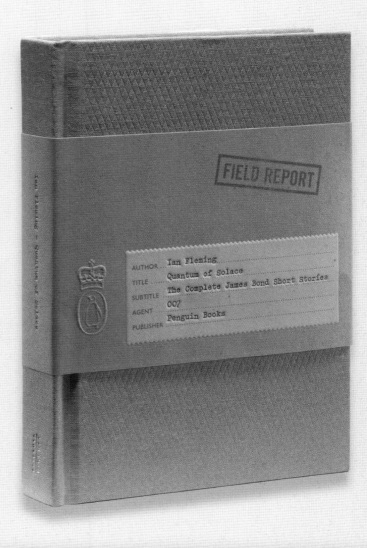

schedules, and we decide between us how the work is split between the designers in the team. All the designers are more or less on the same level, some are a bit older and a bit more experienced, but there isn't really a hierarchy within the team.

TS: Despite having a project manager to maintain day-to-day client contact, I get the impression that you still invest a lot of time speaking to your clients. Is that the case?

AH: Yes it is. In some ways Pentagram is positioned somewhere between a large corporate agency that has a very hierarchical structure with lots of planners and account handlers, and what you might call a boutique studio with five or 10 people. Each partner's team replicates the smaller model, and between us we're able to bring in enough in the way of fees to collectively support that structure. Under those circumstances, as art directors, we're able to maintain a much closer relationship with our own clients.

TS: Have you therefore removed the account handler role altogether?

AH: We do have them, but they tend to handle the really large projects where they're needed because of the amount of time that's taken up. For most projects it's not necessary, which helps to avoid things becoming overmanaged, and I can do it all along with one of my designers or with my project manager.

LH: Once you're up and running with a brief, do you do a lot of sketches and roughs to get your own ideas across, or do you look to your team for that initial input?

AH: Ah, interesting, it varies. For example, I worked on a book cover idea for a collection of stories about the afterlife, and after thinking about it for a while, I

1

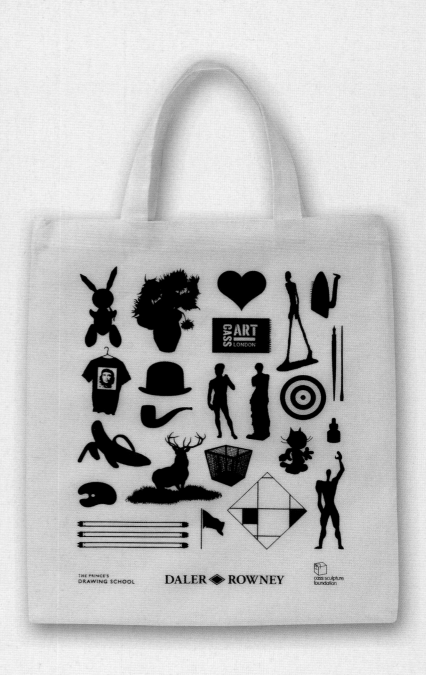

2

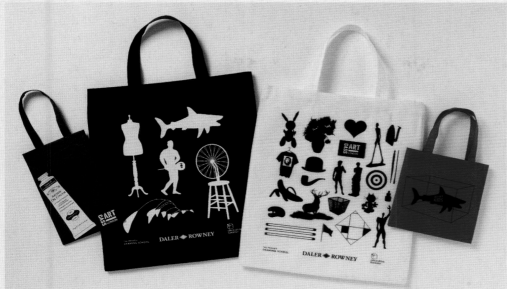

1–3. Cass Art bags

Tote bags for London-based art supplier Cass Art. The reusable bags are given away as a free gift with every purchase worth over £30.
Angus Hyland—Pentagram

3

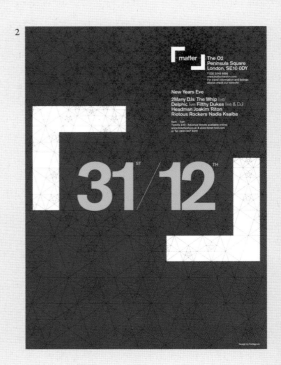

came up with the idea that the cover should be a door, then decided it should be a die-cut so the packaging is saying, "What's beyond this?" Then it was given to one of the designers and an illustrator and someone came up with the idea of adding an exit sign, which really made the idea because it was funny and ironic. I don't do detailed sketches that are beautiful visuals though, I do really rough sketches to get my ideas across.

TS: Does the way you work help to diffuse the need for individual ownership of the initial ideas behind projects?

AH: I really don't mind where an idea comes from ultimately. If it's a good idea we'll use it! Art direction is a constant, ongoing process where you work with different people that bring their own creativity to a

project, it's really a very nebulous process. I'm not that controlling, everyone is potentially going to add something and as art director you're acting as choreographer. Most of what happens during the completion of a project will have occurred as a result of the viewpoints of other people, so it's your role to shape that into one coherent thing at the end. Some things need lots of careful shaping and some things are best left to evolve—the trick of good art direction is knowing when to step in and when to back off. Unless you're an extremely gifted individual, I don't think you can leave college and do art direction straightaway, you have to learn how to do it through experience.

1–6. Matter

Identity for a live music venue based within the O2 Arena in London. All printed material is closely linked to the interior design and signage. *Angus Hyland and William Russell— Pentagram*

3

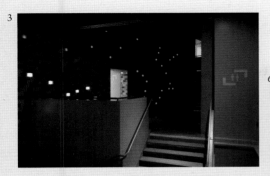

4

6

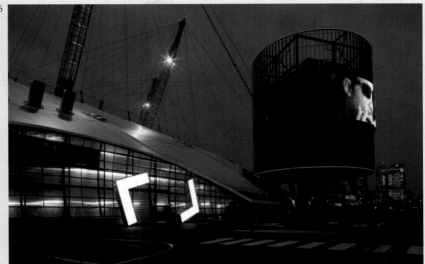

5

The Blank Sheet

BEGINNING A PROJECT

For me, the start of a new project often generates a familiar pairing of emotions. It's exciting because you're about to embark on your next creative journey, which is a good thing, right? Every new project could potentially provide you with the opportunity to learn something new about design, or perhaps to further your art direction skills, or even to discover something about yourself and your own capabilities as an art director. However, at the same time, I always feel a little nervous. Can I come up with something that's going to answer the brief, can I bring it in on time, and can I get it done on budget? What are the priorities?

Analyze and prioritize

I think that all projects should start with a good idea—a sound conceptual approach that will solve the problem elegantly and efficiently. But before you reach for your mouse, take a good look at the logistics that surround the brief and think about all the scenarios that may occur during the course of the project. It's easy to get fired up about the creative part of a project and ignore the potential problems posed by budget and schedule, but for art directors, budget and schedule considerations are right up there with creative development in terms of importance. Equally, the issues of adequate staffing levels, locating the right freelance help if it's needed, and the available skill sets within your in-house team should be looked at carefully at the beginning of any project to ensure you don't slip up once work has begun. If you're juggling

1. Lewis Carroll

An introductory monograph on the photography of Lewis Carroll, author of <u>Alice's Adventures in Wonderland</u>, and one of the most influential Victorian portrait photographers.
Sonya Dyakova—Phaidon

2. Lewis Carroll

The book's case doesn't traditionally repeat what's on the jacket. Instead, it's a playful quotation from <u>Alice's Adventures in Wonderland</u>, something to discover.
Sonya Dyakova—Phaidon

1

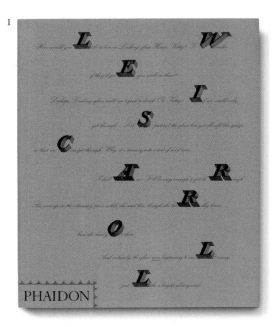

2

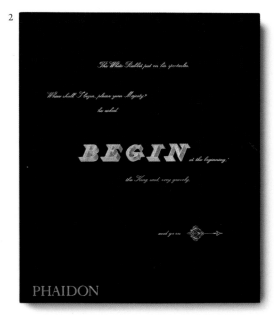

3

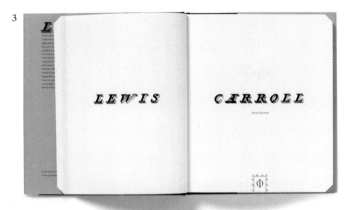

4

5

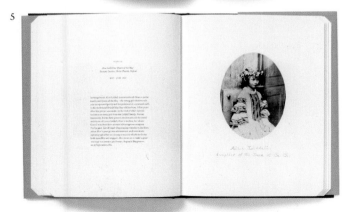

several projects with crossover schedules, you must ensure that crucial deadlines don't leave you with difficult choices to make. A client will only be interested in the success of their own project, and won't accept excuses for late delivery that originate from problems with another assignment. It's important to bear in mind that failure to complete a project successfully because of inadequate management could alienate you from your client and will dissuade them from entrusting you with more work in the future. In this sense it's no different for art directors employed to head up the creative team in a publishing house or agency, except that instead of a client you would have a publisher, editor-in-chief, and so on.

For a book about art direction this may come across as an overly commercial approach to the topic, but I can't emphasize enough how important it is to understand management issues if you are to succeed. Companies have to make money in order to survive, and that profit isn't generated by creativity alone, but also by good business acumen.

3-5. Lewis Carroll

The title is set in a Victorian alphabet that was widely used as a display face in the 19th century, and the corners of the book block have been trimmed to resemble a Victorian photo album. Carroll made his own albums, asking the sitter to sign his or her name under the photograph once it was in place. These albums are now at Princeton University Library.
Sonya Dyakova—Phaidon

BEGINNING A PROJECT

"We think about the idea and the required result first. Then as we work, we fold in the practical aspects: available budget, schedule, and how we create the ideas. The priority for us is what we'd like to make. The rest is just part of how you make it and should be second nature."

Simon Dixon—DixonBaxi

"Budget is a factor in terms of setting parameters, and defining the team is usually based on the deliverables, but for me everything needs to start with a conceptual approach to solving the problem."

Joshua Berger—Plazm

"It's a cliché that the first thing you need to do is nail the idea, but if you pile headlong into that, you'll miss your deadline. You have to plan. Resource is number one—without anybody working on the project, you won't get very far. The right combination of experience matters, getting the right people on the job is essential."

Paul Burgess—art director

"To succeed you need to take style, budget, schedule, and staffing into consideration and prioritizes them under the different stages of the project. The budget, for example, is always very important. I mean, there's no use in coming up with a brilliant print idea if the budget doesn't allow it to be made."

Martin Fredricson—We Recommend

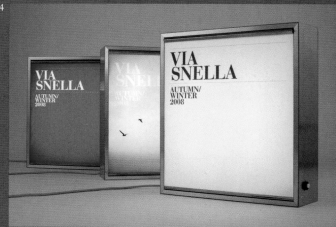

1. Via Snella

Visual identity for a new Swedish fashion brand.
Martin Fredricson and Nikolaj Knop—We Recommend

5

6

7

8

9

5–9. Upplevelseindustrin (Swedish Creative Industries)

Visual identity and printed material for a network of eight meeting places designed to encourage the development and growth of collaborative working between Swedish designers, academics, and public sector businesses.
Martin Fredricson and Nikolaj Knop—We Recommend

CONSIDERATIONS FOR PROJECT PLANNING

It's pretty rare that the solution to a design problem is arrived at immediately. The realization of a creative brief is usually the result of a combination of idea generation and planning. Before I get started on a new project, I grab a notebook and scribble down short answers to three standard questions.

What are the main objectives?

If you're working with a new client, find out as much as you can about their business and what they want to achieve with the design work they have commissioned. They may have a position in their given market, or a business strategy going forward that they want to rigidly maintain, or they might have decided that they've been heading in completely the wrong direction and want to reverse their game plan. Whatever the scenario, focus on the objectives of the project as early as you possibly can, and if the client isn't thinking objectively, encourage them to do so as part of your initial proposal. The same applies if you're working on an in-house brief for an employer or for yourself, and always bear in mind that the completion or delivery date is in itself a specific objective.

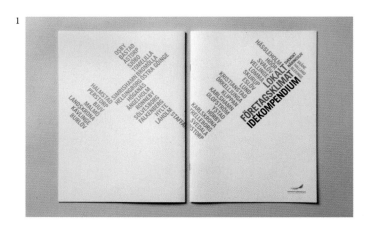

1

1–4. Lokalt Företagsklimat

Visual identity for the Swedish Confederation of Enterprises' initiative for the investigation and development of local corporate conditions in Sweden.
Martin Fredricson and Nikolaj Knop—We Recommend

2

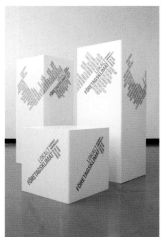

3

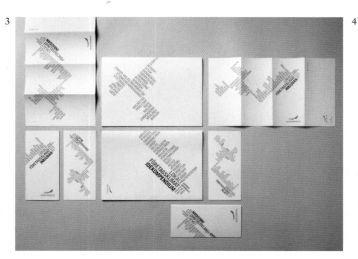

4

How will I get the job done?

Sketch a rough flowchart of the project with each stage represented by a box or note. This will help you visualize in a sort of "family tree" form how the complete project might progress and what you'll need at each stage. Another way to do this, which I favor because you can add and move stages around easily, is to use Post-it® notes to make the chart. There are quite a few software solutions designed specifically for project planning, but personally I think they tend to make the whole process feel more complex than it actually is. Ultimately the choice is yours and it's certainly worth checking what's available if you're keen on the software option. As I mentioned earlier, equipment and staffing needs, and the various skills required to complete the project successfully, will all come out of this part of the process.

You'll also be looking at scheduling and budget at this point of course, and we'll cover that in more detail on pages 56–57.

2

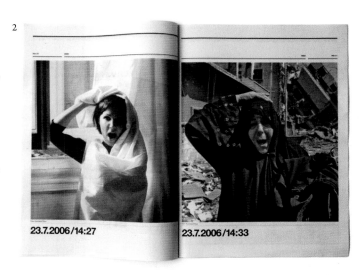

23.7.2006/14:27 23.7.2006/14:33

1

3

1–3. Obs!

A free, Copenhagen-based newspaper comprising of a collection of artists' comments on today's media consumption.
Martin Fredricson and Nikolaj Knop
—*We Recommend*

There are quite a few software solutions designed specifically for project planning, but personally I think they tend to make the whole process feel more complex than it actually is.

What have I forgotten?

The more projects you undertake as an art director, the less likely it is that you'll overlook any of the key stages. However, it's always worth asking yourself, "Are there any differences between this and any other projects I've worked on in the past? If so, what are they and how can I draw on my previous experiences to help with the new project?" Here are some points to consider when planning a new project.

2

- Have the project's key objectives been established?
- Has the client agreed in writing to the objectives?
- Are all the members of your team in possession of the appropriate skills for the project?
- Are your staffing levels adequate?
- Have you allocated the workload fairly so no one on your creative team is overloaded?
- Is there a good network for communicating and recording project-specific information?
- Have costs been placed against the budget?
- Are there any requirements for specialist hardware or software that should be costed against the project?
- Have all the stages been built into the schedule?
- Is there any contingency in the schedule to accommodate unforeseen delays?
- Can any necessary photography or illustration be sourced?
- Have all external suppliers agreed to, and committed to, the agreed schedule and budget in writing?

1

1. Rogue Wave

Catalog for an exhibition showcasing the work of 30 emerging Los Angeles–based artists from the Rogue Wave shows at the LA Louver gallery. *Stefan G. Bucher—344 Design*

2. Sci Fi Channel Brand Book

Brand book incorporating work by various illustrators and photographers, produced as part of the redesign of the Sci Fi Channel's rebranding project. *DixonBaxi*

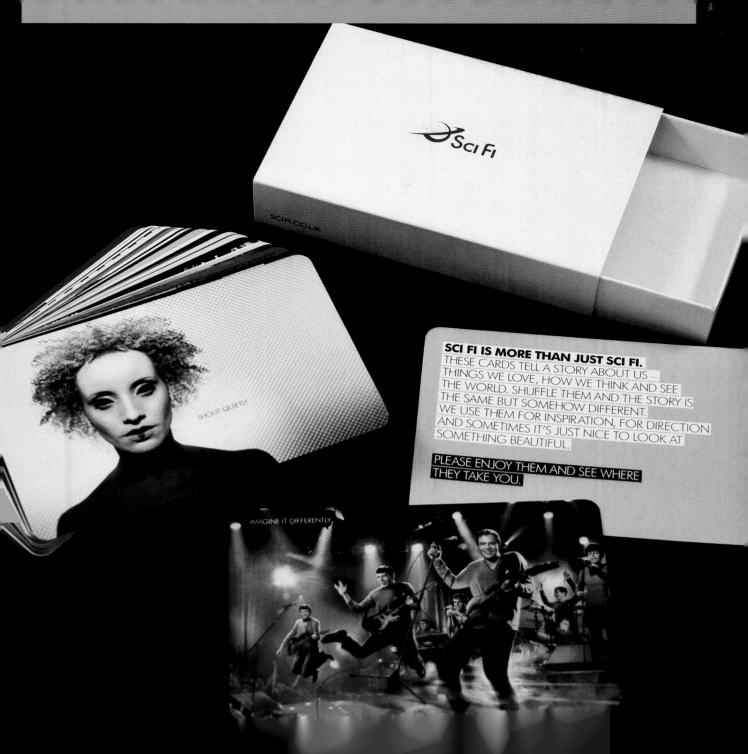

Sci Fi

SCIFI.CO.UK

SHOUT QUIETLY

SCI FI IS MORE THAN JUST SCI FI.
THESE CARDS TELL A STORY ABOUT US —
THINGS WE LOVE, HOW WE THINK AND SEE
THE WORLD. SHUFFLE THEM AND THE STORY IS
THE SAME BUT SOMEHOW DIFFERENT.
WE USE THEM FOR INSPIRATION, FOR DIRECTION
AND SOMETIMES IT'S JUST NICE TO LOOK AT
SOMETHING BEAUTIFUL.

PLEASE ENJOY THEM AND SEE WHERE
THEY TAKE YOU.

IMAGINE IT DIFFERENTLY

THE BRIEF

There's a simple adage that can be applied here—you get what you ask for. A well-prepared design brief is essential if your expectations as an art director are to be met, and any design solution can only be as successful as the original brief. A good design brief should be clearly written, open enough to allow a designer to exercise their own creative vision and ownership over it (that's why you've hired them in the first place), but specific enough in its content to allow no room for error of interpretation. Unfortunately designers often find themselves in a situation where a badly prepared brief has been provided (by either an art director or a client), the objectives for the project are not clear, and the deadline is already looming. If, under these circumstances, a designer gamely progresses with a project, only to meet with the depressing "that's not really what I had in mind" response, the resulting situation will be problematic for the commissioning party. If the quality of the design work is good but hasn't been pushed in the direction intended, the fault most likely lies with the shortcomings of the brief. Under these circumstances, and if the designer has truly given it their best shot, it's unreasonable to reject the work.

Standardizing the brief

The best way to avoid inconsistency and ambiguity when writing design briefs is to standardize the process through the use of a template that includes all the potential requirements you need to specify. In doing this you avoid having to think about what to include every time you write a brief—all you have to do is delete any template items that aren't relevant. Briefing templates can also be used to encourage your clients to provide accurate information when they brief you. Supplying your client with their own customized template, based on your own standard layout, will ensure that you receive all the information you need without having to chase for it every time you accept a new project. Furthermore, the points itemized may also prompt the client to think more carefully about what they really need before briefing you and your designer incorrectly or inappropriately.

A good design brief should be clearly written, open enough to allow a designer to exercise their own creative vision and ownership over it (that's why you've hired them in the first place), but specific enough in its content to allow no room for error of interpretation.

1

2

3

Tips for writing good design briefs

- Use language that indicates you respect the fact that the designer is a professional who is used to working with a design brief. Precise definitions of the project's goals will be absorbed and understood more readily than lengthy explanations containing lots of unnecessary details.

- The designer isn't able to read your mind, so make sure that all the relevant points of reference about the project's requirements are included. Designers can't be expected to fill in the gaps in your own thought processes.

- If the project involves designing with a product or service in mind, make sure you provide the designer with as much background information as possible to allow them a clear understanding of the market they're designing for.

- If your own vision for the project is already highly developed at the time the brief is prepared it would be wrong to not communicate that, but try to do this in a nondictatorial fashion. In other words, don't design for the designer. Instead, suggest an approach they might consider trying along with their own ideas. You're hiring them to provide you with their own creative vision and talent, not to duplicate your own.

- Be very clear about all expectations for the project on both sides. This means including full details of the budget, the schedule for each stage of delivery, preferred methods for delivery of materials and communications, and possibly also payment terms and fees if the brief is doubling up as a purchase order. Combining the brief and purchase order is a good way to cut down on paperwork and helps to streamline the handover process.

- Stipulate exactly what software packages you want the designer to work with, and provide them with written guidelines specifying any preferences you want them to follow when setting up artwork files.

- If distance or time isn't a restriction, arrange a face-to-face meeting with your chosen designer in order to discuss the brief as part of the project handover. If the brief is open to interpretation in any way (and let's face it, most design briefs are) there's no better way to clarify any gray areas that may exist.

4

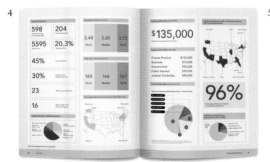

5

1–5. USC Law Viewbook

A new approachable collateral system for one of the top ranked law schools in the US, which aims to increase applicant numbers and to distinguish USC from other top-tier institutions.
AdamsMorioka

RESEARCH AND DEVELOPMENT

Research and development, in an increasingly complex commercial world, are more important than ever. At art college we're taught how to communicate effectively using our typographic and illustrative skills, and how to create individuality for our future clients through the appropriate use of styling techniques. These visual skills continue to develop over the course of our careers and help us, if we're so inclined, to progress and become art directors. However, in today's global marketplace it's not enough to simply produce great visuals. Art directors and designers must also be able to quantify how design solutions will deliver financially. Budgets set aside for design have to be measurable against the results produced by the creative investment.

Including what are essentially traditional methods of research and development in the design process will help to achieve this goal, and needn't be seen as a hindrance to creativity. Design that is in part driven by appropriately applied research and development delivers on more than one level as it defines much more than just the visual solution. A particular design aesthetic can be explained and supported by sound research, as can concepts which might at first seem incomprehensible or notional to a client, or indeed to a publisher/editor-in-chief. In addition, concepts can be supported, target audiences can be clearly defined, and the effectiveness of creative solutions can be quantified on an ongoing basis. The best art directors learn where to look in order to gather the right kind of information, and how to interpret and mold that information into a form that fits neatly with their own creative thinking. Well-practiced research techniques should be incorporated into an art director's everyday workflow as a matter of course, and development techniques formed off the back of that research should map seamlessly to the design sensibilities of an art director's creative team.

3

4

1

2

5

6

7

8

9

10

1–10. Nycomed

This visual identity for Nycomed, a global pharmaceutical company, was implemented in more than 30 countries. Illustration was combined with documentary photography to allow for movement between expressive "visionary" thinking, and the identity was used in multiple print projects including annual reports, brand books, posters, and across a wide range of merchandise. It was developed with multiple creative partners including Interbrand (corporate identity), Pleks (typography), Robert Brandt (illustration), Ture Andersen (photography) and IDEO (strategic innovation).
Mark Stevens—M-A-R-C

Types of research

There are two categories of research that can be applied to most exercises involving gathering data: quantitative and qualitative. Quantitative research involves the gathering of measurable quantities of data which can be analyzed and compared to achieve a "quantifiable" result. For example, you might count the number of cars at a traffic intersection at regular intervals during a day to determine how frequently an adjacent digital advertising screen should change its image. This type of research is well suited to scientific analysis, but it produces objective results and the methodology is harder to apply to creative assignments, so designers are more likely to turn to qualitative methods for their research.

Qualitative research is something we creatives generally feel more comfortable with because it deals with subjective rather than objective data. This data can take the form of words, illustrations, or photographs, so we're much more within our comfort zone when analyzing this material. It uses techniques such as group analysis, peer review, and observation. For example, you might spend a period of time in a store observing how shoppers move from one product range to the next in order to ascertain how the store's layout should be designed to increase the exposure of the most popular items. Most research carried out for creative design projects falls into this category as design relies so heavily on subjective human responses—which are admittedly difficult to quantify at the best of times—but information gleaned from qualitative research can be very valuable nonetheless. The table below provides some comparitive examples of quantitative and qualitative research/analysis.

In addition to quantitative and qualitative research, it's useful to understand the differences between primary and secondary research. Primary research is carried out by you or your company for use with a specific project. This may involve a client's product for which you're designing the packaging, a marketing campaign, and so on. Secondary research is carried out by reviewing any existing data that relates to a similar project to the type you're tackling, but doesn't necessarily have to relate to the exact same product type. For example, if you have data about the kind of television programs typically viewed by 13–17 year olds, you can use that to make decisions about the creative approach you should take for the styling of a newly launched magazine aimed at the same age group.

1. Cultuur.TV

Corporate identity for a television company dedicated to the promotion of cultural topics.
Aslan Kilinger—Maestro

2–3. De Kleine Wereld

Recruitment campaign for a day care center in the Netherlands.
Sharon Kilinger, Aslan Kilinger—Maestro

QUANTITATIVE	QUALITATIVE
• 200 cars stop at the intersection every 20 minutes	• Lots of cars stop at the intersection on a regular basis
• The candidate achieved 79% of the vote	• The candidate is extremely popular with the voting public
• The Airbus A380 can carry a maximum of 853 passengers	• The Airbus A380 is a very large aircraft
• The dog weighs 160 lbs	• The dog is overweight
• The tint is 60% magenta and 100% yellow	• The tint is a pleasant shade of bright orange

1

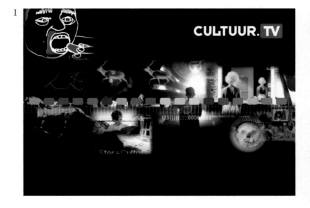

2

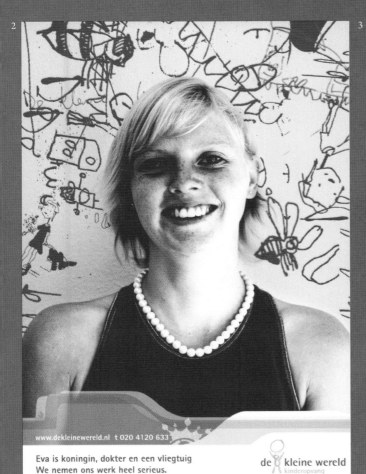

Eva is koningin, dokter en een vliegtuig
We nemen ons werk heel serieus.

de kleine wereld
kinderopvang

3

Ruth is 3 jaar, vanavond weer 23
We nemen ons werk heel serieus.

de kleine wereld
kinderopvang

RESEARCH

"Usually we don't accept a project without knowing who the client is and what their expectations are. After a meeting to discuss their needs and determine if we can creatively collaborate with them, we decide to take on their project or not."

Sean Adams—AdamsMorioka

"It's usually a case of two separate dynamics, researching similar projects that might have stylistic parallels to the project I'm working on, but also educating myself regarding the specifics on history/background/mechanics of the project itself."

Neal Ashby—Ashby Design

"I have found research to be more and more important of late, and I really do believe that the more you understand a brief through research then the better the creative result will be. So much of the creative process for me is about 'clear creative thinking'. I'm not interested in a slick, styled-up solution. I want to know what the idea is before anything else."

Carl Rush—Crush

"We like to wander initially, thinking about the range of executions and styles we'd like to achieve. We also talk about who we'd like to collaborate with. We often create large mood boards or walls in our studio to create the overall tone. Elements we make, found objects and internet research are all considered. We often task a creative to find new directions and examples to feed into this. While we do this we write and draft ideas or copy. Things to pull the overall idea together. Then we decide how prescriptive we want to be. If we want a very specific feel we'll create a very accurate visual. If it's looser or more about who we work with, we'll talk to them and start the ball rolling."

Simon Dixon—DixonBaxi

"I am a fan of getting as much information as possible and trying to synthesize it in a topline manner. I cast a wide net and look at analogous studies outside of the category I'm working in. I want to have this information in the back of my mind (as opposed to the front) so I can be creative and on target."

Joshua Berger—Plazm

"When beginning a print project we always start by defining the objectives of the brief. Once we have an understanding of this we decide who needs to be involved. Our research typically begins by learning about the client and their business. If you are rebranding a company, for example, telling a client what they're doing wrong in a sector that they know implicitly and you don't means you'd better have done your homework. While some projects may require research to drive the direction and ideas, others can be solved by an open studio discussion, usually conducted in our second office (the Sheaf View pub), to see what ideas may transpire."

Paul Reardon—Peter & Paul

1

Jefferson
Sheard
Architects

2

1–3. Jefferson Sheard Architects

A complete redesign for the visual
identity of a 50-year-old architectural
firm. The new logo was partly inspired
by Galt Toys locking shapes.
Paul Reardon—Peter & Paul

3

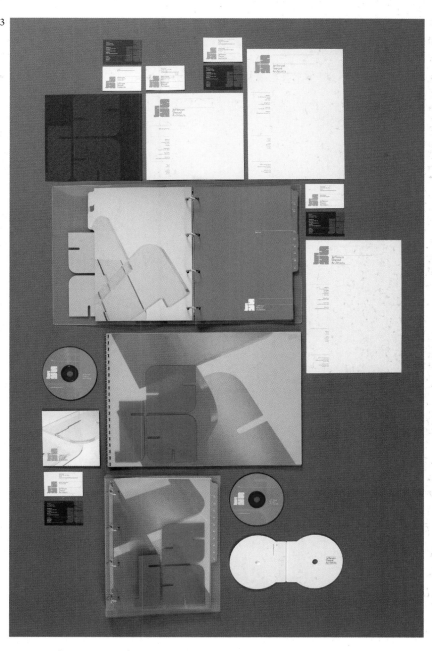

BUDGETS AND SCHEDULING

The preparation of a budget and schedule for a design project are closely linked. If you're not completely clear about how much you have to spend you can't make decisions about anything that might need to be outsourced, such as photography, illustration, or freelance help. The schedule, more often than not driven by a client's needs, will dictate your workflow and indicate if you're able to take the project on. A comparison between the budget and the schedule will tell you whether or not you'll turn a profit on the time required to produce the work successfully. If you're working under strict budgetary controls or on a freelance basis and you can't afford to undertake the assignment, the best advice is to politely decline the work with a clear explanation of the reasons behind your decision. A good client will respect this approach.

A comparison between the budget and the schedule will tell you whether or not you'll turn a profit on the time required to produce the work successfully.

Devising a budget

There are two distinct budgetary scenarios art directors are likely to encounter. If you're working for a client, your budget will consist of your design fee, which should take into account any expenses you'll incur for commissioned work, plus an amount set aside for print and production that may be broken down into further components such as reprographic, print, and delivery costs. If you're an art director running an in-house team, the fee component is replaced with an amount that can be used for outsourcing work to freelance designers if necessary. Once again, there's likely to be an amount set aside for the possible need to commission photography or illustration. I prefer to establish a flat fee in advance for any outsourced work, particularly if I've not worked with the person before. This gives you much more control over a budget and ensures there won't be any surprises on completion of the project. If you're able to establish (and trust your freelancer to stick to) an exact number of days for commissioned work, a day rate is fine. The layout of books and brochures can be costed on a page rate too.

There's nothing wrong with a little negotiation when commissioning work, but be realistic about paying appropriately for the skills of the photographers, illustrators, and designers you choose to work with. Budgetary cuts from one project to the next will not help you to maintain good working relationships with your suppliers.

1

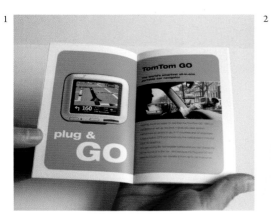

2

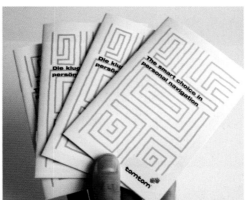

1–2. TomTom

Brochure supporting the launch of a mobile navigation device for use in cell phones.
Maestro

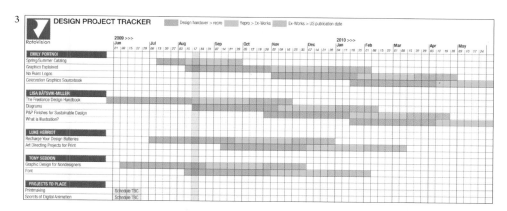

3

DESIGN PROJECT TRACKER

RotoVision

Design handover > repro | Repro > Ex-Works | Ex-Works > US publication date

2009 >>>
Jun Jul Aug Sep Oct Nov Dec 2010 >>> Jan Feb Mar Apr May

EMILY PORTNOI
Spring/Summer Catalog
Graphics Explained
No Rules Logos
Celebration Graphics Sourcebook

LISA BÅTSVIK-MILLER
The Freelance Design Handbook
Diagrams
P&P Finishes for Sustainable Design
What is Illustration?

LUKE HERRIOT
Recharge Your Design Batteries
Art Directing Projects for Print

TONY SEDDON
Graphic Design for Nondesigners
Font

PROJECTS TO PLACE
Printmaking — Schedule TBC
Secrets of Digital Animation — Schedule TBC

3. Gantt chart

Simple Gantt chart indicating the dispersal of projects by date between members of a creative team.
Tony Seddon—RotoVision

4–7. ORF

Poster campaign for the Austrian national public service broadcaster.
Maestro

The schedule as a workflow

I like to think of schedules for creative projects as workflows. For me, it makes more sense to take this approach because each stage of a schedule must be allocated a realistic amount of time for completion, and it's this that influences the timing decisions along with the client's or publisher's requirements for the project. The trick is to identify fixed points in the schedule which have to be achieved in order to begin the next stage, avoiding accumulative delays in the process. These could be, for example, finalizing the concept and design, planning the distribution of material and pagination, sending the job to repro and checking proofs, and of course, getting the job printed and delivered.

Simple projects that only involve one or two people don't present too much of a scheduling challenge. If problems arise during the execution of the project it's easier to adjust and compensate in order to meet the final deadline successfully. Complex schedules are another matter as they may involve multiple handovers, such as text and images for a publishing project that are being delivered in stages. When faced with this scenario, which is probably the case for the majority of print projects, I recommend using a Gantt chart to track the project's stages. A Gantt chart is basically a type of bar chart illustrating a project's schedule/workflow from start to finish, with each separate element of the workflow represented by its own bar, and with all bars set along the same timescale. They provide the best visual method for spotting problem areas in a schedule, and can be tracked easily using a vertical "today" line indicating whether deadlines are being met.

4

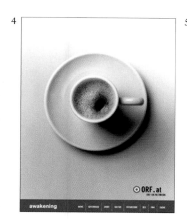

5

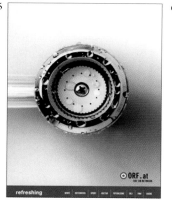

6

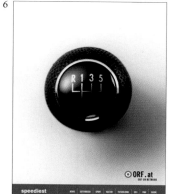

7

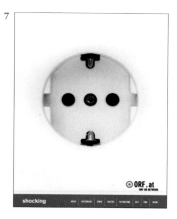

SONYA DYAKOVA
PHAIDON PRESS

Profile

Russian-born designer and art director Sonya Dyakova is the associate art director of Phaidon Press, London. She studied at the Academy of Art in San Francisco before moving to London where she began her career as a graphic designer, working with Frost Design and Kerr|Noble before joining Phaidon Press in 2005.

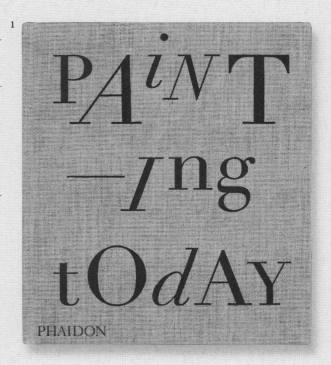

1

Tony Seddon: To begin our conversation we'd like to ask you what you think an art director is?

Sonya Dyakova: An art director is simply a designer who has a creative vision that he or she uses to go beyond their own work and see the bigger picture. It's important to be able to inspire yourself and others around you. It's a valuable skill to help someone see things in a different way, to offer a different perspective. An art director should be someone who is able to talk about ideas in a way that other designers can easily understand and interpret for themselves. They should definitely not be someone who offers a solution in a prescriptive way.

TS: It's interesting that you've raised that point this early in the conversation as we're particularly keen to see how prescriptive art directors feel they need to be when working with a team of designers. You know the kind of thing—make that red, move that up slightly, use this font, and so on.

SD: When an art director resorts to that, it feels like the project is being suffocated. It's true that sometimes it's difficult to avoid specific suggestions, but one must always try to identify the problem, not just issue an instruction. Instead of saying "make this type bigger," you could say this text is difficult to read. Then a designer can consider the problem and respond to it.

If you get to the stage you are describing, you might as well just start again, because if you have to do that you might as well just do it yourself, which isn't the point of the exercise at all. When I first arrived at Phaidon, Alan [Fletcher] was here, and I watched and learned from him how to approach this part of the job. He had a kind of magic way about him where he was very hands-off with his art direction. Or perhaps he made it seem that way. He didn't have to say do it like this or like that, he could just make you think about doing something in a certain way. If you brought up a question about something, he would often not answer it, but pose another question to make you think about it instead.

Interview

2

1–3. Painting Today

A comprehensive overview of painting of the last 30 years. The title is blocked with 'Yves Klein Blue' pigment directly onto canvas.
Sonya Dyakova—Phaidon

TS: So he was in a way art directing you without you knowing it?

SD: Yes, he was doing exactly that. A good example of this is the book *The Story of Art* by E. H. Gombrich, which is a very important title for Phaidon and has sold over 7 million copies. Alan Fletcher designed the cover for the most recent, full-sized edition, which features the title carved in stone. The publisher, Richard Schlagman, wanted to design a pocket edition of the book that would be portable and easy to handle. After I presented my first proposal, he suggested I talk to Alan about the cover, as it wasn't yet working. So, one morning I went along to Alan's studio thinking we'd sit down and discuss the cover, but instead he said "Why don't you have a look through my 'special books' collection?" There, on his shelf, were four large cardboard boxes full of wonderful books. I spent the entire morning looking through them, it was incredibly inspiring. About noon Alan took me to lunch at the Nicole Farhi store around the corner. We had a glass of wine, a lovely chat about this and that, and I'm thinking, when are we going to talk about the book cover?

Eventually when we were walking back to his studio I asked what he thought about the cover, and rather vaguely, he just suggested I should think about the time when Gombrich was writing the book. That was it.

TS: So not exactly what you wanted at the time?

SD: No, not really, but it was actually perfect because the idea he gave me—thinking about the particular period when Gombrich began writing the book—provided the graphic influences for the cover. The solution didn't present itself immediately of course, but the starting point came from the moment with Alan.

Luke Herriot: **Would you have your design team working on that kind of thing or do you get involved in the hands-on work yourself?**

SD: I always work on the concept on my own, but often I'll get some help doing the layout. When I start a new project, initially I like to go away and bury myself in it for a while.

I do get involved in a lot of the actual hands-on work—I can't do without that. When you work on something yourself, even something trivial like trimming a page you just designed, you come across questions that you would not be aware of if you were not doing that work.

LH: Do you get involved in the design for every cover?

SD: If you mean "do I design every cover," then no. If someone else is designing the interior it's really important that they take care of every single element of the design of the book, which includes the cover. If a designer contacts me to ask if they could work on cover designs for us, the answer is—how can you separate the two? It's like eating cherries off the cake, isn't that boring?

TS: I feel the same way about this. If a designer can't tackle the whole project then they probably shouldn't be involved at all.

SD: A cover isn't just a decoration that you put on the front of a book without also paying attention to what's inside. It's important that the design is fully integrated, otherwise the cover is just a shell. A book has to feel like a homogenous object. The cover should connect with the insides with all its might.

1

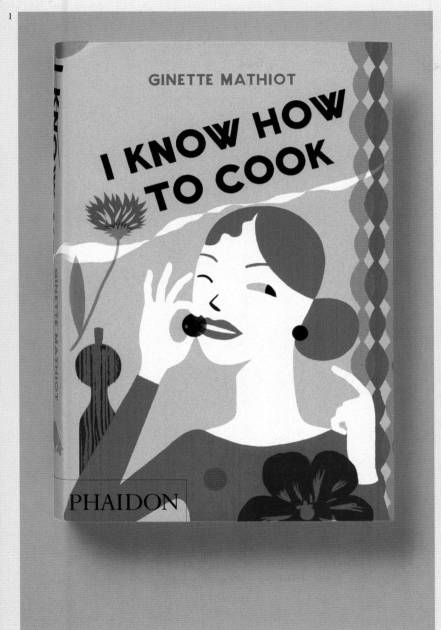

2

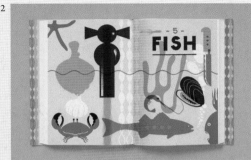

3

4

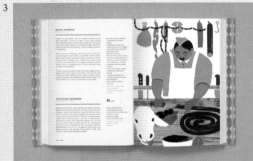

1-4. I know How to Cook

The bible of traditional French
home cooking, by Ginette Mathiot,
illustrated by a French comics artist
and illustrator, Blexbolex.
Sonya Dyakova—Phaidon

1

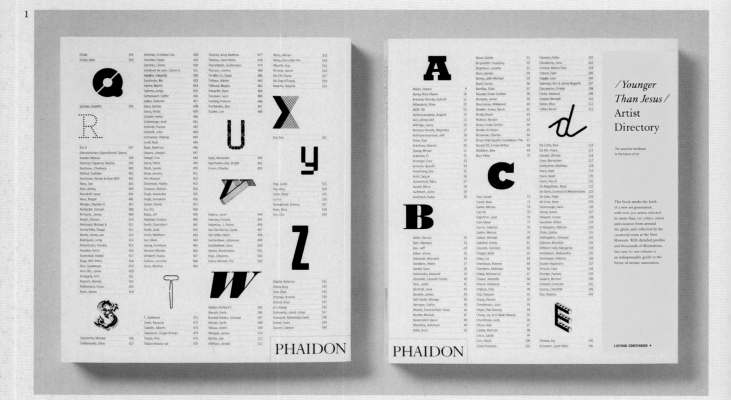

LH: Phaidon's books often feature special finishes on the covers. How do you and your design team come up with ways to do that? Do you get involved in the production side of things?

SD: When the designer presents a concept, he or she specifies a treatment that helps to communicate the idea in a visual and physical sense. Part of my job is to carry that process through and to stand by ideas that

help to make a book into a beautiful and functional object. We work very closely with the production team in order to communicate exactly what is necessary, and they strive to make that happen. We can't always do everything we would like to, and have to accept the occasional disappointment, maybe because a certain material wasn't available, or it's too

1–4. Younger Than Jesus: Artist Directory

This artist directory is a visual reinterpretation of the yellow pages, and was typeset in Bell Centennial, a typeface designed by Matthew Carter for AT&T in 1978.
Sonya Dyakova—Phaidon

2

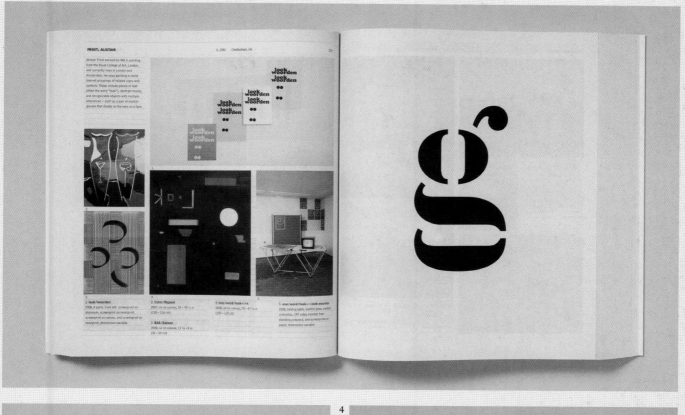

3

4

1

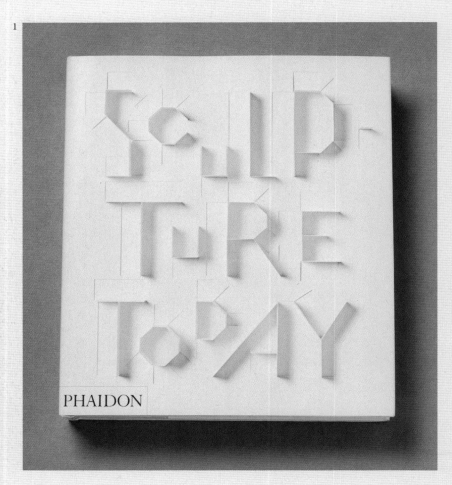

costly. In those circumstances you have to pare back on what is essential and try to keep the most important elements.

TS: **Maybe another key skill that an art director should develop is the ability to know where to go to source unusual materials, or to have something made so it can be photographed and used as part of a design. Do you remember the covers for the RotoVision books about materials that you worked on when you were at Frost Design? They featured type made from the material covered by each book.**

SD: Yes, I remember [working on the *Wood* materials book]. Our studio was across the road from Clerkenwell Workshops. After popping my head into a few studios and asking around, I found a brilliant craftsman who could make fantastic objects out of wood, all kinds of different things, and he made us the unique wooden letters which we photographed for the cover. If you are genuinely interested in people around you—in your industry or community—you will find that it will reward you. It's also invaluable to see people face to face; it's a great shame the Workshops is no longer there, it had a great camaraderie to it.

TS: **I think you can tell from looking at a piece of design work if the designer enjoyed doing it and was proud of the end result.**

SD: It should be the ambition of every designer or art director to make something unique and fresh. Not only to make their colleagues or their clients happy, but also to make themselves happy. Otherwise, what is the point?

1–4. Sculpture Today

Richly illustrated and authoritative overview of contemporary sculpture. The three-dimensional typeface Paper Alphabet, designed especially for the book, reflects the essential qualities of sculpture.
Sonya Dyakova—Phaidon

"It should be the ambition of every designer or art director to make something unique and fresh. Not only to make their colleagues or their clients happy, but also to make themselves happy. Otherwise, what is the point?"

2

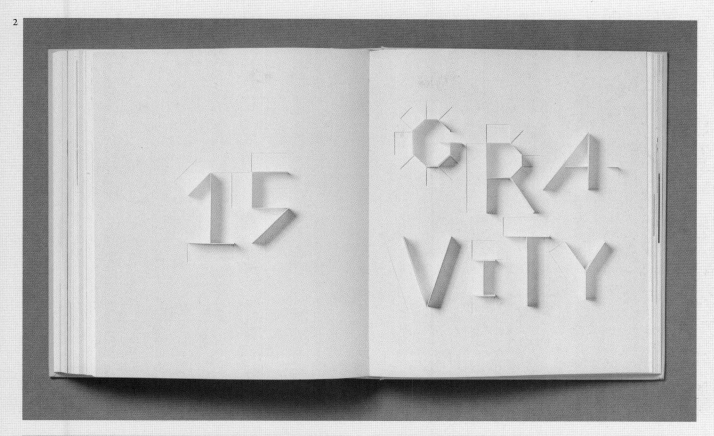

3

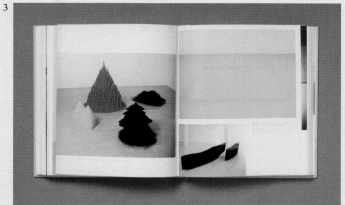

4

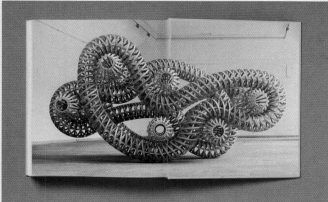

1

1–4. Story of Art—E.H. Gombrich

Pocket edition of the most famous
and popular book on art ever written.
It has been transformed from a
668-page, three-and-a-half-pound
original, into a handy-sized format.
The book is printed on rough
newsprint, making it bulky, yet
extremely light.
Sonya Dyakova—Phaidon

2

The book shown displays the following text on its pages:

The Story of Art is...
on art ever publi...
remained unriv...
subject, from th...
experimental a...
backgrounds th...
Professor Gom...
knowledge an...
communicatin...
works of art h...

The Sto...
the directness...
also the auth...
He described...
order into the...
which crow...
and using h...
the visual a...
'a continuou...
which each...
future', 'a l...
with the P...
edition of...
triumphan...
remain th...

8

Western Art
in the Melting Pot

Europe, sixth to eleventh century

We have taken the story of Western art up to the period of Constantine, and to the centuries in which it was so adapt itself to the precept of Pope Gregory the Great that images are useful for teaching laymen the sacred word. The period which followed this early Christian era, the period after the collapse of the Roman Empire, is generally known by the uncompli mentary title of the Dark Ages. We call these ages dark, partly to convey that the people who lived during these centuries of migrations, wars and upheavals were themselves plunged in darkness and had little knowledge to guide them, but also to imply that we ourselves know rather little about these confused and confusing centuries which followed upon the decline of the ancient world and preceded the emergence of the European countries in the shape, roughly, in which we know them now. There are, of course, no fixed limits to the period, but for our purpose we may say that it lasted almost five hundred years – approximately from 500 to 1000 AD. Five hundred years is a long time, in which much can change and much, in fact, did change. But what is most interesting to us is that these years did not see the emergence of any one clear and uniform style, but rather the conflict of a great number of different styles, which only began to fuse towards the end of that period. To those who know something of the history of the Dark Ages this is hardly surprising. It was not only a dark, it was a patchy period, with tremendous differences among various peoples and classes. Throughout these five centuries there existed men and women, particularly in the monasteries and convents, who loved learning and art, and who had a great admiration for those works of the ancient world which had been preserved in libraries and treasure-houses. Sometimes these learned and educated monks or clergy held positions of power and influence at the courts of the mighty, and tried to revive the arts which they most

3

4

Working with Clients

HANDLING CLIENT RELATIONSHIPS

At some stage in our careers as designers and art directors it's probable that we've been less than happy with an awkward client. If you're working for yourself, or perhaps for a small- to medium-sized studio or agency, the client liaison will be down to you. But what are the alternatives? Are there merits in employing the services of an account handler, or handing all client liaison to your project manager?

Steve Price of Plan-B Studio in London sums up the issue, saying "This is an age-old battle isn't it? Running my own company I have no choice but to be involved, and you have to get used to taking the hits as well as the slaps on the back. I've not always had great experiences working with account handlers. They certainly have their merits, but their commitment to protect or fight for the idea isn't always a priority. Their focus is the production and the budget, and sometimes it's in their interests to say yes to a client when a creative would argue harder for the concept. In an ideal world, the art director should be the point of contact in the initial stages of development, then someone more impartial creatively could take over for the later stages. Whoever handles the client should be someone that understands the parameters of their creative team, while being mindful of the budget and schedule. Get that balance right, and you have a recipe for success."

1

2

3

4

5

6

1–6. Entity

New identity and branding for
Entity Partnerships, a regeneration
development company with strong
beliefs in sustainable regeneration
through partnerships in the industry.
Steve Price—Plan-B Studio
Craig Coulton—Concept Guardian

Maintaining the relationship

Regardless of whether or not you have access to account handlers or project managers, a client relationship must be nurtured and maintained if you want to be invited back. The strongest client relationships are built around two basic principles: trust and partnership. Bear in mind that your client is almost certainly dealing with many other issues thrown up by their business in addition to the commissioning of design work, so it's important that they feel that you're a safe pair of hands with their best interests at heart.

Accurate and well-timed communication is vital during the early stages of forming new working relationships. There's nothing more likely to generate concern for a client than protracted periods of silence, and heaven forbid that a client should ever have to chase you for information about a current project. On the other hand, it's not good to overdo it either. Too much in the way of relatively unimportant detail isn't helpful and only serves to complicate the workflow, so stick to the issues of deliverables and budget, which are the points the client will be most concerned with.

It's also vital to be honest about what can be achieved. If a client approaches you with a request that is unrealistic given the available schedule or budget, it's always better to politely let them know that what they're asking for isn't possible. This approach may not go down well with a client initially, but they should see the wisdom of it eventually. If they don't and insist they can find someone else to do the work, you're probably better off letting them do just that without further discussion. It's a situation I've been in myself, and it's interesting how often clients return a few months later, having been let down by another design firm's unrealistic promises. In these kinds of situation the trust factor is hard won, but the partnerships that form between art directors and clients as a result can last for many years and provide much in the way of mutual benefit for everyone concerned.

ACCOUNT HANDLERS

"Conflict can come out of too many layers between you and the client. You have to understand each other, so lots of yes-men are a problem. What's important is to find out who the client really is and try to talk to that person. Often it's not the person in the room."

Mark Stevens—M-A-R-C

"Account handlers should be the prevalent point of contact with the client, acting as the buffer between creative and client so you can be freed up to do the actual work. I've seen many art directors' temperamental personalities jeopardize a client relationship by throwing their weight around and acting as prima donnas. What's needed is a guiding hand, not an iron fist."

Paul Burgess—art director

"Creatives should definitely present their own work to clients. Seeing the reaction and getting the feedback first hand is invaluable. It's like when you give your girlfriend a dress and she says she loves it... but you know by her face that she is never going to wear it."

Erik Kessels—KesselsKramer

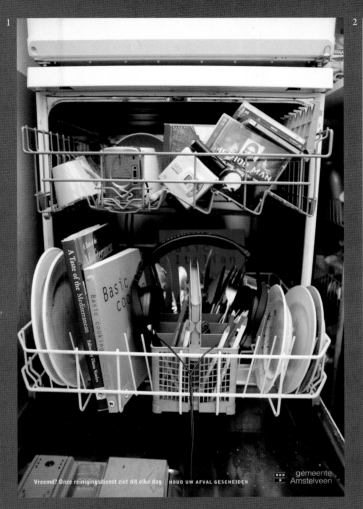

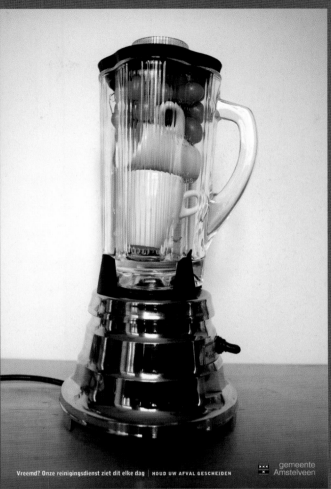

1–2. Gemeente Amstelveen

Poster campaign for Amstelveen City
Council's recycling campaign.
Aslan Kilinger—Maestro

Creative client partnerships

As an art director it's obviously important to maintain a level of control and therefore ownership over the concept and subsequent direction for a project; this is after all what you are being paid to do. However, clients should also be allowed the opportunity to put forward their own ideas and to engage in the creative process if they want to. Locking clients out of the process against their wishes is not constructive and could lose you the commission. Give them a chance to involve themselves in the process and, if their ideas are off the mark, don't be afraid to tell them.

1–3. ESPN Ultimate Highlight Reel

A 400-page coffee table book produced to mark the 25th anniversary of the Entertainment and Sports Programming Network's sports center.
Joshua Berger and Todd Houlette—Plazm

DOS AND DON'TS

- Do try to maintain a relationship with your client's company, not just your contact, as people change their jobs.

- Do treat everyone you come into contact with, from the MD to the junior staff, with respect.

- Don't let complacency creep into a relationship with a long-standing client as they may decide you're not providing them with the level of service they've grown used to.

- Don't discuss one client's business with another—you could end up losing both accounts.

1

2

Loose Cannon

June 1, 2004
Milton Bradley

Dodgers outfielder Milton Bradley always had a rep for being a bit of a loose cannon, but even he was a little surprised to get tossed from the game as he entered the batter's box to begin a sixth-inning at-bat against Milwaukee. Bradley was busy jawing at the home plate ump, Terry Craft, about previous calls (in at-bats extending nobody knows how far back) when he got the heave-ho. Fearing the worst, LA manager Jim Tracy raced out to restrain Bradley, who then took off his batting gloves and helmet and left them at the plate, along with his bat. But Bradley was just getting warmed up. Back in the dugout, he picked up a bag of balls and threw it onto the field. Then he picked up a ball and fired it into the outfield. The outcome? A four-game suspension. "He attempted to embarrass the umpires," said ump crew chief Joe West. Good call, Joe.

June

3

I Said Move!

March 11, 2004
Steve Francis

Two of Steve Francis' 19 points for Houston in a 97-86 win over the Hornets came when Baron Davis just wouldn't get out of his way. Francis wasn't bothered: he went right over—way over—Davis and slammed home a killer dunk that left the Baron reeling.

The Longest Play

March 13, 1998
Bryce Drew

Thirteenth-seeded Valparaiso was down 69-67, and with just 2.5 seconds and the length of the court left in the game, in perfect position to do what everyone thought they would do: lose to fourth-seeded Ole Miss in the first round of the NCAAs. But Valpo had a secret weapon: a three-point play they called Pacer, which they'd practiced every day all season long. Bryce Drew, the shooter on the play, nailed the three about half the time. This turned out to be one of those times. Teammate Jamie Sykes juked the Ole Miss player guarding him on the inbounds pass and lasered the ball three-quarters the length of the court to Bill Jenkins, who made a touch pass to Drew, who then let fly as the clock ran out to give Valpo the 70-69 win. Drew leaped for joy—a horizontal leap that became a victory slide on the hardwood, where he was soon joined by his fellow Crusaders.

CREATIVE CLIENT INVOLVEMENT

"When you start a project there should be a phase where the client is able to express their communication expectations and needs. From that, a list of criteria is created and when design concepts are presented it's no longer about whether the client likes it or not, it's about what solution is most effective, based on the criteria."

Sean Adams—AdamsMorioka

"Whenever possible, I engage clients in the creative process. I find the best thing is to define my process with the client in advance, explaining the points of collaboration. I always want to hear the client's ideas, particularly at the outset. They are intimately involved and often know a lot more about it than I do."

Joshua Berger—Plazm

"I want the client to be completely involved in the whole process. I like the quote from Tibor Kalman: 'Good clients are smarter than you.'"

Peter Stitson—Peter Stitson Ltd

"Dictating creative solutions makes you a dictator and, as we know, that kind of setup ultimately fails. If you don't engage your clients, you'll lose them. They love to feel involved, so let them have a voice. After all, it is their brand. But don't let them dictate either—they're paying you for your advice, so advise."

Paul Burgess—art director

1

2

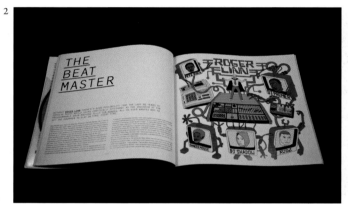

3

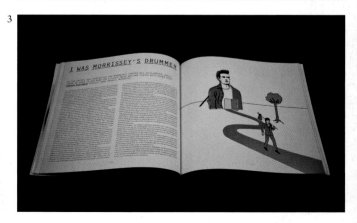

4

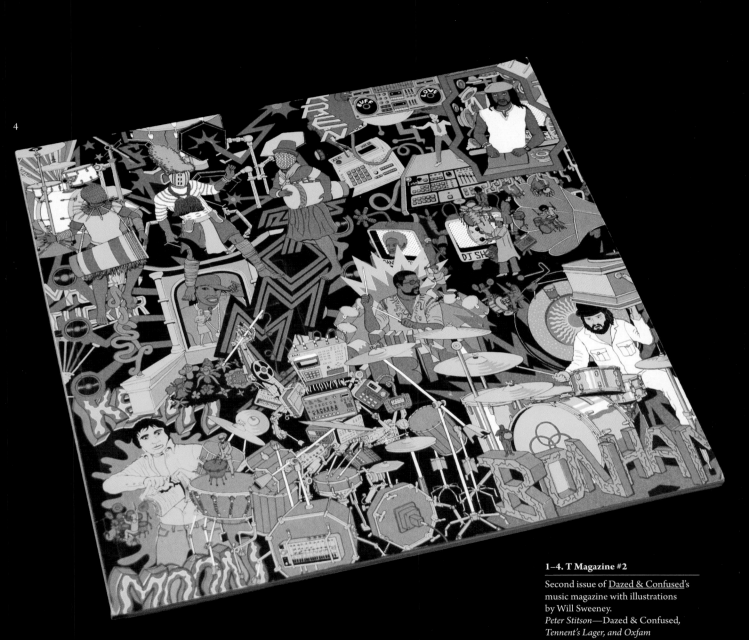

1–4. T Magazine #2

Second issue of <u>Dazed & Confused</u>'s
music magazine with illustrations
by Will Sweeney.
Peter Stitson—Dazed & Confused,
Tennent's Lager, and Oxfam

DESIGN CONTRACTS

It's never a bad idea to ask your client to sign a written contract for all projects you undertake for them, even if you've known and worked with them for a long period. For simple projects, this can be just a short letter detailing fees and deliverables; for larger commissions a prepared contract may be necessary. If you're employed by a publishing house, a brief from your editor-in-chief or publisher is equivalent to a client contract.

The key points you should consider including in your written contracts are:

· An outline of the work you are specifically undertaking, with a fee breakdown if individual budgets have been allocated to different parts of the project.

· A qualification of any necessary work that hasn't been itemized in the client's purchase order. For example, state that any photography and illustration will be charged as an extra if it hasn't been factored in already. The client may be assuming that it's already included as part of the design fee.

· The schedule that you've agreed to meet, with all deadlines listed.

· The full specification of the commissioned work. For example, trim size and extent for a brochure, special print finishes, and so on.

It's also advisable to include a set of terms and conditions to help avoid any potential conflicts of interest that may arise. The boxed example shown here can be adapted for different types of project. Some of this is intended to sound rather heavy-handed, but you could always tone it down for clients you know and trust.

CONTRACT TERMS AND CONDITIONS

1. The Contract

1.1 - Quotations expire _____ days after the issue date on the contract.

1.2 - If you (the client) wishes to terminate the contract, all fees for work carried out to that point are payable in full.

1.3 - This contract must be renewed if a delay of more than _____ months from the signature date is imposed.

1.4 - Any quoted fees for outsourced reprographics and print must be paid in advance before that work is initiated.

1.5 - If the contract requires significant alterations before the project is completed, figure 1.2 will be invoked and a new contract must be issued.

2. The Payment

2.1 - You must provide payment in full no more than _____ days from the invoice date.

2.2 - If payment is not received, we (company name) will be entitled to charge interest on a per day basis in line with the current base rate of _____.

2.3 - All deductions from the agreed fee are at our discretion and must be confirmed in writing.

3. Copyright

3.1 - You are liable for any breaches of copyright law resulting from any material you provided for inclusion in this project.

3.2 - Any creative work reused by you without prior permission, or in the event of the termination of this contract, will be treated as a breach of our copyright.

3.3 - You are not permitted to "resell" any work created by us specifically for the project outlined in this contract.

4. Deadlines and Delays

4.1 - We cannot be held responsible for any late deliveries resulting from a delay in approvals to proceed, provision of content, or change of supplied content.

4.2 - We cannot guarantee compliance with late schedule changes which shorten the agreed time frame for the project.

4.3 - In the unlikely event that we fail to meet the agreed deadline, you have the option to cancel the contract, paying only for work completed by that time.

5. Liability

5.1 - We will not be held liable for any failure to carry out the full terms of this contract for any reason that is not solely the fault of (company name).

5.2 - All material supplied by you or on your behalf shall remain at your risk unless otherwise agreed in writing. Appropriate insurance cover is advised.

6. Delivery

6.1 - We cannot be held responsible for any loss or damage to material during transportation, but undertake to use responsible carriers. Appropriate insurance cover is advised.

1–4. YouthNet Annual Review

Financial and project review brochure
for a UK-based youth charity, with
photography by Mark King.
DixonBaxi

1

2

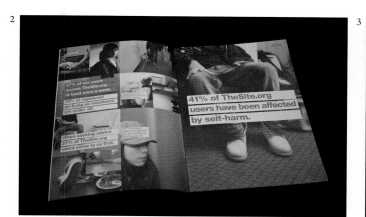

3

4

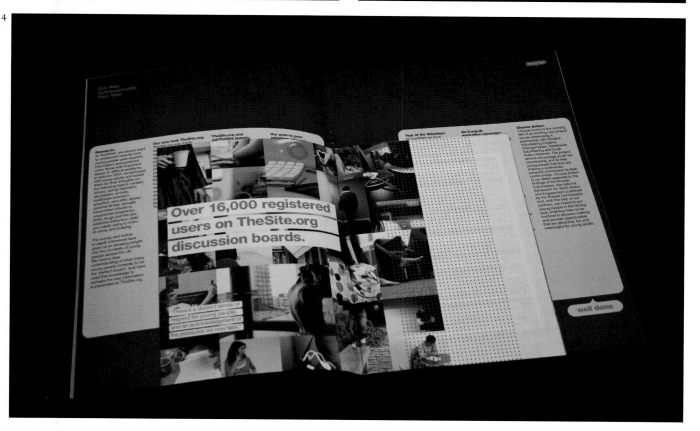

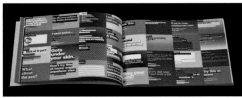

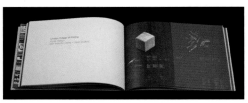

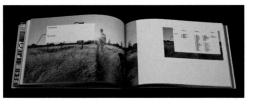

QUOTING FOR DESIGN WORK

Coming up with the right fee for a commission isn't always straightforward, particularly if you're working with a new client. If your client is looking for a low spend (as so many seem to these days) and has made that clear in their initial approach, how low should you go in order to get the job while still making a reasonable return? And should you treat the whole process as a delicate issue or be forthright in your communications? Sean Adams is clear on the subject, saying, "Creativity has value and a designer should never feel that their work is not worthy of payment. This is not a delicate issue, it's business." Joshua Berger takes a similar stand, stating, "Know what you are worth and ask for it, but always be able to substantiate your proposal."

I'm inclined to agree with these points of view, with a caveat that sometimes it may be acceptable to break your own rules in order to secure a project that you want to be involved in because of its merits. My own view is to be up front and ask straight out what the client is prepared to pay, then act on that information accordingly. Simon Dixon supports this view, saying, "We're honest, and ask how much they have. Ninety percent of clients have an idea of their budget. If they don't, then it's not a project on stable ground. We don't work with anyone who can't tell us how much money they have to spend."

Mark Stevens agrees that honesty is the best policy when quoting. "Be up front about the rates, don't have any hidden fees or costs, and keep the client in the loop. Oh, and don't discount your fees in the hope of putting them up later. Set a fair rate that will still be fair in a few years' time."

1–4. DixonBaxi brochure

Creative overview of work produced by DixonBaxi.
DixonBaxi

5

"We're honest, and ask how much they have. Ninety percent of clients have an idea of their budget. If they don't, then it's not a project on stable ground. We don't work with anyone who can't tell us how much money they have to spend."

Simon Dixon—DixonBaxi

6

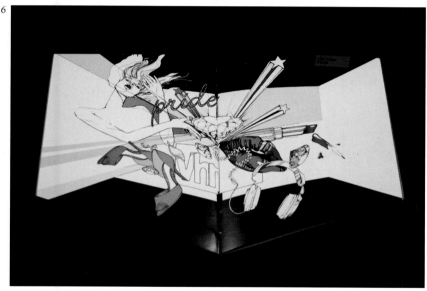

7

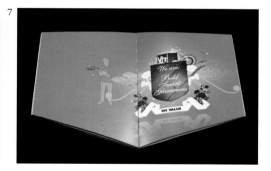

5–7. VH1 brand book

Brand book incorporating work by various illustrators, produced as part of the redesign of the music channel VH1. *DixonBaxi*

"Creativity has value and a designer should never feel that their work is not worthy of payment. This is not a delicate issue, it's business."

Sean Adams—AdamsMorioka

CREATIVE CONFLICT

What happens when you produce work that your client isn't happy with? If this has never happened to you, you're very fortunate as it's fairly common for creative conflict to develop during the course of a project. You'll obviously feel that your solution is the best possible one—that's why you've presented it—but your client may not feel the same way.

While working on a project for the band Thievery Corporation, Neal Ashby found he had chosen an inappropriate creative route to answer the brief. "Designing [the album] *Radio Retaliation*, I'd spent about six weeks moving down a path that I was sure was going to be a huge success. The problem was, when I showed it to Thievery Corporation, they acknowledged that it was pretty but they clearly let me know that it couldn't have been more wrong. But they were right: in the initial creative meeting they told me they wanted something raw, rootsy, handmade. They wanted unadorned design, busy with spontaneity. I designed something that was pretty as a piece of graphic design, but void of meaning regarding the client's intention. I deal with this kind of thing differently now than when I was a younger designer. There is no sense in feeling anger, insecurity, or defeat. I hadn't listened as closely as I should have. You can't be married to one of your concepts so closely that you can't let it go. Let the fish back in the water, chances are you'll catch a bigger one."

This really is the best approach you can take—there's no genuine alternative unless you're prepared to potentially ruin your working relationship with your client. However, if your client is being awkward for no good reason that you can ascertain, walking away may be the more preferable option.

1

2

3

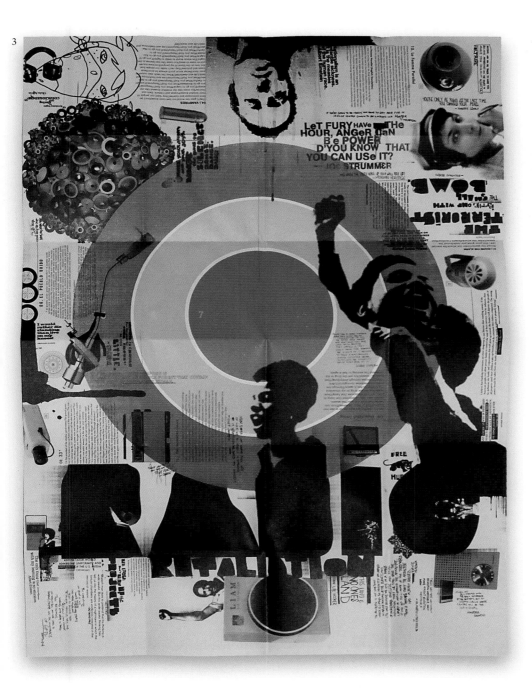

4

**1–4. Thievery Corporation—
Radio Retaliation**

CD packaging incorporating the use
of cardboard and flexography printing.
The CD is wrapped inside a double-
sided oversize poster.
Neal Ashby—Ashby Design

PAUL WEST AND PAULA BENSON
FORM

Profile

Form was founded by designers Paul West and Paula Benson who art direct, design, and project manage the agency's work alongside their creative team. Their core message is clear: they don't create "eye candy" but their mission is to ensure that all their work is beautiful, seductive, and has impact. They consider themselves to be problem solvers who always ensure that their work communicates directly with their target audience—their company slogan states that they will "amplify your message." Form's particular expertise lies in visual branding with a noticeably strong understanding of contemporary culture, something which has proved to be highly desirable to the music, media, arts, and sports industries, and they pride themselves on the collaborative relationships they cultivate with their clients.

Interview

Tony Seddon: Our first question to you both is, what is an art director?

Paula Benson: I think we're a bit like psychologists or mediums that interpret our clients' thoughts. We don't get a written brief for every project, so when we meet our clients we're crystalizing what they say and passing that directly to our creative team. Sometimes our clients have a lot of briefing experience, sometimes not, given that some of them are relatively small and haven't had so many opportunities to deal directly with art directors. We define in our own heads what we feel the client wants and needs, and we art direct our designers after passing on our vision for the project, but we also try to ensure that the designers themselves have as much creative input as possible. That's very important to us.

1. The Roundhouse

Events branding and brochure design for London music venue The Roundhouse.
Form

TS: So it's really a matter of having a comprehensive overview of a project?

PB: Yes. We always put a lot of effort into understanding exactly what our client's audience is first, rather than immediately setting out to create pretty pictures for them. It's easy to come up with something that simply relies on a stylistic solution but doesn't address the real problem. We filter, and I don't mean edit, perhaps funnel is a better word actually, the key points of a brief while thinking about the overall solution and managing the whole creative process.

Paul West: Can I consolidate that in a few words: for me it's about having a 360-degree overview. It's about learning to instinctively know what's right and being able to see the overall picture.

PB: We could be working on a brief that needs everything from a range of printed items right up to websites, stage sets, merchandise, all sorts of stuff. We have to come up with concepts that'll work across all those items, which is where the 360 idea comes in.

TS: You mentioned a moment ago that purely stylistic solutions don't cut it for you. Do you see a lot of "style over problem solving" type of work being produced these days, and do you think that's a problem?

PW: Totally, and it's getting worse. Blog culture is in danger of turning a generation of designers into wannabes that seem to think being a designer is like being a pop star. The harsh reality for graphic designers is we work in a service industry and I worry that new generations of designers don't get that at all. They're so preoccupied with stylistic tweaks that they don't seem to see what graphic design is actually about—problem solving.

PB: I agree. A lot of the younger designers we encounter get very wrapped up in the stylistic solutions to a design brief very early on. We try to make sure ideas really answer the brief before too much time is spent styling something that isn't going to work.

Luke Herriott: Do you think that's always been the case?

PW: No, not at all. Look at Fletcher, Forbes, or Gill, for example, all pioneering, problem-solving graphic designers. Previous generations of design graduates would know about that kind of approach, they would be educated to know about the important principles and practices that designers like them introduced. In the digital age and with blog culture, it's concerning that with instant access to millions of examples of graphic design from around the world, it's all too easy to appropriate someone else's thinking and simply restyle it. It's all out there on show and up for grabs. In fact someone from outside the UK rebuilt an entire website for their company with our work a few years ago—simply grabbed from our website.

PB: The other worry with design blogs is that you don't get a sense of why something has been designed the way it has or what the brief was. I've seen designers look through a blog saying, "That's nice. That's nice. Oh, that's really nice," but you don't get more than a few lines of information about the work. Was the budget really small? Was the piece distributed in a really interesting way? Was the client happy that the brief was answered?

PW: Exactly, so much of it is just eye candy.

PB: Everything seems to be predominantly about cool work, and the problem is that this breeds quite a lot of dissatisfaction. Everyone is given the impression that everyone else is doing cool work, not realizing that the work on show is often promotional work, or only a small percentage of what that company or individual is actually doing. Also, it's a fact that a lot of the studios producing "cool" work all the time are really struggling financially. What art directors should be doing is communicating on a much wider scale about what a big difference good design can make, not just how cool it looks.

PW: It's about realizing how design works on a business level, and how relevant the work is.

LH: So, when you take a brief from a client, how involved as art directors do you get in the actual design work?

PW: Hugely involved. There's a common misconception that art directors who reach a certain level don't have anything to do with the hands-on design work. Our own designers are sometimes surprised at how involved Paula and I get with the projects. We set this company up to be designers, not to do other stuff that we're not as good at or don't enjoy as much. Our individual roles have fragmented over time, of course. Paula does a bit more of the strategic stuff while I do a bit more of the art direction stuff.

1. The Roundhouse—Creative Projects

Brochure cover for music venue The Roundhouse, advertising events and projects specifically for young people.
Form

2–4. The Roundhouse—What's On

Brochure spreads designed to capture the personality and energy of the venue in The Roundhouse's "What's On" brochures which advertise its events and projects.
Form

1

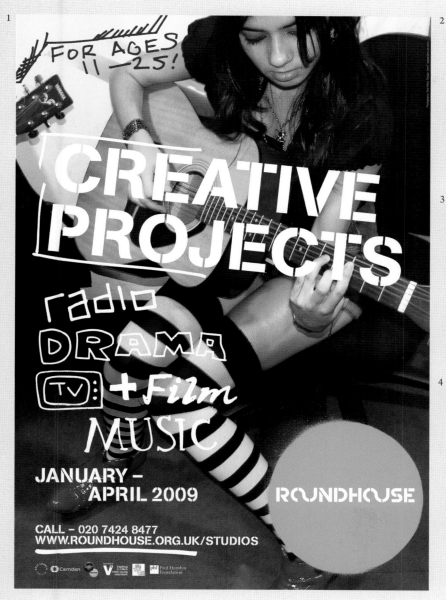

2

3

4

1. Sex—How to do everything

A completely new kind of sex book
that combines contemporary design
and art direction with the best erotic
photography and sex writing.
Form

1

PB: Yes, you're much more hands on—you'll spend
two days finalizing the curve of a P! We both do a lot
of art direction and project management though.
Normally Paul and I will do client meetings together
and by the time we get back here, having chatted
about the project on the way, we'll have an idea of the
direction we want to go in, but at the beginning of a
project we'll all sit down around a table and pitch ideas
in. We have three full-time designers and there's
usually a freelancer or an intern working with us too.

**LH: Are your full-time designers all at the
same level or do you have a junior, senior, etc.?**

PW: We've got a relatively young workforce who all
have slightly different levels of experience and skills,
but that's working well.

**LH: We were talking to Angus Hyland and
Domenic Lippa at Pentagram about this same
topic recently, and it's well-known that they
avoid having a hierarchy in their office. They
work within their teams and the intern is given
as much of a chance as the guy who's been
there for 15 years to put their ideas forward.**

PW: It's very much the same with us.

PB: I think having some ownership over the work
you do is very important and if you can feel that way
about what you're doing, it helps you to produce
better work. A good art director should create
situations with their team where that can happen.

PW: Designers that have been with us for a while
sometimes brief the work to the younger designers.
Having a strict hierarchy doesn't really work for us.

2

3

4

Manual Sex

5

6

Fantasy

2–6. Sex—How to do everything

All photography was commissioned and art directed by Form, and shot by renowned fashion and portrait photographer Rankin. The book was pitched to client Dorling Kindersley as having real energy and sex appeal— sexy photography with models you could relate to—shot in real locations. *Form*

TS: I guess the fact that you've kept the company relatively small helps you to maintain that, and I would imagine it also helps you to maintain the high quality that's evident in the work that Form produces?

PW: Yes, that's true. It's nice to know the quality of the work is coming through.

TS: Well, I think when you're trying to define the role of an art director, quality control plays a big part.

PB: Yes, I agree, and that quality control can be applied to both the creative and the commercial aspects of any one project.

TS: Can we ask about the kind of relationships you maintain with your clients? As a rule do you maintain a lot of close contact?

PB: It depends on the client. Some we may only see a couple of times a year, others we may see every week, but the important thing is we try to keep them as involved in the decision-making process as possible. We would never present a design and say "This is it, take it or leave it." At the end of the day, this business is all about relationships and clients need to feel that they're able to make choices and influence decisions. It's also important to acknowledge that the really critical decisions are normally made when the art director and the client are in direct contact.

TS: Do you think it's ever possible to engage a client in the creative process? I guess that it depends very much on the client of course.

PB: It is possible but it has to be managed carefully.

PW: We're probably at a stage with most of our clients

**1–3. The Roundhouse—
Emerging Proms**

Logo and flyer for Emerging Proms,
a series of three gigs and three creative
projects showcasing the best of new
young talent. The event was in
association with the BBC Electric
Proms, The Roundhouse, and
Roundhouse Studios.
Form

3

where they know us well and they know what we can do for them, so they don't feel the need to get too involved, but if they want to they're always encouraged to put their views forward.

PB: I think pretty much everything in life is about compromise, and any designer that thinks they can just do what they want … well, under those circumstances I don't think that's graphic design any more. It's part of the role of an art director to manage that situation and make sure that the designer and the client both get what they want from a project. It takes a lot of experience to handle that kind of situation well.

TS: **Returning to your creative team, how much time do you allocate to mentoring and training? Do you see that as an important part of the art director's role?**

PW: A lot. We train up everyone that comes through our doors, and that's not been easy for some people as we're probably quite "old school" in our approach to the craft of art direction and graphic design, but we're confident that anyone who has ever worked with us has become a very good designer that really thinks about what they're doing. We've never deviated from that approach.

PB: And it's not just the creative side of things that we work at. I think being a good art director or designer is 50 percent design and 50 percent organization, you know, understanding project management, keeping a log of what's happened on a job, even having the latest printouts in the file when the client rings.

TS: **It is odd that some designers don't see that as being important and only concern themselves with what I suppose you could call the fun part.**

PW: Yeah, it is strange, and you do hear nightmare stories about things that can go wrong, with clients or printers suing designers and so on. Keeping track of things like email trails, making sure you've done everything right, is incredibly important. Especially when you're art directing as you're the decision maker, and if anything can go wrong it probably will.

PB: Keeping track of changes is another important part of the art director's role.

LH: **Do you build in limits for that kind of thing in your contracts?**

PB: Yes we do. Unfortunately clients will sometimes try to get away with making as many changes as they possibly can. It's amazing how much better they get at managing their corrections when they know it's going to cost them more.

LH: **How much illustration and photography do you generally commission?**

PB: A lot of photography, but not so much illustration in our case.

PW: We try to do a lot of illustration in-house.

LH: **And do you have a pool of photographers you like to use or do you choose people based on the needs of each project?**

PW: We know two or three photographers that we work with a lot, and we have lots of websites bookmarked for different photographers and agents. We also keep a large photography reference file that we use when we're doing pitches, and that's good for our staff as it helps to educate them into knowing exactly who to look for. It's a good way of working.

1

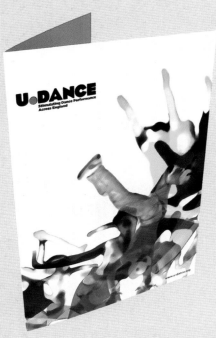

PB: Also, in terms of choosing the right photographer, we've worked with a lot of fashion photographers in the past whose work we really like but they aren't so good at working with nonprofessional models. Sometimes it's important to use someone that is good at making the people in front of the camera feel relaxed, so personalities and people skills come into it a lot as well.

LH: At a photo shoot, how do you judge when (and if) your art direction stops and their photographic creativity takes over?

PW: That's a difficult one to answer, it depends so much on the shoot, but well thought out shoot plans are essential. We always lock down plans before a shoot, such as the number of ideas that we can cover in the time or for the budget, and include visual references for each idea. I worked with a great

photographer on the Girls Aloud album campaign who had a real talent for photographing girls in a sexy but "pop" kind of way, if you know what I mean. He loved the whole collaborative way that we worked on that project, with him shooting and me standing on a chair behind him art directing the whole time, but relying on him to react to my thoughts as the shoot progressed. It was a great session, probably my personal favorite.

PB: We work with some photographers a lot because we like their vision of how things should look, and mixing their creativity with our direction can bring a lot to a project. A good example: we've worked with Rankin on a lot of projects and he's so on it, he has such a strong vision, but he was so open to our art direction. A real pro in that respect, he knows exactly how to make an art director feel comfortable.

TS: How about specifying and buying print; do you try to work with tried and trusted printers in the same way?

PB: Yes, we have a roster of printers that we like to work with which fluctuates occasionally. Those at the higher end are the kind of printers that always provide good feedback and don't come up with bullshit answers when you're not completely happy with something. They're also good at suggesting better ways of achieving things with the print. We tend to bring our chosen printer in right at the beginning of a project, because they can help us develop concepts and formats, suggest using an alternative technique or finish, that sort of thing.

LH: How do you decide on the appropriate fee for a project, and if it's a fixed fee, how do you work out whether or not you can take on the project?

PB: We have rough hourly rates that we use as a start point for working out how much a project will cost us to complete. That way we can put together quotes pretty accurately, and if the budget is fixed we can work out how long we can spend on it. We know how much the company needs to earn to keep the doors open, so there's no point in us taking on lots of work that's going to drive us under; but we like to keep a balance and some jobs are just too good to pass on.

PW: It would be terrible if, as a business, our merits were judged on our cheapness rather than on the quality of the work. Winning pitches because you've provided the lowest price just devalues the design market, you can't quantify what you think you're worth against what you might have to quote just to get the job. And the other scourge of our industry, free pitching, is something we fight against as much as possible. It devalues what we do.

PB: It's a sad fact that a lot of young designers that aren't established haven't got a choice, they have to try to build a portfolio somehow, but it really doesn't do anyone any good.

PW: We have to earn money to run the business, but we will take on lower-paying projects if we really want to do them. We have a philosophy, which is basically "love and money," and keeping those little nuggets balanced is how we've made it work for so long.

1–3. U.Dance

Brand identity for U.Dance, a youth dance performance program launched by Youth Dance England. Form devised the naming and strapline of this umbrella brand, together with the design of the logo and all other communications.
Form

2

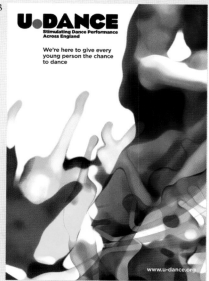

3

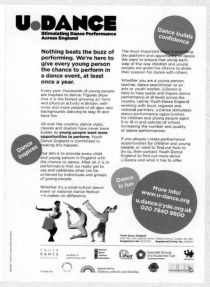

Working with your Creative Team

BUILDING YOUR TEAM

Not every art director gets the chance to build their own creative team as some prefer to work alone or as a freelance for hire, but those that do face some unique challenges. When the requirement for a new team member arises, it's often a matter of placing an ad and hoping the right person answers the call. There's no guarantee of success with this method, it's simply a practical reality, but it's not the only way to find the right people.

I think it's important to be proactive and keep a constant look-out for gifted designers that you'd like to invite onto your team as either permanent staffers or freelancers. Regular trawls through emerging talent will also help you to stay on top of current design trends. Designers don't necessarily have to be locally based as software technology and the internet means your team can be in more than one location and still communicate and exchange material with relative ease, although I do think it's preferable to keep your permanent team together under one roof so they can interact with each other more readily.

Personalities are just as important as design skills when it comes to team building as there should be no barriers to effective communication. Having people in the team that constantly clash is a recipe for disaster, and sometimes hard decisions need to made when things aren't working out, even if it means losing valuable talent to maintain the status quo. "The very first thing you need to be certain about when recruiting is, are they a good cultural fit?" says Paul Burgess. "Can I work with them? Could I go for a beer with them? Do they have the right passion for the job? If this isn't right, you'll fall at the very first hurdle. But if the culture is right, the work needs to back it up. You can spot a good creative or designer within seconds of seeing their book, no matter how they dress it up."

This last statement raises an additional point concerning qualifications and presentation, which are of course relevant but not necessarily a true indication of ability. Erik Kessels has a view on this, saying, "In the last 10 years, a lot of schools have popped up that purport to teach people how to be art directors. To be honest, these schools don't really work for me. It seems like most of them just show people how to make advertising that looks like every other piece of advertising in the world. Add a headline at the top of the page. Add a tag line and pack shot at the bottom. That's not the way it should work. I'm a big fan of apprenticeship. Great art direction is something that you learn through doing." I don't think Erik is condemning design schools here, but rather he's touching on the point we raised at the beginning of chapter one—you can't be taught how to be an art director, you have to become one through experience. Creative teams that get on well will learn from within, and building a great team will produce great designers and art directors.

1

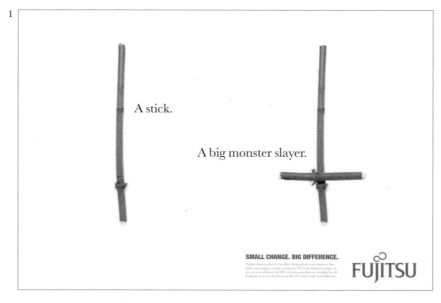

A stick.

A big monster slayer.

SMALL CHANGE. BIG DIFFERENCE.

FUJITSU

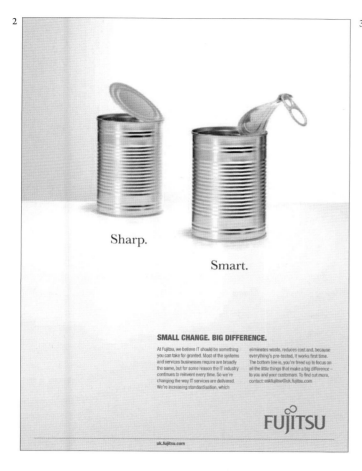

2

Sharp.

Smart.

SMALL CHANGE. BIG DIFFERENCE.

At Fujitsu, we believe IT should be something you can take for granted. Most of the systems and services businesses require are broadly the same, but for some reason the IT industry continues to reinvent every time. So we're changing the way IT services are delivered. We're increasing standardisation, which eliminates waste, reduces cost and, because everything's pre-tested, it works first time. The bottom line is, you're freed up to focus on all the little things that make a big difference – to you and your customers. To find out more, contact: askfujitsu@uk.fujitsu.com

FUJITSU

uk.fujitsu.com

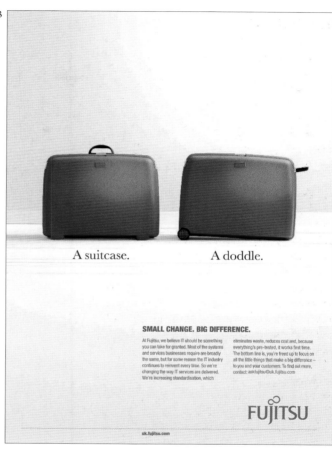

3

A suitcase.

A doddle.

SMALL CHANGE. BIG DIFFERENCE.

At Fujitsu, we believe IT should be something you can take for granted. Most of the systems and services businesses require are broadly the same, but for some reason the IT industry continues to reinvent every time. So we're changing the way IT services are delivered. We're increasing standardisation, which eliminates waste, reduces cost and, because everything's pre-tested, it works first time. The bottom line is, you're freed up to focus on all the little things that make a big difference – to you and your customers. To find out more, contact: askfujitsu@uk.fujitsu.com

FUJITSU

uk.fujitsu.com

"The very first thing you need to be certain about when recruiting is, are they a good cultural fit? Can I work with them? Could I go for a beer with them? Do they have the right passion for the job? If this isn't right, you'll fall at the very first hurdle. But if the culture is right, the work needs to back it up. You can spot a good creative or designer within seconds of seeing their book, no matter how they dress it up."

Paul Burgess—art director

1–3. Fujitsu campaign

Press advertising and annual report for Fujitsu's campaign, Small Change. Big Difference.
Paul Burgess

Managing your team

Management isn't an easy word for many art directors. Let's face it, many of us don't embark on a creative career in order to become managers, it just seems to happen over time, and most if not all of our training is received "on the job." Whether we like it or not, the reality is that as art directors we spend most of our time managing, not designing, and it's important (and difficult) to take that on board.

Ed Templeton of UK-based Red Design admits that he had no interest in the management side of things when he first founded the company, but soon realized that he had to get to grips with management techniques. "Management mistakes, and some unhappy staff, prompted me to evaluate how I dealt with people in my teams and the realization dawned on me that I couldn't just talk to employees as I would my mates, and that everything an art director says to his team members is hierarchically loaded. With the help of a mentor I learned that keeping a professional distance between yourself and your creatives promotes a healthy, happy, and motivated team." My guess is that many art directors experience this realization during the course of their developing careers, given that internal promotions may mean you find yourself managing designers that were at one time your equal in terms of responsibility.

For me, the most important thing to do is take your team seriously, treat them with the respect they deserve, and never try to force your own design sensibilities on them.

For me, the most important thing to do is take your team seriously, treat them with the respect they deserve, and never try to force your own design sensibilities on them. Being overly prescriptive as an art director has never seemed to me to be the right way to go about getting the most out of creatives— you have to let them design for themselves and then work with them to create the best design solutions. I also think it's vital to let the team know when they've done a good job, and to make sure that your own managers, if you have them, are also made aware of the team's successes. The reciprocal of this is to teach yourself to enjoy encouraging others to draw out the best in themselves creatively. Having been an art director for a number of years, and after initially finding it difficult to move away from the hands-on design work I love to do, I now enjoy art directing others as much as I enjoy creating the work myself.

1

1–4. Joe Lean & the Jing Jang Jong

Album campaign for Joe Lean & the Jing Jang Jong and Universal Records. The band and the label worked with the design team at Red to provide shared points of reference for photography and art direction.
Ed Templeton—Red

2

3

4

Mentoring your team

One of the best things about working as an art director, aside from the work itself, is being in a position to pass on the knowledge you've learned to your team. The question is, do you set time aside to do this or should it just happen as part of the everyday workflow? Carl Rush has this to say: "We don't really have time to do this, but I hope that they (and I) are learning every day from live projects. We have weekly meetings to discuss the progress of jobs and every few months we have extended 'best practice/key learning' meetings where we talk about how to improve our working methods, how to correct mistakes that may have happened, and how to move forward. Most importantly we look at what *did* work and why. Why did we win a pitch? Why did the design press like our work? So actually the answer is yes, we do mentor when we can."

Justin Ahrens at Rule 29 takes this approach a step further. "We have quarterly meetings and events to educate, inspire, evaluate, and reward our creative team. Also, everyone is responsible at least twice a year for giving a presentation, or for sponsoring an event at the office, that covers one of those areas. I also review everyone twice a year and give bonuses which are either financial, extra time off, or an office field trip. I've also tried to create an environment that inspires a shared knowledge experience. We do this through creative lunches, our blogs, and other social networks."

Mentoring your team is another way of expressing how much you value the work they do for the company. It's a way of giving back something that isn't simply a financial bonus, although they're nice too!

1

2

3

4

5

1–5. Life In Abundance

Life in Abundance is a nonprofit organization working in the poorest areas of sub–Saharan Africa. This fundraising book relates the story of the empowered people it works with to potential donors.
Rule 29

1

A project manager is a bit like a head waiter who knows what's happening in the restaurant, the kitchen, and the wine cellar, as well as providing the "face" of the restaurant to the diners. They bring together all the resources required to fulfill the needs of a project, managing the workflow from inception to completion, and usually working directly with and reporting on a daily basis to the art director.

1–5. Mr. Cato

Promotional piece created to show the collaborators' various skills in creating unique and impactful packaging through their use of materials, music, imagery, and production techniques. Any collaborative project will benefit from the input that a project manager can provide.
Rule 29

PROJECT MANAGERS

If you're lucky enough to have one, a project manager is a huge asset to any creative team. Project managers can come under a variety of different guises: account handler, client liaison, studio manager, and so on. Personally I've always thought of account handlers and project managers as slightly different animals. To me an account handler is someone who deals exclusively with the client and their needs, the budget, schedule, communication, and so on. A project manager does a little more besides, also dealing with the communications within the creative team itself, managing overall workflow, and generally making sure everyone knows all they need to know. I tend to associate account handlers with advertising and project managers with graphic design.

A project manager is a bit like a head waiter who knows what's happening in the restaurant, the kitchen, and the wine cellar, as well as providing the "face" of the restaurant to the diners. They bring together all the resources required to fulfill the needs of a project, managing the workflow from inception to completion, and usually working directly with and reporting on a daily basis to the art director. This is of course excellent news for the art director as it means they can concentrate on the creative aspects of the work and not become immersed in administrative activity. Project managers often assume all direct communications with clients following the original creative briefing (which art directors should chair), leading me to the point that the role of a project manager is a senior role but not necessarily a creative role. A project manager doesn't have to have any formal design training, although one who has creative skills is an even more valuable asset. Their organizational and interpersonal skills combined with a clear understanding of the workings of the creative team are key.

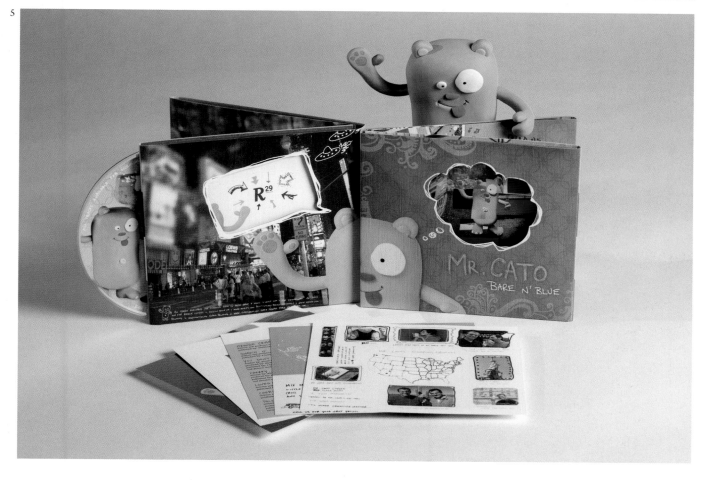

FREELANCERS

As this chapter is about working relationships, I'm talking here about collaborating with freelance designers rather than working as a freelance art director. For me, building long-lasting connections with a wide range of trusted freelance designers is practically as important as maintaining good working relationships within your own permanent creative team. The area that I work in, illustrated book publishing, requires that I think carefully about how the design of a book works with the content and in support of the subjects discussed, and how appropriate it is for the book's market. I'm fortunate to have a small but very talented creative team working with me in-house, but we couldn't possibly adapt our own favored design styles (and we all have them, whether we care to admit it or not) sufficiently enough to cover the range required to support a full publishing program. Also, it wouldn't be great if every single book published looked as though I or one of my team had designed it—a successful publishing program needs variety. This is one of the reasons why freelance designers are so important to any publishing house, design studio, or agency that produces work with a broad range of styles and applications. Projects can be matched precisely to the designer with the most appropriate stylistic approach or skill set, helping to guarantee the best results for your client or product.

The best freelance designers are fully prepared to respond to a brief without stubbornly trying to transform the project into something they want to design, rather than the solution you need. (freelancers that aren't good listeners are not great to work with).

Good freelancers aren't afraid to put forward their own views if they feel strongly that a brief is off the mark, but are then willing to go with the art director's instinct for a creative direction all the same. On the other hand, a good art director will always consider a freelancer's views and should always be able to explain why an alternative concept isn't right. The same points I raised earlier when discussing the management of an in-house team with regard to personalities and mutual respect apply here.

"For me, building long-lasting connections with a wide range of trusted freelance designers is practically as important as maintaining good working relationships within your own permanent creative team."

1

1. PULL

Promotional poster for an exhibition of contemporary music posters.
John Foster—Bad People Good Things

First-time working

If you've found a new freelancer you think you'd like to work with, don't dive straight in with an important project for one of your biggest clients. Try to find a smaller project with a reasonably flexible schedule, and commission a "sample" such as ideas for a presentation that you can discard if it's not up to scratch. I should stress that this must be treated as a paid commission, not a freebie. Asking a freelancer to produce work for nothing as a test is unrealistic as the effort they put in will never be as much for unpaid work as it would be if they will receive an appropriate fee at the end. There is far too much "unpaid pitch" work around as it is, and it's a practice which should never be encouraged, so please pay for creative work every time.

Freelance designers—the advantages

- A range of choice from one project to the next.
- Flexible working, particularly when schedules are seasonal or liable to periods of "downtime" for design. Publishing is a good example, where layouts may be unavailable for extended periods while text is being edited.
- Flexible cash flow. You don't have to pay freelancers when your workload is light, when they are ill, or when they are on vacation.
- It's much easier to sever working relationships if things don't work out.
- Freelance fees are always negotiable (but don't take advantage of this by sequential rate cuts, it's unprofessional and will backfire on you).

2. Full Bleed

The poster issue of <u>Full Bleed</u>, a magazine published by the Art Directors Club of Metropolitan Washington.
John Foster—Bad People Good Things

DOMENIC LIPPA
PENTAGRAM

Profile

Domenic Lippa studied at the London College of Printing, and together with Harry Pearce, formed design studio Lippa Pearce in 1990. Domenic's reputation is founded on his work in packaging, print, identity design, and retail graphics, and his clients range from upmarket UK furniture retailer Heal's & Sons, to global brands such as Unilever and Vodafone. He became a partner at Pentagram's London office in 2006.

Interview

Tony Seddon: **Our standard opening question is, what is an art director?**

Domenic Lippa: It's strange to think about the answer to that question actually. My father was in advertising, so I've always felt that the term art director applies more to advertising than graphic design. To me, there's a clear differentiation between an art director who's the visual side of an advertising team, and a copywriter. As I became involved in design it was more obvious to me how that role worked in editorial design, but for graphic design I think it's more of an ambiguous term and it's not necessarily a term I use to describe what I do. I'm more inclined to use the term design director, but it's ultimately down to semantics. To me the role of an art director can be defined by saying an individual designer will do every part of a project, but an art director is someone who runs a team of those designers. It's like the conductor of an orchestra, or the director of a movie. The director decides what the shot should look like, but they're not looking through the camera. The art director is the person ultimately responsible for the visual direction and the end product.

TS: **So "design manager" could be another way to categorize the role?**

DL: Yes, although designers can be snobby about having "manager" in their job titles because it sounds a bit corporate. I don't think it matters too much really, it's still just one person bringing together the various parts of a creative project and making sure everything works.

TS: **I think the comparison with a conductor is a good analogy, because a conductor controls the whole orchestra but probably can't play all of the instruments, and certainly couldn't play them all at the same time.**

DL: Exactly, but they influence every part of the end result, be it a piece of music or a piece of design. I actually still really enjoy hands-on design and certain projects, like *Circular* magazine for example, I do myself. I'm art director, designer, typographer, copywriter, editor, everything, but it's rare that I'm able to do a project of that kind in that way. I've realized that there are people in my team who have certain skills that are actually better than mine, particularly when it comes to using software. I haven't kept those skills up because of time and so on, and because of that I increasingly rely on my team's input. But I enjoy directing the work as much as I would enjoy sitting in front of a computer doing the work myself.

TS: **So becoming an art director is partly about learning to let go of some of the "hands-on" side of things.**

DL: Yes. I guess one of the most rewarding periods of a designer's career could be seen as the "senior designer" section, when you've got a lot of control and you're also doing a lot of the actual work yourself, but if you choose to progress beyond that you do

WE SEEK
THE HARMONY BETWEEN
SCIENCE AND NATURE.
FINDING THE BALANCE
WHERE EACH
DRAWS THE BEST
FROM EACH OTHER.

WARMTH.
A LINGERING
SMELL OF NATURAL
PLANT OIL. UPLIFTING
YOUR SENSES.
RELAXATION.
THE SPA
BROUGHT HOME.

SPAS ARE OUR
HERITAGE

1–3. ESPA

Brand identity for ESPA, a range of spa-inspired products that combine ancient and modern therapies with fine ingredients. The bold and classical concept is designed to reflect the quality of the product and the integrity of the established brand.

Domenic Lippa—Pentagram

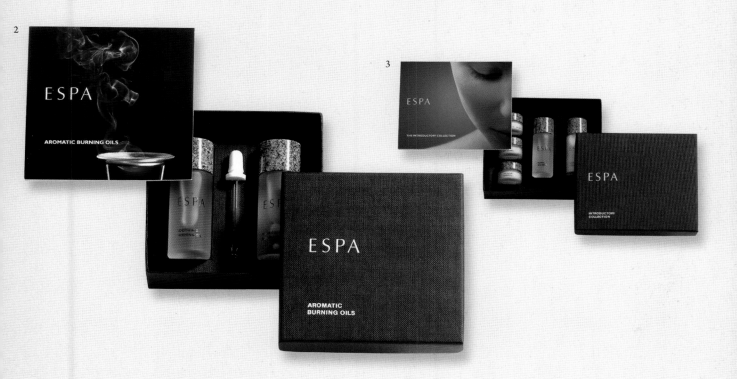

1–2. ESPA

Strong colors and a subtle use of
embossing and luxury materials are
central to this packaging concept.
Domenic Lippa—Pentagram

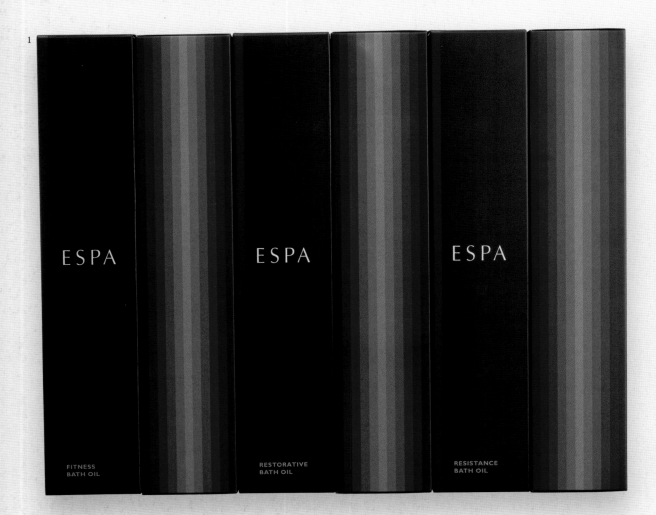

1

FITNESS
BATH OIL

RESTORATIVE
BATH OIL

RESISTANCE
BATH OIL

2

ESPA

HYDRATING
CLEANSING MILK

ESPA

CONCEPT
INTENSIVE
BIO-COMPLEX

ESPA

CONCEPT
REGENERATING FACE
TREATMENT OIL.

ESPA

CONCEPT
REVITALISING
EYE MASK

ESPA

CONCEPT
FIRMING FACE MASK

ESPA

CONCEPT
REVITALISING
EYE MASK

ultimately have to decide whether or not you're prepared to relinquish some of that control to others.

Luke Herriott: **Tony and I have been discussing designers that complete their education and then decide to set up on their own straightaway, so in effect are both designers and art directors immediately.**

DL: I think things have gone full circle in that respect. A lot of designers in the 1960s and 1970s started their own companies straightaway, maybe because there weren't so many around in the first place. Then during the 1980s

and 1990s, graduates tended to work for other companies first and learned that way. I graduated in 1984 but always had ambitions to start my own company as my father had done that previously and it never seemed to me to be something I couldn't do. When we started Lippa Pearce in 1990 during a period of recession, a lot of people were quite shocked and thought it was a really big thing, but it didn't seem like that to me. One of the good things about recession is that it forces designers to not take the easy path, but what I learned working for companies in the time preceding that was very useful. It wasn't so much what I learned about good or bad design, but what I learned about how to manage myself.

3

1

2

With 25 years experience in producing and designing a range of vases, glassware and ceramics, LSA International defines what is desirable in contemporary style

LSA International
Vases and Glassware
HEAL'S

HEAL'S

Panton Chair 1967
Herman Miller Vitra

The Panton Chair is a furniture design classic. Verner Panton created it back in 1960, and with the assistance of Vitra developed a version ready for production in 1967. It was the first fully plastic chair made from a single section.

20% OFF

1–3. Heal's

The brand identity for Heal's, the London retailer at the forefront of stylish, contemporary design for almost 200 years. The identity includes the logo, in-store communication and signage, bags, gift-wrapping, packaging, vehicle liveries, and literature. Work on the project began at Lippa Pearce, prior to Domenic becoming a Pentagram partner.

Domenic Lippa—Pentagram

1

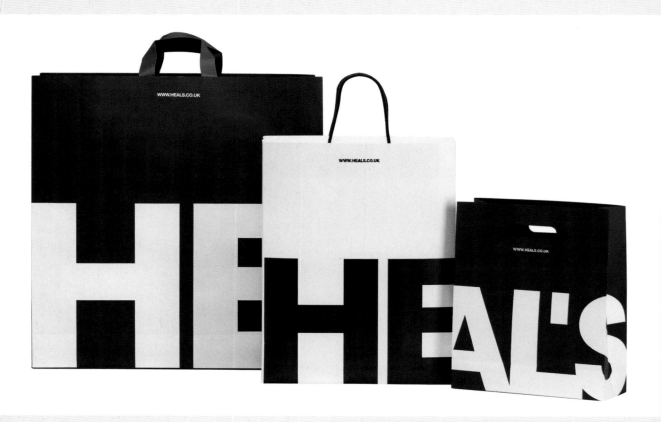

2

3

4

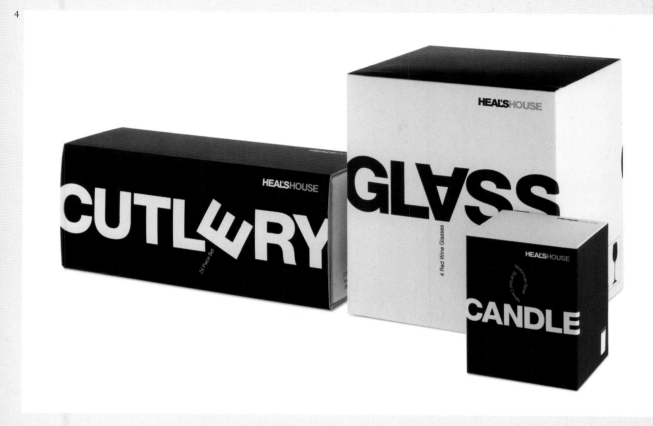

"I don't think I have a signature style, but as Alan Fletcher once said to me, 'Of course you've got a f*****g signature style!'"

1–4. Heal's

The identity's strong typographic element can be applied across the entire range of items used by Heal's for all areas of their business.
Domenic Lippa—Pentagram

LH: **Can you recall the point at which you became an art director?**

DL: I think I sort of drifted into it to be honest. I can't remember the point at which I became an art director; it's a very fluid process for most people.

TS: **And there's no such thing as a degree in art direction.**

DL: Exactly.

TS: **Moving on to a different topic, how do you feel about art directors having or developing a signature style? Do you think that approach can hinder creativity?**

DL: Some designers will be approached by clients because they have a signature style, so it's not necessarily a hindrance. I don't think I have a signature style, but as Alan Fletcher once said to me, "Of course you've got a f*****g signature style!" You think you don't of course, but everyone does to a degree. Harry [Pearce] and I think we're very different designers but Alan used to say that he couldn't tell us apart, and to the outside world our work probably does bear lots of similarities because we've worked together so often.

1
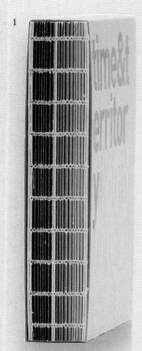

2

3

4

5

TS: We all like to think of ourselves as completely flexible and adaptive, but how often do you look at a piece of new work and think, "Damn, I've done the same piece again."

DL: Oh, often, but to say it's a hindrance to creativity—I don't think you can answer that question. I admire some designers that have a distinct style, and I admire other designers that are more chameleon-like.

LH: How important is it to maintain close contact with your clients throughout projects?

DL: I have a very good project manager, who does a lot of client liaison, and my senior designer also talks to our clients and runs some of the meetings. Clients will often ask to meet the team, in fact. The main thing is, it's important that I know about every aspect of the projects the team are working on, then I can get involved when it's most appropriate, whether that be from the outset or whatever.

TS: How prescriptive do you feel an art director should be? Do you think it's better to be less prescriptive and allow your team to formulate their own response to a brief first?

1–9. Time & Territory

A book published to mark the 25th anniversary of the establishment of landscape architect and urban design firm J&L Gibbons. The use of bleach-free, FSC-certified paper stock, vegetable-based inks, and recycled grayboard reflects the sustainability that is characteristic of the firm's work.
Domenic Lippa—Pentagram

DL: There are certain things which I dislike so I do have a kind of "self rule book," but I've been lucky with the designers working with me and their ideas tend to fit with my own way of thinking. The answer is probably, yes, it's better not to be too prescriptive, but as the work I do is very varied, there are always a wide range of solutions that everyone can contribute to. The most important thing is that the quality of the design work is paramount, our portfolio is what gets us more work, and we're very conscious that what we do must be of a standard. I would never simply dismiss a designer's idea out of hand though, I would suggest that an alternative idea was better. The psychology of getting the best out of people is to motivate and inspire them, and if you can't interpret a brief straightaway, it's best to give yourself a day or two to think about it before you give it to your team. Having said that, if the budget is tight and the schedule is short, I might well be more rigid with the brief in order to get the job done.

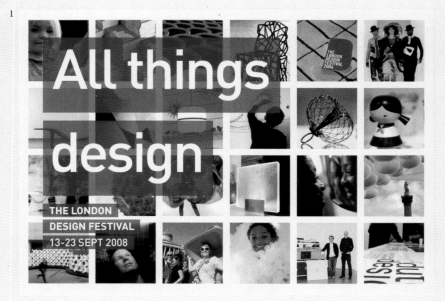

1–4. London Design Festival

Guide and promotional material for the London Design Festival, reviving and updating the original identity created by Vince Frost in 2002.
Domenic Lippa—Pentagram

1

1–9. The London Design Medal

Book celebrating the work of Marc Newson, recipient of the London Design Medal in 2008. The medal is awarded annually for outstanding contributions to contemporary design.
Domenic Lippa—Pentagram

2

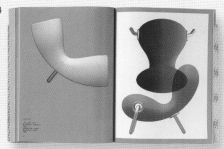

3

4

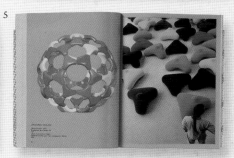

5

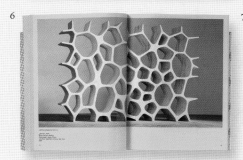

6

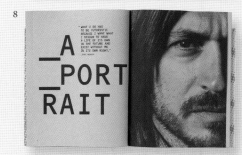

7

8

9

Working with Photo- graphers

SELECTING AND BRIEFING PHOTOGRAPHERS

Choosing the right photographer is of course a critical decision for any project, and it's difficult to advise any one particular method for making that choice as the criteria vary so widely. Some art directors prefer to work with only a few trusted photographers who can adapt their styles for different projects; others like to constantly seek out new talent and experiment.

Using the internet to find new photographers is a bit hit-and-miss, but at least you can localize your search, and I've always felt that it's an advantage to use people that you can meet with easily to discuss new projects face to face. Agents can be expensive, adding another layer of both cost and communication, but sometimes they can be the best way to locate a talented specialist, so never discount them as a viable option. Regular research is also important and, as much as time permits, should form a part of every art director's schedule. Read as much as you can, both off and online, and when you come across a photographer you like, keep a record of their work and contact details. Many of the art directors we've spoken to during the writing of this book find photographers in this way and invest a good deal of their time in research.

If you're fortunate the right photographers will find you. I regularly receive submissions from photographers and I always look over their work, even if I'm not sure that they're right for our kind of projects. It's not always appropriate to go for obvious choices and asking a photographer to work outside of their known specialty can sometimes produce exciting results—a risky option perhaps but one that's worthy of consideration. Erik Kessels states, "Break the rules whenever possible. When you have to photograph a car, get the guy who is great at shooting food. Or people. Or landscapes. Screw the natural order up a bit. Throw some curve balls at your idea."

One piece of advice I'd like to pass on is, always ask to see a photographer's personal work. It's often very different from their commercial material and could inspire a previously unconsidered direction for a project.

COME AS YOU ARE

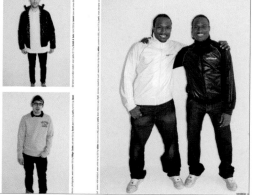

TODAY IS THE GREATEST DAY

SODA POP

1–8. Saturday

Art direction of <u>Saturday</u>, a style magazine published with clothing retailer USC in support of the Teenage Cancer Trust. Photography is by (1 & 2) William Selden, (3 & 5) Ben Rayner, (7) Ben Toms, and (4, 6, & 8) Mari Sarai.

Peter Stitson—Peter Stitson Ltd

SELECTING PHOTOGRAPHERS

"It's a combination of style, experience, location, and facilities. I mean, for example, if you're doing a still life shoot, or food, it's about their studio setup and their experience. There are some fantastic up-and-coming photographers out there. Wherever possible I try to work with new guys because, as is often the case, they have a lot of energy in their work, which is sometimes all you need."

Steve Price—Plan-B Studio

"The selection of a photographer can make or break a campaign. I prefer to give photographers as much freedom as possible. I don't believe in showing them detailed sketches of what I'm looking for. I would much rather give them written descriptions of what I want. That way they can add their own vision and creativity to the shot."

Erik Kessels—KesselsKramer

1

1. J&B Start a Party

Campaign for whisky brand J&B, with all ads featuring a glitter ball representing the start of a party.
KesselsKramer

2

I'll give you Satisfaction

2. Donald Diesel

Part of the ongoing campaign for clothing retailer Diesel to market their product to a wider audience through ironic and arresting imagery.
KesselsKramer

The photography brief

When commissioning any photography, in fact before even selecting your photographer, draw up a shoot list with art direction notes for each separate image. This helps indicate whether or not there's enough in the budget, and enables you to focus on what you may have to drop from your "ideal" image requirements. If you're going to attend throughout the entire shoot, the written brief can be restricted to the shoot list as you'll be able to brief each shot verbally. If you don't plan to be (or can't logistically be) in attendance the brief should include notes about your preferences for lighting, styling, backdrops, models, locations, props, and so on. Including some visual references of existing photography similar to your requirements is a simple way to get your message across.

Other useful topics to focus on are:

- **Digital or film**—there are still some distinct advantages with film. Large-format film cameras produce originals that can be scanned at resolutions much higher than those achieved by digital equipment.
- **Resolution**—discuss the sizing requirements when shooting digitally to ensure the images will be of sufficient resolution.
- **Orientation, proportion, and background**—match the orientation of each image to its planned use, and give the photographer the page proportions as a guide. For example, full-bleed images should be portrait for magazine pages and landscape for spreads. There should also be enough background area around the main subject of the shot to allow cropping without major compromise. Pack shots that will be cutouts should be shot against plain backgrounds to facilitate easier edge detection.
- **Empty areas**—if an image is intended for use as a cover shot, indicate which areas of the shot need to be visually uncluttered for the placement of the masthead and other typographic elements.
- **Simultaneous RAW and JPEG shooting**—uncorrected JPEG files can be supplied immediately for editing and selecting your final choice before RAW files are processed, and can be used as positionals if schedules are tight.
- **Postproduction**—your photographer will process the RAW images files before supplying them so specify any extra work required beyond the standard color balancing, brightening, and sharpening. If you want to do this yourself to keep costs down, make sure you let them know in advance.

1

2

1–7. Made in Sheffield

Art direction of a series of portraits commissioned to promote Tony Christie's album <u>Made in Sheffield</u>, with photography by Shaun Bloodworth.
Paul Reardon—Peter and Paul

3

4

5

6

NEGOTIATING PHOTOGRAPHY CONTRACTS 7

Fees

There are two ways to negotiate photography fees—you can opt for either a flat fee or a day rate. If you're confident that you know exactly how long a shoot will take, a day rate works perfectly well. However, if you have any doubts about the time required or have a finite budget (which, let's face it, is nearly always the case), a flat fee is recommended. To arrive at a suitable fee, I usually work out how long I (not the photographer) think the shoot will take, check the photographer's day rate, and multiply the two. In a sense the photographer is still working for their preferred day rate, but if the schedule runs over, the fee remains fixed. This is a further incentive for them to complete the work on time. As always, it's important to be fair with both your proposal for the fee and to not purposely underestimate the time needed with inaccurate briefing. That would be unprofessional, and word gets around.

Contracts

The brief and shoot list discussed are in a sense part of the contract between you and the photographer. The additional issue here is to ensure that the rights for the photography are assigned correctly. When you commission a photographer you're not necessarily buying the images outright. The photographer can retain the right to charge you for any additional use of the images. Paul Burgess comments that, "The problems start when you get into fees and buyouts for the wider use of commissioned images. It's extremely frustrating when the photographer owns the rights to an image the client has paid for and that we as a creative team have conjured, designed, and planned."

I always negotiate photography contracts based on the fact that the images being shot belong outright to us so we can reuse them if we wish. If a photographer is reluctant to sign up to that, I don't work with them. Other than that, the structure of the contract for creative work discussed can be adapted as required.

ART DIRECTING A PHOTO SHOOT

One of the first things I ask myself when planning the art direction for a photo shoot is whether or not I need to be there for the duration of the photography. For a complex and varied shoot it's essential that the photographer is provided with on-site art direction—at least for the first day or so—or there's no recourse for you if you're not happy with the final results. However, simple photography that requires little in the way of art direction is another matter. In this situation, it's better to leave the photographer alone to get on with the job, and if the brief is well written there may be no need for you to attend at all. If you want to track progress, you can always ask the photographer to email low-resolution JPEGs for approval before the main shoot goes ahead.

Photo shoots are hard work, requiring a lot of concentrated effort, and can therefore be quite grueling over the course of a long day. With this in mind, the art director should be prepared to expand their role beyond the creative. That can mean turning oneself into both a facilitator and negotiator in order to keep things moving, particularly if the shoot is on location and things like catering and other basic facilities are not easily to hand. If it's left to the photographer to organize everything they'll have less time to concentrate on the job they're being paid to do, which is a false economy.

Ultimately, and I've touched on this in other sections of the book, you've chosen the photographer because they're right for the job and will add their own sense of creativity to the images they make for you. My advice is to try not to "over direct," and only step in when you feel the photography is straying from the prepared shoot list either physically or stylistically. The old phrase "too many cooks spoil the broth" sums this up pretty well—one strong creative approach will invariably produce the best result.

1–11. Grow Your Own

Art direction of photography for use in the promotional brochure for regeneration company Urban Splash's first development project—Saxton—in Leeds, UK, which includes allotments for the use of the residents.
Paul Reardon—Peter and Paul

1

PHOTOGRAPHIC ART DIRECTION

"During a shoot I try to consider what hasn't been covered and what we might be missing. The art director's role is to push to make the work the best it can be and to be open to changing direction if needed."

Joshua Berger—Plazm

"We often produce test shots for lighting, composition, locations, look at timings and schedules, staff, transport, weather, and whatever needs addressing that could be a problem on the day. It's common sense really but the more preparation you do the fewer problems are likely to occur on the day. As an art director you have to have energy and excitement on a shoot, keeping everyone on their toes, organizing people, delegating responsibilities to your team, giving directions, making quick decisions."

Paul Reardon—Peter and Paul

"Some photographers like to dominate and don't really want anyone else's input on the shoot. Others are totally reliant on your input, expecting you to direct everything. The best photographers are the collaborators who work with you to achieve a common goal and not just something they fancy doing. Photographic shoots are hard work, there is a lot to do, and the best technique I know of is to never let the flow stop, keep everyone going all the time."

Paul Burgess—art director

1

2

3
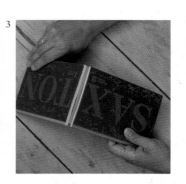

4
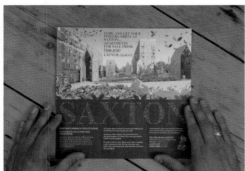

5
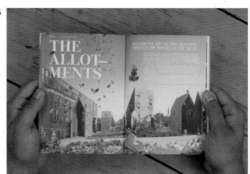

6
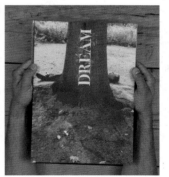

7
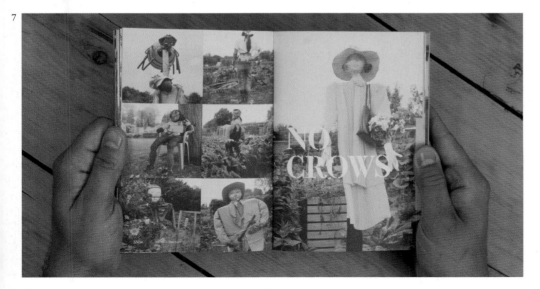

1–7. Grow Your Own

Spreads from the project's
promotional brochure.
Paul Reardon—Peter and Paul

JONATHAN ELLERY
BROWNS

Profile

Jonathan Ellery cofounded Browns, a multidisciplinary design studio, in 1998 and runs it with business partner Nick Jones. His approach is to strive for simplicity, originality, and clarity of message, and the company's reputation is built on both its ability to deliver thought-provoking visuals and its mastery of the print process. As well as his work with Browns, Jonathan publishes his personal work in the form of conceptual limited-edition books and individual works of art which often combine typography and sculpture, and in 2008 staged a live performance piece, *Constance*, at the Wapping Project in London.

1

136 Points of Reference Ellery/ Browns

Interview

Tony Seddon: **We're starting each of our interviews with the question: what is an art director?**

Jonathan Ellery: There are lots of overlaps these days, but in my mind it's about the overall aesthetic and language, the points of reference that lead to the way a project looks. I also link art direction very strongly with photography. Like for instance Peter Saville and his working relationship with Nick Knight, with his ability to intellectualize about a project and then get exactly what he wants from the photography. Art direction seems to be associated with advertising more than design; I don't really know why that is to be honest, but here at Browns I'm the art director, and also the creative director.

TS: **Do you think there's a difference between art directors and creative directors? Do the apparent overlaps mean that the term art director is becoming redundant in certain areas of the graphics industry?**

JE: To be honest I don't really mind what you call it, essentially my role on any project doesn't change that much whatever title it's given. I think art direction is probably more visually-led, and for me that certainly involves more on the photographic side. Creative direction is more about thinking through the earlier stages of the development of a concept.

TS: **I've noticed that you like to work regularly with a fairly limited number of photographers on many of your projects.**

JE: We've worked very hard on gathering knowledge of photographers and on building our points of reference for photography. Browns have built a tradition for working closely with Magnum for instance, and we've adopted a certain way of working with them because, well, they are Magnum. In the studio you'll find that we work with either Davy Jones or John Ross, and again we use different styles of art direction with each of them. Most of the strong art direction that comes out of this studio is due to the good working relationships we have with people. It's not just because they're great at what they do. We've worked with them so much now that we're also friends, and the art direction becomes almost like a sort of telepathy.

2

3

4

5

6
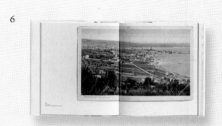

7

8
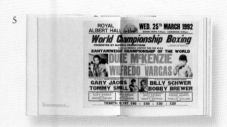

9

10

11

12

1–12. 136 Points of Reference

Cover and spreads from Ellery's self-published title. The book examines the influences that define Ellery and his studio.
Jonathan Ellery and Lisa Smith—Browns

1

2

Luke Herriott: How do you decide where to draw the line between pushing a project in a certain direction yourself, or giving the photographer the creative freedom to bring their own vision to a project?

JE: There are a few different ways of looking at this. We worked with 10 different Magnum photographers on a book for The Climate Group which carried an environmental message, and I started out by speaking to all the photographers and setting out our ambitions for the project, after which I simply had to have the confidence as art director to let them go and do what they thought was right. The last thing a Magnum photographer wants is to have someone next to them telling them what to do! Sometimes good art direction simply requires the confidence to let people be so they can interpret the brief in their own intuitive way.

Good communication up front is really important if this is going to work of course. For example, we worked with Davy Jones on a project promoting a series of Welsh rugby games at the Millennium Stadium in Cardiff. We were very clear about the specific elements we needed to get from a

shoot, which is where the up front communication comes in, but what we really wanted from him was his gut reaction to what looked interesting on the day during a rugby game between Wales and Australia, and we didn't want to stifle his creativity. Working in the studio with someone like John Ross, we'd do the same sort of thing. I'd probably put together color palettes or a visual mood board in order to put him in the world that I'm thinking about visually, work with him for about 30 or 40 minutes at the beginning of the shoot, then just give him the freedom to work with the brief and interpret it for himself. Most of our art direction is intentionally quite loose. There's no point in hiring a fantastic photographer or filmmaker and then dictating what they should do, at least not too much anyway. I always try and instill that in the designers working with us—I ask them to be firm but not to sit on photographers' shoulders. When I first began working in the design industry, I often made the mistake of spending too much time at a photo shoot when in fact my being there was creating more problems than if I'd left the photographer alone to get on with it. It was undermining the photographer's decision-making process.

1–7. Mother's Necklace

Cover, incorporating a foldout poster, and spreads from the book that accompanied the "Mother's Necklace" exhibition. This celebrated the launch of a new identity, also by Browns, for fund-management company Invesco.
Jonathan Ellery—Browns

3

4

5

6

7

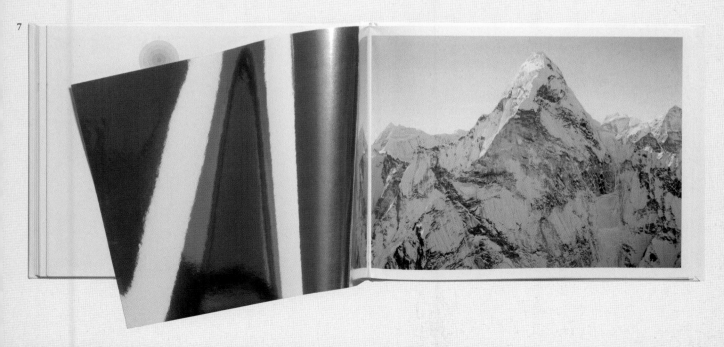

TS: **I agree with that view. If you're confident you've chosen the right person for the job in the first place, they'll know what's needed and what to do to achieve it. The art direction is largely about making that initial choice.**

JE: As long as it's for a commercial brief, which generally they are. On the art/personal project side it's a bit different. For that side of my work there obviously has to be a lot more collaboration. I did a performance piece called *Constance* in 2008, and I shot the whole piece in the studio with John Ross first because I wanted an accompanying book to be available for the performance itself. The process of art directing the shoot from start to finish in the studio with the actress that would eventually perform the piece in front of an audience, produced some really interesting moments. As I was directing the actress in the studio, asking her to look anxious, desperate, fractious, and so on, John had to pick up on that and pick his moments to get each shot to represent each stage of the performance. There was a lot of art

2

1

direction running through the whole process, but all beautifully interpreted and captured by John if that makes sense, and it gave me the opportunity to look even more closely at the way the piece was working. This was ultimately a performance piece rather than a print project so I'm not sure how relevant it is to your book, but I wanted to mention it because it's probably the strongest art direction I've ever done in both a physical and editorial sense. It's multifaceted art direction.

LH: **It's relevant because the art direction techniques you used can be applied to print projects too.**

JE: Yes, that's true. I suppose for a commercial project the nearest you would get to something like *Constance* would be an exhibition where you care about how the graphics read and how the photography looks, how all the elements work within the space, and so on.

3

4

5

1–5. Constance

Cover and spreads from the book published to support a live performance piece by Ellery entitled "Constance." The performance was staged at The Wapping Project, London.
Jonathan Ellery—Browns

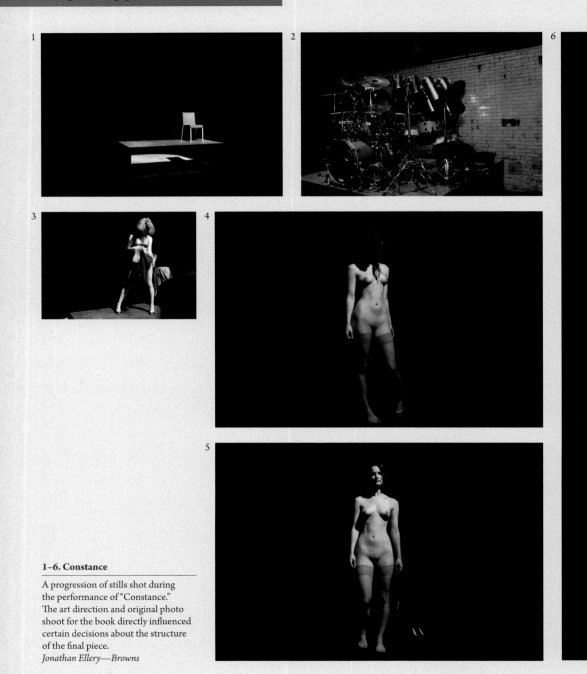

1–6. Constance

A progression of stills shot during
the performance of "Constance."
The art direction and original photo
shoot for the book directly influenced
certain decisions about the structure
of the final piece.
Jonathan Ellery—Browns

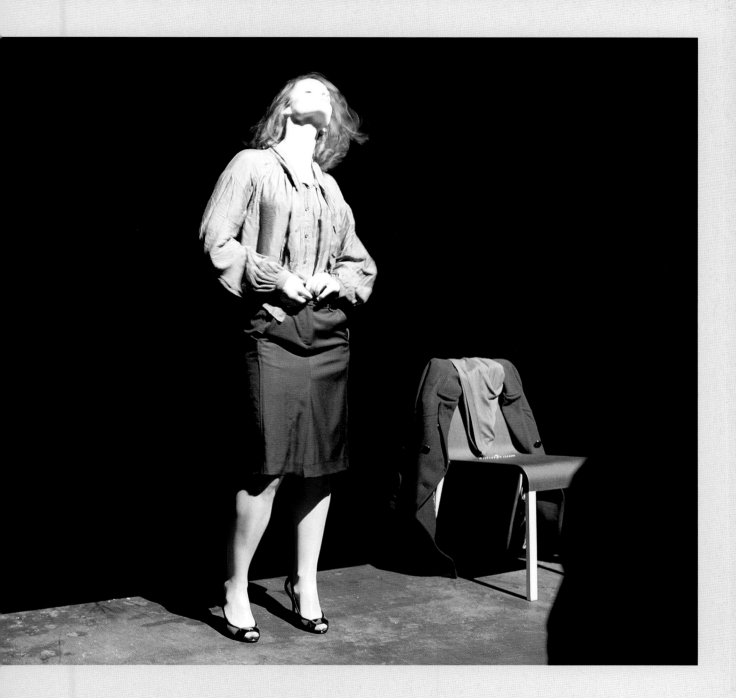

LH: **How do you go about making personal work like *Constance* alongside your other commercial work with Browns?**

JE: There's a clear distinction between one type of work and the other. Browns is a commercial graphic design studio which I love being involved in, and as far as I'm concerned, with commercial graphic design there's a brief, a client, and there's generally money involved. If those things aren't present, then it isn't graphic design. That's what brownsdesign.com does. To make the distinction and avoid confusion, my personal work, which I fund privately, comes under jonathanellery.com. It's important for me, and I think for the work itself, that this distinction is maintained and we're always careful to explain the difference to clients, students, and everyone who visits us. There's now also a third arm which is brownseditions.com, which is the publishing side of things.

TS: **I wanted to ask you how much your personal work influences your commercial work and vice versa. Is there a crossover of influences?**

JE: Well there is actually. There's quite a lot of ambiguity and overlap when we're thinking about ideas for new projects and I really love that. Ambiguity is a lovely word and it sits nicely with the whole Browns ethos. The way I generally think about things and the way I art direct projects isn't going to change between commercial projects and art projects. For example, the things I included in my *136 Points of Reference* book are all about my personal viewpoint, but they also rank among the things we feed off in the studio so there's bound to be some cross-referencing going on. In terms of art direction I encourage the designers here at Browns to "speak" the language of the elements they're bringing to a project when they're art directing, so if they want a grungy shot of something they might show "Ray's a Laugh" [item 54 in *136 Points of Reference*] to the photographer as part of their brief.

1–4. Dries Van Noten

Belgian fashion designer Dries Van Noten's 50th show at Paris Fashion Week in October 2004. The show climaxed with a commemorative book designed by Browns descending from the ceiling, delivered simultaneously to the 500 guests.
Jonathan Ellery—Browns

5

6

7

8

"Good art direction should come in part from life experience that's been collected along the way."

5–8. Dries Van Noten

Cover and spreads from the book.
Jonathan Ellery—Browns

"I think being an art director is really about constantly learning how to improve on the last job."

TS: Using visual references as part of a brief is good practice for any art director to follow.

JE: To come back to your original question, I think being an art director is really about constantly learning how to improve on the last job. There's the answer, or at least one answer anyway. For me art direction isn't about making sure that the head on top of a pint of Guinness looks perfect in a shot for an ad, it's a lot broader than that, it's about putting things into designers' or photographers' heads and running with it. Art direction isn't just about a layout.

LH: You work with paper companies quite a lot and have them as clients too, which obviously demands high production values. To ensure that happens, you must presumably involve yourself heavily with the print and with the choice of printer?

JE: We're talking about art directing going through to something tangible now, right? For Browns production values are key, right down to, for example, how a book feels, the format, the paper, the ink, how it smells, everything. We've built long-term relationships with printers over the years, it's a big part of how we work.

TS: I notice that you work with one particular print firm, Westerham Press, on a lot of your projects. Do you prefer to work with printers you know you can trust as much as possible?

JE: We've worked with them ever since Browns started. They've got us out of trouble on more than one occasion, and we've done the same for them. They understand how we work, they can have a conversation with me based on my points-of-reference approach, and they're not afraid to tell me that something I'm asking for can't practically be achieved. A good relationship with at least one printer is a valuable asset for a commercial design studio.

TS: How much print production knowledge do you feel art directors need in order to talk effectively to printers, and to brief designers correctly too?

JE: It's important to keep up with things and store as much knowledge as possible. It may be that the brief requires a very lavish production, or it may be that the client wants something that's a very no-nonsense affair. It's important for your clients that you know how to achieve the best result for them in terms of print, regardless of the type of end product needed.

LH: Another practical question—do you always take a new brief from a client yourself?

JE: It depends. We only employ people that are good communicators and we're up-front with everyone, we let the clients know what level everyone they might be dealing with is at. Some clients just want to sit down with me and the project manager, some like to sit down with the whole team, there aren't any set rules. I guess it would always be myself or Nick (Jones) if it was a brand-new client.

TS: On the subject of new clients, the reputation of some art directors or design companies for producing work with a certain look, say a signature style, is what attracts those new clients. Do you think it's useful or relevant to have a visual style that you can associate yourself with for that reason?

JE: I think there is a strength to that, it can be helpful at times.

TS: I'm asking the question because I think there's a lot of "style over concept" work appearing at the moment, and I was wondering if you had a view on that.

JE: I think there are some very good art directors and design studios out there that can keep doing the same kind of thing simply because they do it very well. If the work has stamina and continues to look good and fresh, then why not? Personally I get bored with that approach and I try to seek out changes and challenges wherever I can. Life's too short to stick too closely to what you feel completely safe with, so I like to try and keep moving on to new things. If I walk past a desk downstairs and say "That's nice" it's not a positive. It's not good just to give someone a bit of what you think they want to hear. If you make mistakes along the way, then so be it. Art directors and designers who simply put style over concept and don't draw on their own experiences, who just produce a piece that looks nice, are being lazy. Good art direction should come in part from life experience that's been collected along the way. To be a good art director you also need to learn what not to do.

TS: I don't think you can achieve success without making some mistakes along the way.

JE: I don't worry about making mistakes so much now. As I said, I think it's all part of the process and you just have to crack on and do your best work as you think it should be done. We try not to draw influences directly from existing design, most of our art direction points of reference come from places other than design. Having said that, if you're an art director that wants his studio's work to consistently reference, say, a Swiss or German master of typography, then that's OK. It's not wrong to do that if it's a commercially successful decision. Personally I never understood the rationale of designing in a completely Swiss or German style if you're working in London. Do you know what I mean?

TS: Yes—and I agree that it's important for art directors to be inspired by their own experiences and not to turn only to existing work for inspiration.

JE: I think the ability to art direct, as you get older and more experienced, is simply about gaining a more sophisticated palette of points of reference which you can articulate. That really defines you, and defines what kind of art director you are.

1

2

3

1–6. A British Graphic Design and Print Landscape

Cover and spreads of a book designed to accompany the relaunch of Howard Smith Paper's annual awards scheme. Each spread featured an uncaptioned image of an empty UK design studio. Readers were invited to try to match the studios to the list of names printed at the back of the book.
Jonathan Ellery—Browns

4

5

6

Working with Illus- trators

SELECTING AND BRIEFING ILLUSTRATORS

The process of briefing and art directing an illustrator differs from that used when working with a photographer. Unless the photography is very straightforward, it's unusual for a photographer to provide single options for each shot requested. You'll probably receive a couple of different angles to choose from, some variations in the lighting setup, and so on. In contrast, an illustration tends to be one piece of artwork that may have taken many hours to complete. Because of this it's more important than ever to choose who you work with carefully and to make sure illustration briefs are absolutely watertight with no ambiguity whatsoever about your expectations. Conversely, the process is generally more relaxed, given that photographic shoots are time-limited, happen quickly, and can be fairly stressful affairs. If schedules are not too restrictive, illustration can be commissioned and created at a more leisurely pace with art direction and development figuring prominently along the way.

I mentioned at the beginning of chapter five that I try to set research time aside as often as possible, and keep records of any interesting photographers I come across. I look out for illustrators with an interesting portfolio at the same time, and normally turn to my notes as the first port of call when searching for someone new to work with. Agencies are very useful too, particularly if agency staff are happy to collaborate with art directors when forming a brief, and I think the added cost of using an agent is generally worth it.

If location isn't an issue, I like to try to meet up with illustrators I've not worked with before to review their portfolios as it's not possible to judge character by email. In my experience an illustrator's personality is a significant influence on their work, and subsequently will play a part in your decision to work with them. Look for illustrators that have strong conceptual abilities as well as great work in their portfolios as it's their ideas as well as their drawing skills that will produce amazing results. Beware of portfolios displaying many different styles— restaurants with endless menu options tend to serve unremarkable food that's been preprepared. The same can be said of illustrators that can mimic lots of styles but lack individuality and good conceptual skills.

1. Anna Blundy series

Series of type-led covers designed to convey the humor and energy of Anna Blundy's books.
Crush

2. Agatha Christie

Highlights from a series of jackets created for Agatha Christie's back catalog.
Crush

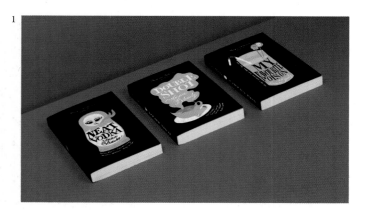

1

Look for illustrators that have strong conceptual abilities as well as great work in their portfolios as it's their ideas as well as their drawing skills that will produce amazing results.

The illustration brief

As well as a written brief that clearly outlines the requirements for the illustration, it's a good idea to show the illustrator how the finished piece will be used. That means providing them with a visual reference of the proposed layout, even if it's not final, indicating the space which will be occupied by the illustration. Also, specify the way you would like artwork to be delivered. Nondigital artwork will require scanning so should be on a flexible material, otherwise an additional stage of photography will be necessary. Other than that, good communication is once again the key.

1

SELECTING AN ILLUSTRATOR

"We don't use external illustrators that much, but if we do it's because of the need for a specific style. We have our own collection of illustrators that we like but agencies can be a good way to find someone new. When working with illustrators, we usually have a good idea of what we want but it's always better to give the illustrator creative freedom as well."

Martin Fredricson—We Recommend

"Either you're looking for a specific style, or for someone that can work with a brief. I find that there are either good visualizers—people who create beautiful images—or great conceptualizers, people who are idea-based. I have a preference for the latter."

Mark Stevens—M-A-R-C

"I choose illustrators whose work I really admire, and whose style complements the brief."

Peter Stitson—Peter Stitson Ltd

1. Don't be a Victim

Illustration for London Fire Brigade's campaign to highlight the dangers fire fighters face when carrying out their duties. This piece focuses on watching for burnt cracks and gaps in floors.
Carl Rush and Chris Pelling—Crush

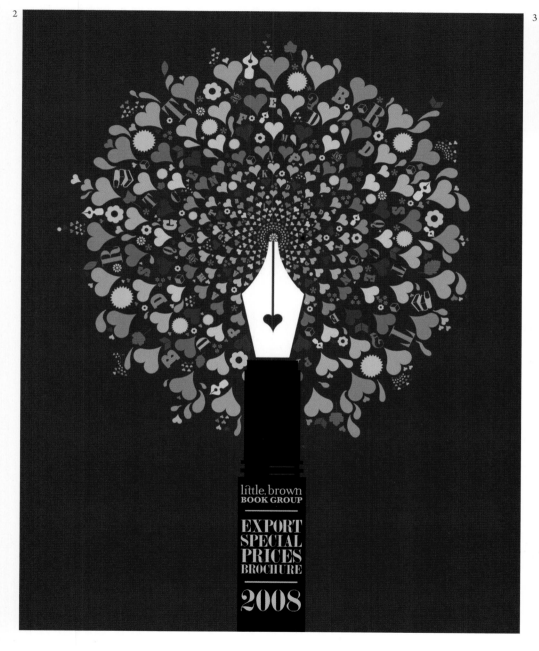

2–3. Heart Pen

Cover illustration for the <u>Export Special Prices Brochure</u>, highlighting new book releases by the Little, Brown publishing house.
Carl Rush and Helen Crawford-White— Crush

NEGOTIATING ILLUSTRATOR CONTRACTS

Fees

In my experience, illustration costs are always negotiated as a flat fee based on a number of specific criteria. Professional bodies, such as the Association of Illustrators (AOI) in the UK, set out annual guidelines to help illustrators establish their rates, so it's a good idea for art directors to refer to the same scale when deciding on an appropriate fee to offer for a project. Bear in mind that you could be dealing directly with the illustrator's agent who will be strict about the correct fee level, so do your best to be realistic with your calculations, even if your budget is restrictive.

1–2. The Bible

A fresh new look for the Bible, created to emulate the cover of a best-selling summer read.
Carl Rush and Chris Pelling—Crush

1

2

Contracts

The main considerations when calculating a fee and negotiating a contract are:

- **Usage**—is the illustration going to be used for a magazine or book cover, a press ad, a poster, etc.? Will it be used on a commercial product offered for resale, or for a promotional piece that has no commercial value? It's important for all parties that the specific use is clearly defined in the contract as it will have a bearing on the fee and the rights owned by you or your client. The rights to use illustrations for promotional purposes, for reuse, and on the internet are all important considerations.

- **Territory**—linked to usage, the areas where the illustration will be used influences the fee considerably. For example, world rights for all territories will cost a lot more than permission to publish only in the USA.

- **Duration**—illustrations can be licensed for specific periods of time, after which the rights revert to the illustrator unless otherwise agreed, upon which they can then resell the rights to another client.

- **Quantity**—a high-volume print run may command a higher fee than one where only a low number of units are reproduced.

- **Time**—this may seem a little obvious, but if a complex job requires a lot of time to complete, expect the fee to be higher. In addition, if a job is briefed at very short notice an illustrator may feel obliged to charge a "rush" fee.

- **Expenses**—if any expenses are incurred by the illustrator it's reasonable to expect to reimburse on a cost-only basis. Expenses should not include any materials required to produce the artwork.

3

3–4. Faber & Faber

Faber's 2009 seasonal catalog, which coincided with the company's 80th birthday. The design incorporated key imagery from Faber's history and these iconic elements were used to create an exploding book in celebration of the anniversary.
Carl Rush, Chris Pelling, and Helen Crawford-White—Crush

4

1. Hurricane Katrina

Limited-edition poster inspired
by Hurricane Katrina, created for
a charity website which sold the prints
and sent all funds generated to the
American Red Cross.
John Foster—Bad People Good Things

1

2

1. The Green Issue

Cover for a special issue of UK-based magazine <u>The Big Issue</u>.
Carl Rush and John McColloch—Crush

FROM ROUGHS TO ARTWORK

A concept can be more fully realized if any and all possible ideas are quickly thought through and either worked up further or discarded, and sitting down with a pen and a layout pad is still the best way to do this. This doesn't just apply to illustration work of course, the same goes for layouts, typography, and photography. One of the most important skills to develop as an art director is the ability to get across what you're thinking with a quick sketch or scribble. Drawing ability is obviously useful but not essential as roughs can be pretty basic affairs. That's why they're called roughs!

It's simply common sense for an art director to request roughs from an illustrator before the process of producing any finished artwork begins, and most illustrators would automatically assume they'll be required. Roughs have several uses beyond the basic function of indicating the direction for the illustration, thus allowing art directors and illustrators to thrash out ideas before any chargeable time is spent on a final piece. Firstly, they provided both parties with a kind of secondary contract, meaning that both art director and illustrator have agreed on the illustration's content and style. As long as the illustrator sticks to the rough, there should be no surprises when the final piece is delivered. Secondly, if a client is involved and is shown roughs for approval, the art director is covered in the event of a client's rejection of the work further down the line. If a client approves roughs, it's much harder for them to dismiss finished work as being "not what we had in mind." Thirdly, the ability to exchange roughs with illustrators as many times as necessary in order to get the concept and style right means that face-to-face briefing meetings, while still preferable, are actually less important. Unless you're working toward an extremely tight deadline, illustration work tends to happen in a more relaxed way to the average photo shoot which you have to get right on the day. Illustration work can be easily briefed via email and telephone, meaning you can choose to work with people independently of their location. Remember, too, that you can use roughs as part of a layout while waiting for delivery of the final piece in order to get a project moving.

1–5. Saturday

Illustrations created for <u>Saturday</u>, a style magazine published with clothing retailer USC in support of the Teenage Cancer Trust. The work is by Han Lee, Oushka Duncan, Charlene Namukasa, Jethro Haynes, and Harry Malt.
Peter Stitson—Peter Stitson Ltd

THE VALUE OF ROUGHS

"Huge value—have to have them."
Justin Ahrens—Rule 29

"I'm quite crap at drawing, always have been, so in that respect probably not as important as the conversations that I'll have with them, along with a written brief."
Steve Price—Plan B

"Each illustrator's process is different, but I like to keep initial sketches rough at the outset. I'd rather give feedback early on than to have someone spend tons of time refining something that isn't going to work."
Joshua Berger—Plazm

"Roughs are important if the client requires approval of ideas or if you need an illustration to fit in within a specific layout."
Peter Stitson—Peter Stitson Ltd

3

4

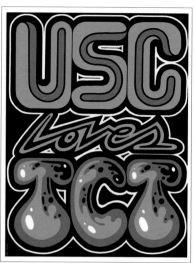

5

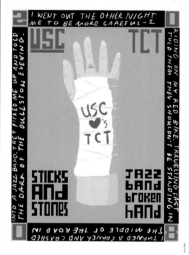

1

2

3

4

5

1–8. Graphic Design for Nondesigners

A series of illustrations by Rick Landers
of Landers Miller for use as chapter
openers in RotoVision's Graphic Design
for Nondesigners.
Tony Seddon—RotoVision

6

7

8

GREIG STEVENS
THE NEW YORK TIMES MEDIA GROUP

Profile

Greig Stevens studied at Central Saint Martins College of Art & Design in London, graduating in 1991, and has worked in publishing throughout his career. He has designed magazines for a variety of clients including BBC Worldwide and Condé Nast. Greig joined the New York Times Media Group in 2005, and is based in Paris.

Luke Herriot: Could I begin by asking you to define briefly what you think an art director is?

Greig Stevens: An art director is the creative and inspirational driving force in the creative team.

LH: Can you recall how and at what point in your career you became an art director?

GS: I think I became an art director when I was first able to bring all my design skills together and actually apply them to a project. All these skills were acquired by working with other art directors. For example, from one art director I learnt the basics of magazine design, how to art direct all kinds of photo shoots, and how to commission illustrators. Another art director led by example and taught me how to work well with my editorial teammates in a collaborative manner. Another guy insisted on speedy working practices which was a painful but necessary lesson! Eventually, I pulled all this experience together and took an overview approach on projects. That's it really—seeing the bigger picture and interpreting a brief with this in mind.

Interview

1

1. LuxeAsia magazine

LuxeAsia is a glossy quarterly advertising supplement distributed to the International Herald Tribune's Asian readership.
Greig Stevens—The New York Times Media Group

LH: **So, do you think an art director is a creative with management skills, or a manager with creative skills? Which do you think is more important, expert project management skills or creative autonomy over your team?**

GS: An art director has to be all things to all people. Good communication and management skills are needed, but solid creative skills and a thorough knowledge of print production are indispensable. I think the ability to interact freely with the creative team is the key actually.

LH: **Referring specifically to the creative aspects of the role, do you think it's OK for an art director to have a signature style?**

GS: Anyone with preconceived ideas about how a project should look is going to make life very difficult for themselves, and besides, I think change is good for personal growth and creative satisfaction. The ability to take on a new project, make mistakes, and learn from them is vital—an art director needs to approach a brief creatively and with an open mind.

That said, there are often international signature styles at work. Take a look at British and French magazine design, for example. British magazine covers are usually a mixture of edgy, busy designs with lots of cover lines. In France there is a preference for rather starkly beautiful, uncluttered covers. Looking back at my own *LuxeAsia* magazine covers, which were designed in Paris and shot with French photographers, I can see how that cultural difference has really affected my work.

LH: **Do you like to work closely with your clients and do you try to engage them in the creative process, or do you think it's better to have account handlers act as go-betweens in order to help avoid conflict?**

2–5. LuxeAsia magazine

Covers for the magazine reflect the wide variety of subjects covered in each issue.
Greig Stevens—The New York Times Media Group

"An art director has to be all things to all people. Good communication and management skills are needed, but solid creative skills and a thorough knowledge of print production are indispensable. I think the ability to interact freely with the creative team is the key actually."

GS: It really depends on the client. Generally I find that clients are keen to work with the art director and the editor of a project, if only to reassure themselves that their project is being taken seriously. It helps build confidence and respect on both sides, and I generally leave it to them to decide how much they want to be involved in the creative side of things. Having said that, involving a good account handler to manage a client's expectations can produce a powerful winning combination.

LH: **Have you any advice about how to approach the sometimes delicate issue of quoting and setting your fees?**

GS: When I was freelance I found it best to ask for the budget; this is the simplest solution. Try to tally that with your day rate and how long it will take to do the work under ordinary circumstances. If you're working as I do in magazine publishing, have a different day rate for editorial, advertorial, and straight advertising work, and be prepared to haggle if you think the client will prove loyal or you like the creative opportunities on the project.

LH: **And while we're on the subject of delicate issues, how do you deal with creative conflict, either within your team or with your clients?**

GS: Unfortunately this is part of the baggage that comes with being an art director. A friendly smile and a reasoned argument normally resolve issues. Be prepared to be flexible with the design, as really good design has to evolve. I've learnt over the years not to get too precious and to think of any creative conflict as a necessary part of the design process.

LH: **How do you go about finding the right designers to work with?**

GS: This is normally word of mouth—the editorial design industry is smaller than you might think and I pool recommendations from friends and colleagues. I like to be part of a happy, creative team and I always bear that in mind when recruiting—personalities are important. The high level of concentration needed when designing can be shattered with any kind of agitation or distraction, so highly-strung types rarely make it on to the team permanently.

1–3. LuxeProperty magazine

A sister publication of LuxeAsia that focuses on property-related topics in Asia.
Greig Stevens—The New York Times Media Group

4–7. Tides of Time

Environmentally conscious publishing project incorporating a mixture of advertising supplements, a hardback book, and an interactive DVD.
Greig Stevens—The New York Times Media Group

4

5

6

7

LH: **How prescriptive are you when art directing your design team?**

GS: I'll ask a designer to align elements, to tighten up the typography, or change the crop on an image but if the page is working visually, why drastically change it? Having confidence in your designers is important. There's normally more than one solution to a design problem anyway, and nobody likes a picky art director!

LH: **How do you go about locating the photographers you like to work with?**

GS: Like designers, photographers are strong in some areas, weak in others. It's rare to come across a photographer who can take amazing still-life images in the studio, rough it on a difficult location shoot, *and*

has the rapport to get the best out of a fashion model. I look for a good portfolio and then try to build up a good working relationship. You have to be able to trust the photographer you choose.

LH: **Do you prefer to commission for a flat fee or do day rates make more sense?**

GS: Generally I prefer day rates for photographers on assignment. For an hour or two's work I normally suggest they invoice for a half day, considering the travel and set-up time involved. Flat fees are better for fashion assignments as the photographers like to work with their preferred stylists, make-up artists, and assistants. Given the complicated nature of organizing a shoot of this kind, it's better to avoid spending hours on the phone negotiating everything individually.

1

2

26 ACCESSORIES

Light fantastic

This Christmas, the lights shine on a selection
of golden handbags, watches and shoes.

PHOTOGRAPHS: STEPHANE MARTINELLI. FASHION STYLIST: LYDIE D'BRICT BESSE

3

36 art

The fine art of collecting

Over the past decade, demand and
prices have skyrocketed for Asian art,
and in particular for contemporary
Chinese art.

Paul Serfaty

1–3. LuxeAsia magazine

Image-heavy pages like the examples
here are often designed before the
photography is finalized in order to
allow editorial work to progress while
the images are being shot or sourced.
*Greig Stevens—The New York Times
Media Group*

1

2

3

LH: **Do you have any advice on the best approach to the art direction of a photo shoot?**

GS: The secret to a good photo shoot is preparation. Sketch your layout if you can, get props lined up well in advance, and listen and learn from your photographer. He or she wants to do a good job so try to go at their pace. It may seem daft to say it, but make sure you break for lunch as tempers can get frayed in a dark and hot studio on an empty stomach.

Over the years I've art directed everything from husky dogs to food photography and fashion shoots, but fashion is by far the most difficult. My most successful shoot was in Paris with a French photographer called Marc Philbert, who is highly respected over here. Everything came together, and we were incredibly lucky with our model who was a total professional. Coupled with great make-up and styling and a decent studio, all went incredibly smoothly. That said, I had done my prep work beforehand and we did six pages and a cover shot. Not bad for a day's work.

4

34 fashion

1–4. LuxeAsia fashion shoot

One-day shoot in Paris, France.
All photography by Marc Philbert.
*Greig Stevens—The New York Times
Media Group*

This page: Fitted cotton
jacket by Yves Saint Laurent,
eyelet skirt and ankle-strap
heels by Alexander McQueen.

Model: Tina Baltzer at Idole.
Photographer: Marc Philbert at
Madé, assisted by Fred Bealet.
Stylist: Giannie Couji at
Jed Root, assisted by
Mildred Giraud.
Hair: Maxime Macé at Callisté.
Makeup: Deedee at Callisté,
assisted by Lola.
Special thanks to:
Sam O'Neill at Callisté.

1

ISSUE 06

GROWTH
CHALLENGES
FOR ASIAN ENTREPRENEURS

MARKETING INNOVATION

Beyond better products

Building on a tradition of
product improvement,
Asian companies are bringing
innovation to marketing and
customer interaction

RESEARCH
Key findings based on Asia-
specific business expertise

VIEWPOINTS
Top managers offer insight
into their success, and
lessons learned

CASE SUMMARIES
Entrepreneurs describe
how they achieved innovation
through new approaches
to marketing

INSEAD
The Business School
for the World

InnovAsia CREDIT SUISSE

An IHT Publishing Solution of the International Herald Tribune. December 2006

2

3

4

5

**1–5. Growth Challenges
for Asian Entrepreneurs**

Asian business review with
illustrations by Alastair Taylor.
*Greig Stevens—The New York
Times Media Group*

"Generally I try to find an illustrator whose style already fits
the project, and I'll always use someone who's going to do a
clear and concise job."

LH: Is the process similar for selecting illustrators?

GS: Generally I try to find an illustrator whose style already fits the project, and I'll always use someone who's going to do a clear and concise job. There are many illustrators out there but not everyone can interpret a brief in a clever and original way, so if you find any please pass their names on to me!

I tend to use agencies because I find they usually have the right kind of illustrators for me on their books. That said, often the best thing to do is flick through magazines until you find a style you like, check the illustration credit, and then track them down on the web.

LH: How important are roughs to your working method?

GS: Roughs are vital—reject the illustrator if they don't want to work in this way. You can also save time by using roughs as positionals to allow editors to get moving on a project.

LH: And how about printers. Do you have any advice on how to find the right printer?

GS: It's a straightforward process, and always comes down to their experience and the cost.

LH: Do you get heavily involved in the preparation of final artwork?

GS: It's the art director's head on the block if print goes wrong, so I always check and then double-check artwork. I'll always see chromalins or match prints and check them thoroughly for bitmapped images, rich blacks, bleed and fattening of type—all common problems that are easily overlooked. A good printer will always appreciate this level of attention to detail as it helps avoid expensive reprints and other potential delays. Basically, work with your printer, not against them.

LH: Do you ever pass work on-press, and do you have any insights into effective and nonconfrontational ways for rejecting print if it's not up to scratch?

GS: I feel that if you supply approved color proofs it's up to the printer to get it right. They'll have all the material they need to do a good job so let them do it, but you should be prepared to reject it if the printing is substandard. Printers want to avoid this of course, so the need to reject print is rare. One thing to bear in mind though: it's not always possible to replicate color proofs precisely. In magazine production, advertisements or full-bleed images are given priority on press, which means the printer has to regulate the amount of ink hitting those pages. You sometimes find that other pages on the same eight-page section are affected by this.

LH: Do you consider a high level of technical knowledge to be an important and useful tool for art directors working with the latest technology?

GS: I always try to be realistic about my limitations and the time that I can spend on a project. After all, I'm paid to be creative and to come up with elegant design solutions. I was always amazed at how technically inept art directors seemed to be when I first became a designer. However, I'm now experiencing the same thing again, but from a multimedia perspective. Trying to keep up technically is difficult, particularly because I find I need to apply acquired knowledge to an actual project before I can see its value. Every day I learn something new, but ultimately there really is no substitute for plain old-fashioned print design skills.

6–7. Wind is Power

Advertising supplement centered on the subject of renewable energy. Illustrations by John Batten.
Greig Stevens—The New York Times Media Group

Specifying Print

PRODUCTION AND PRINT PROCESSES

I'd like to begin this section by debunking a view which I've heard expressed on one or two occasions in the past—production and print issues are no longer something that your printer exclusively "deals with." Admittedly, it wasn't so long ago that the production process was dealt with solely by repro and print professionals with access to specialist equipment large enough to fill an entire room. Art directors and designers would send out artwork consisting of pasted up text and trace guides for the sizing and placement of images with no certainty whatsoever of what to expect from the color proofs. Of course, advances in digital technology mean that nowadays a large portion of all prepress reprographic work is taken care of by the designer, which means art directors are required to make informed decisions throughout the design process based on their knowledge of production processes. With this in mind, if a project is conceived correctly and prepared well by the art director and their creative team, there shouldn't be any issues for the printer to deal with beyond scheduling press time, maintaining quality control, and organizing the delivery of the finished material.

Putting this into perspective, it's not necessary for you to know literally how to run a lithography press or large-format digital printer, but the more you know, the easier it'll be for you to talk to and understand your printers when commissioning print. How much you choose to learn depends entirely on your own circumstances as either an art director in a large organization, a small independent studio, or as a freelancer working alone. The fewer people you have in support, the more likely it is that it'll be you talking directly to the printer. In my opinion, it's essential to acquire as much print and production knowledge as you possibly can in order to get the best out of printers for both your clients and yourself.

The choice of which process to go with is linked closely to the material you must print onto and the size of the print run, and there are a number of viable processes to choose from. The three main categories still in regular use are lithography, flexography, and rotogravure. Letterpress is still used widely too, although it's admittedly now considered to be more of an artisanal process available through specialist printers.

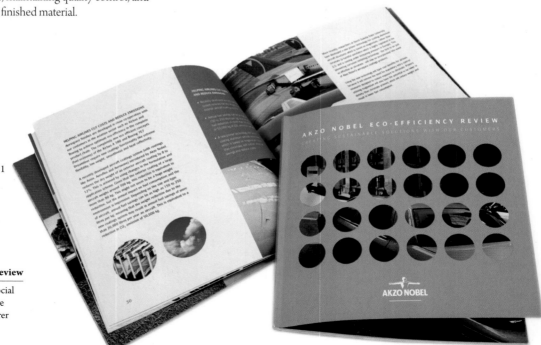

1

1. AkzoNobel Eco-Efficiency Review

Internal report about corporate social responsibility for Dutch decorative coatings and chemical manufacturer AkzoNobel.
Maestro

2

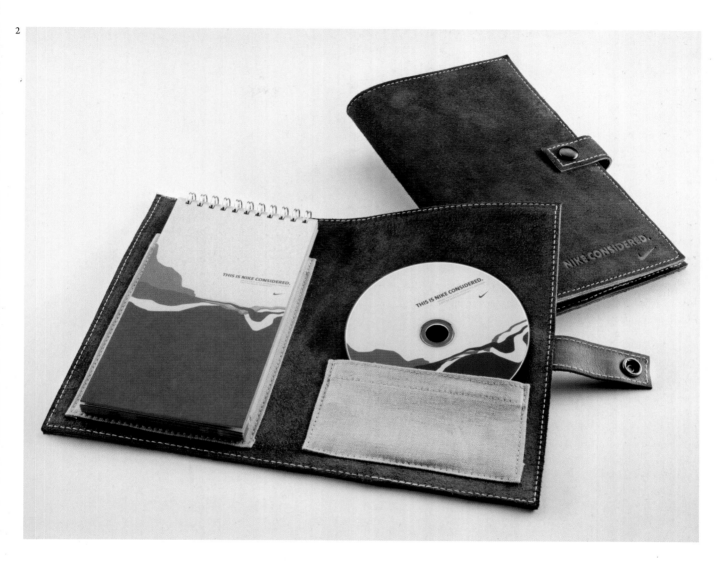

Advances in digital technology mean that nowadays a large portion of all prepress reprographic work is taken care of by the designer, which means art directors are required to make informed decisions throughout the design process based on their knowledge of production processes.

2. Nike Considered

Media kit for Nike's line of environmentally conscious footwear. The billfold is made from the same vegeta leather as the shoes themselves, and the logo is blind stamped without the use of inks or foils.
Joshua Berger and Pete McCracken—Plazm

Offset lithography

Most print professionals refer to offset lithography simply as "offset." It's arguably the most widely used process as it's particularly suited to the large-volume printing of magazines and newspapers, books, catalogs, and brochures, and can be web- or sheet-fed. Web-fed means the paper is fed from a continuous reel, making it considerably faster than sheet-fed. It's also cost-effective for large print runs as the life of the printing plates is prolonged because there is no direct contact between the plates and the printing surface. Modern offset presses can handle at least six colors (cyan, magenta, yellow, and black, plus two additional spot colors or special ink finishes) and are able to print on a variety of flat surfaces other than paper.

Flexography

Often shortened to "flexo," this process uses a flexible relief plate and is basically a contemporary version of letterpress. Flexo is relatively inexpensive compared with other processes as the low viscosity water-based inks dry faster than the oil-based inks used for offset printing, meaning faster production times and therefore lower costs, plus plates are cheap to make. It's widely used by the packaging industry as it's capable of printing on a broad range of materials including paper, cellophane, plastics, and metal foils, and is increasingly a favored option for printing newspapers.

Rotogravure

Often referred to simply as "gravure," this is an *intaglio* process, meaning the image is recessed into a copper-coated plate or cylinder rather than being flat or raised. Liquid ink fills the recessed cells and a doctor blade cleans the excess ink from the plate's surface before the paper is pressed onto the cylinder by another rubber-coated cylinder to create the impression. Gravure is also a good choice for printing on the various materials used in packaging applications, and other processes such as die-cutting, embossing, and foil stamping can be included in-line without switching to a different machine.

Screen printing

Screen printing is arguably the most versatile of all the print processes because you can print on pretty much any surface. Stencils can be hand-cut or produced photographically for much finer details, and the process is particularly well suited for use in the clothing industry. Plastic and metal signage, CDs and DVDs, and even electronic circuits can be printed using this method.

1–5. CH Invest

Stationery range for French firm Cabinet Claoue-Heylliard. *David Sampedro and Ximena Xiveros—Iceberg*

5

Digital printing

Historically the quality of digital printing hasn't been comparable to traditional offset, but the technology is getting better and better and I'm sure will rival offset before too long. Digital printing is great for short print runs as no platemaking is involved so startup costs are low, although it's important to note that costs per sheet are higher because inks are currently more expensive. The advancements within the print-on-demand book publishing industry are driven entirely by the ability to reduce a print run to as little as a single copy.

If you would like to find out more about these print processes I recommend *The All New Print Production Handbook* (David Bann, RotoVision), which includes detailed explanations of all the above processes.

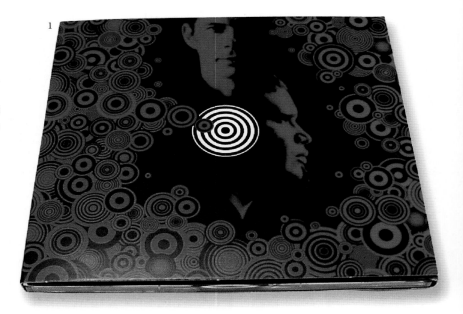

1

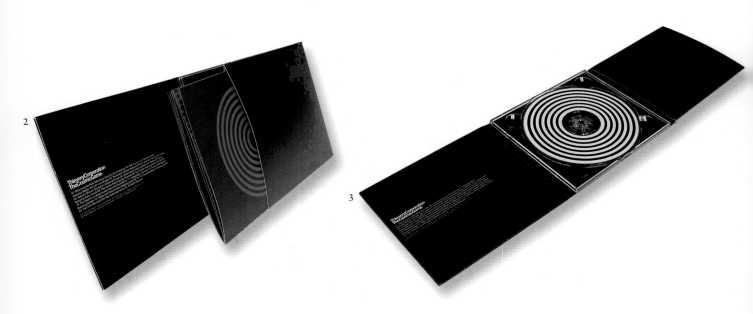

2

3

4

5

1–6. The Cosmic Game

CD packaging and poster for
the Thievery Corporation.
Neal Ashby—Ashby Design

6

TIP

Get the printer involved in the project as early as you can and include them in the creative process too. If you want to achieve a particular look or use a specific finish, ask the printer how that can be achieved and make sure it'll work well. There may be an alternative, possibly a more cost-effective option, that will work better on the stock you've chosen. Your printer is in the right place to supply you with that information.

The choice of stock isn't just a pragmatic decision based on cost and availability as both the durability and tactile qualities of paper stock will greatly influence the value and tone of a project.

1

CHOOSING AND SPECIFYING PAPER

Choosing which paper stock to use for a project is one of the most crucial decisions an art director must make, and some thought should be given to that choice at the earliest possible stage of a project. Ideally, print specifications should work in support of an idea rather than prescribe its limitations, so the final choice need not be set in stone as a developing idea may dictate a change to the original specification. On a practical note, different paper and board stocks will of course vary in price by a considerable margin depending on their finish and quality, and budgets can be blown wide open without due care in this area. Availability of stock is another important consideration, specialist paper stocks may need to be preordered from the manufacturer. If the end product has to be sent through the mail, your client will appreciate you sourcing stock that keeps weight to a minimum without compromising on the quality, thus reducing their distribution costs.

The choice of stock isn't just a pragmatic decision based on cost and availability as both the durability and tactile qualities of paper stock will greatly influence the value and tone of a project. Therefore, the choice of stock should be seen as part of the creative process. Paul Reardon from agency Peter and Paul elaborates on this, saying, "When we specify print, it is always to drive the idea, not to dictate it. It's an important part of a project for us and we spend a lot of time looking at different printing methods, substrates, and stocks as the right choices can massively enhance a piece of print. While we may work on formats early on, final print specification and finishes come later in the design development stages."

Most art directors build up collections of swatch books, often provided free on request from paper manufacturers and distributors, in order to compare and contrast the particular qualities of a range of suitable stocks. Remember to check that the paper you want to use is available to your chosen printer with regard to their location, given that a lot of bulk printing is now sourced from the Far East and India for reasons of cost.

1–12. Mohawk Via

A series of products designed to promote Mohawk Fine Papers' Via line.
AdamsMorioka

2

3

4

5

The properties of paper

It's probable that paper costs will represent the largest portion of the spend on a print project, so a bad choice of stock is likely to be an expensive mistake. Therefore, listen to your printer's advice and use their expertise to influence your choice. If you've chosen your supplier well they'll be able to advise on availability as well as suitability, and will also be able to tell you if any special finishes you have in mind will work on the specified stock.

To a certain extent, the choice of printing process will point you in the right direction. For example, paper for use on offset lithography machines should ideally have a low moisture content to help with the drying process, and good dimensional stability is important if lateral distortion during print runs is to be avoided. As offset can print on a wide variety of different surfaces the finish of the stock isn't much of an issue. On the other hand, gravure is best matched to paper stock with a very smooth surface with no small abrasions, so go for a gloss- or matte-coated stock. The level of absorbency must also be enough to draw the ink out of the small recessed cells on the imaging cylinder. If in doubt, simply ask your printer to provide a sample, ideally a printed sample that they've produced, and judge for yourself whether or not the stock is right for the job.

7

8

9

6

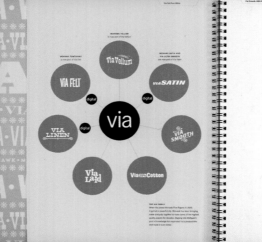

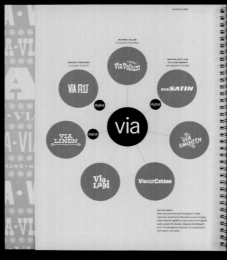

Freedom of Choice

Choice is the single major factor in creating successful printed pieces. Just like software, where the ability to navigate quickly and seamlessly is paramount, being able to choose among alternatives in paper is critical. That said, too many choices can be overwhelming. While Via has a paper to meet your every need, it stops short of redundancy. Via is comprised of seven finishes and each has a palette of compatible colors. Fans of Mohawk papers are probably familiar with Mohawk's Vellum, Satin, and Tomohawk. These finishes have been added to the Via family to create a simple and comprehensive system.

Every day is Via Day

The wide range of options provides the versatility to meet your project's needs. Via is easy to use, easy to get, and easy on the budget. Whether your project involves four color process, duotones, line art, or black and white images, Via has you covered. Our papers print beautifully, are easy to specify, and have incredible colors and textures. Mohawk Via's stable of papers is diverse but they're true workhorses.

Quality Control

Mohawk has always been linked with quality and value. Mohawk standards of excellence lead the industry in color, quality, formation, texture, opacity, smoothness, and printability.

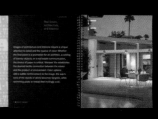

ENVIRONMENTAL CONCERNS

The environment is probably the biggest global controversy facing us today. Fortunately, the design industry is aware of what is at stake and is contributing much toward the clean up of our out-of-step working practices through responsible print specification.

"We do consider environmental issues in print as there's become more of a demand over recent years for clients, particularly when they're consumer facing, to show a level of corporate responsibility with carbon issues." says Paul Reardon of Peter and Paul. "Most ask for 100 percent recycled stock because that appears to show the clearest intent to go green. While that's the obvious choice, in practice it's far more environmentally friendly to use stocks that are sourced from sustainable forests, and where the manufacture and transportation is carbon offset. The only problem is communicating this into the mainstream public consciousness."

Joshua Berger of Plazm adds to this, saying, "I place a very high level of importance on this issue—on social and ethical issues in general. As artists trained in methods of mass communication, art directors and designers are uniquely positioned to effect positive change in our society. Beyond simple things like specifying recycled materials, creative professionals in partnership with corporations can work toward reducing packaging, simplifying steps to market, participating in and initiating discussions about social responsibility, and connecting corporations with community nonprofits. It's not just that we are capable of making a difference; we also have a real responsibility to do our best."

Steve Price of Plan-B Studio underlines this approach, saying, "I've introduced my own environmental policy and no longer print my own stationery. I rarely print anything out unless I have to, and I take it upon myself to make the best possible environmental recommendations to my clients. Printing on stocks that are recycled or made from consumer waste is no longer an expensive luxury. In fact it's very competitively priced. I only work with printers that are recognized by the Forest Stewardship Council (FSC), and that use chemical-free inks, such as soy or vegetable inks. Small things, but important to instill change on a larger scale."

1

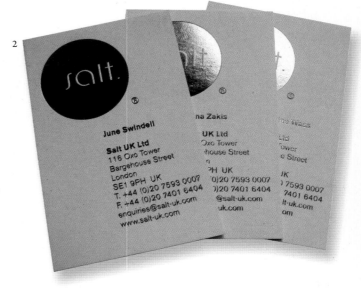

2

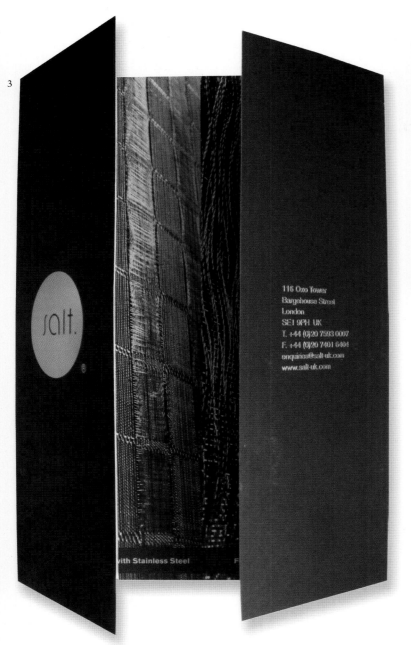

3

116 Oxo Tower
Bargehouse Street
London
SE1 9PH UK
T. +44 (0)20 7593 0007
F. +44 (0)20 7401 6404
enquiries@salt-uk.com
www.salt-uk.com

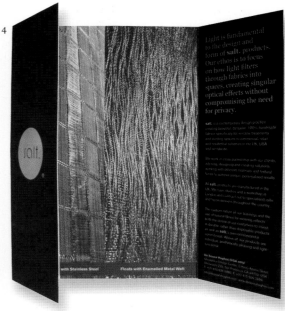

4

"I only work with printers that are
recognized by the Forest Stewardship
Council (FSC), and that use chemical-
free inks, such as soy or vegetable inks.
Small things, but important to instill
change on a larger scale."

Steve Price—Plan-B Studio

1–4. Salt

Stationery and mailouts to
promote textile design company
Salt's 2008 collection.
Plan-B Studio

JOHN FOSTER

Profile

John Foster is the brains behind Washington, DC–based design firm Bad People Good Things, which he admits is a strange name but necessary all the same. Bad People Good Things was born out of the realization that the equation of "success = clients that are true partners + final products one can take pride in" had gone slightly askew, so he decided to change the scenery. Therefore "Bad People" are no longer needed, and "Good Things" are produced on a daily basis. In addition to his work as an art director and designer, John is an author and speaker on design issues. His work has been published in numerous books and every major industry magazine, and is included as part of the permanent collection at the Cooper-Hewitt National Design Museum. His books as an author include *Dirty Fingernails: A One-of-a-Kind Collection of Graphics Uniquely Designed by Hand* from Rockport and a monograph on Jeff Kleinsmith for Sub Pop Records.

Interview

Tony Seddon: The first question is the toughest to answer. What do you think an art director is, and can you recall the point at which you became one?

John Foster: The definition is a tough one, but I became an art director very early in my career. It was mainly just a title to give me the proper respect in dealing with internal clients as I ran an in-house design department. I didn't become a "true" art director until I left to work at a design firm where I very clearly gave direction on creative issues, finance, client relations, and overall strategy to a team working with me but dependent on my approval for every aspect of the project. This was seven or eight years into my tenure in the biz.

TS: That ties in with becoming a manager of things other than creativity and design. Do you think an art director is a creative with management skills or a manager with creative skills?

JF: I think an art director can be either, but the key is to build a team around you that complements and expands your skills. I had a long run with a firm that proved very successful as the owner began to only hire people exactly like himself with one notable distinction—me—who was the polar opposite. In the end the job is truly about being a manager of every aspect, so that's the core skill needed.

TS: Judging by that answer I'm guessing that you don't think an art director should have a signature style?

JF: I believe that for a designer to be successful in every visual way, a signature style cannot be apparent unless they only have one client (and that brings up its own set of questions). Every client has different needs

1

THE WORK OF JOHN FOSTER

A COLLECTION OF GRAPHIC DESIGN AND WHO DUMPS WHAT FROM THE MAN BEHIND BAD PEOPLE GOOD THINGS AT THE SAWHILL GALLERY ON THE CAMPUS OF JAMES MADISON UNIVERSITY

08.24 THROUGH 09.18 WITH A FANCY TALK ON 09.14

l see you

1. I See You

Promotional poster for an exhibition
and talk on the work of John Foster.
John Foster—Bad People Good Things

so every solution has to offer an appropriate alternative. Now, I do think an art director needs a signature philosophy about problem-solving and clients should be able to see their intellectual approach consistently throughout a portfolio.

TS: **When you kick a project off, do you prioritize style, budget, schedule, staffing, or a combination of all four?**

JF: Well, you have to throw them all into the pot and see what rises to the top. I quickly make out what the top three items controlling the parameters of each job are and then move to make them strengths as opposed to barriers. Every job has a different top three. If budget or schedule are going to heavily restrict some production considerations, that can't be ignored and needs to be addressed immediately so you turn it into a positive aspect. A properly run firm should never have staffing as a consideration. You simply can't take work on that you can't perform. Easy to say of course …

TS: **And what about prioritizing research and development before the commencement of a project?**

JF: That *is* the commencement of a project. It starts as soon as I start thinking about it. I consider research an enormous part of any job and it is the part of scheduling that I have fought for most often.

TS: **Which of your recent projects illustrate your responses to the last two questions?**

JF: An easy example is a project for a chocolatier. We exchanged emails and had a long telephone conversation to be sure we were a good fit and I made sure we were both very honest during those early discussions as to expectations and working styles.

A lot of research on the company and its competition took place, and I quickly followed that with a visit to their shop to really see how they worked. It was done in an informal manner, which suited their style, and it proved my philosophy that I never pretend to know more about my client's business than they do. I then took what I'd learned and boiled it down to just a few major points in a creative brief, which I gave to the client to confirm that we were all working from the same page. This simple document was used to keep the project on course as we moved forward. Only then did I start the actual design process.

TS: Do you think it's useful to have account handlers act as go-betweens with your clients?

JF: I don't believe in account people. A one-to-one relationship with a decision-maker on the client side provides the only possibility for truly successful creative work.

TS: So you try to engage your clients in the creative process?

JF: If you have good clients they're often pretty smart folks who have a lot to add. The key is to educate them on when they can be a part of the discussion (usually on the front end) and when to stop (usually just past the first presentation). The client needs to feel like they're a part of the process or they won't really be happy, and if the client isn't happy you can kid yourself about how amazing the design is but you really haven't done your job. Now, good clients also respect the expertise you bring to the table and should know that their place is in forming the creative brief that will serve as the checklist for the project and then knowing not to get caught up in subjective matter if the presented options are meeting the stated goals.

TS: Setting your fees can sometimes be a delicate matter. How do you approach that side of things?

JF: I'm too old to be delicate at this point. Haggling over money is the quickest way to sour you on working with a client, so I just ask what the budget is upfront and then decide my comfort level with that and move on. If they don't have a budget, I give a price and move on.

TS: Do you think there are good and bad ways of presenting work, or does it always vary between different types of client?

JF: The worst thing that you can do is present work you're not comfortable with. I stopped doing that a few years in as they *always* pick the solution you know is the least successful. Now the rub is that you have to work incredibly hard to get a variety of viable options but that's how you do real work. No compromising.

TS: Moving from clients to colleagues, do you ever set time aside to mentor or inspire your creative team?

JF: If I have ever had a major weakness as a manager, I imagine it's that I simply don't mentor. I know I'm terrible at this aspect as I fully expect everyone to do the work assigned right off the bat. That's not to say that I don't adjust for experience level and speed, but I certainly don't coddle or feed ideas either, which is why I don't hire people right out of school. However, I do believe in making time daily to connect with team members, to know their moods, and so on. When the team at my previous firm stopped going to lunch together when new members joined, I felt it showed up in the collaborative work immediately and never came back.

1

2

3

4

5

6

1–6. Logotypes for …

(1) Americans for the Arts convention based around the theme ARTpreneur. (2) U.S. rock band The Caribbean. (3) Artisan Confections chocolatier. (4) HOW Design Conference presentation. (5) Smith Fellows, a research program of The Nature Conservancy. (6) Honorary dinner staged by the U.S. Conference of Mayors for jazz dignitaries.
John Foster—Bad People Good Things

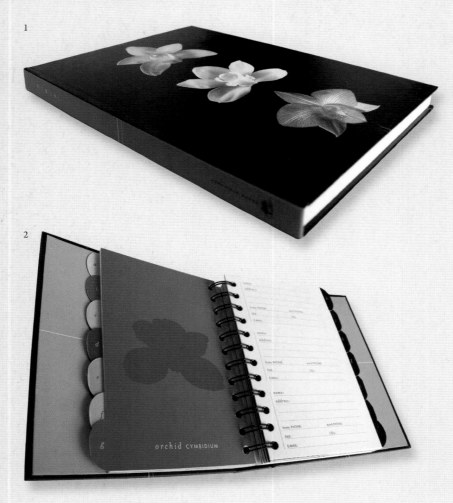

1

2

1–2. Orchids Journal

Journal and address book designed for
Chronicle Books with photography
by Eric Hansen.
John Foster—Bad People Good Things

"I believe in hiring talented people and letting
them do what they do best. I try to master the
art of getting out of the way and seeing them
do what I paid them to do..."

TS: Have you worked with a large team on a project recently?

JF: Yes, a spring catalog for a fashion client whose previous catalogs had been far too stiff. I worked with the owner and our day-to-day contact, their marketing director, to press upon them a chance to show their true personality. I knew the client could do the copywriting based on other work I had seen as long as she was kept on track. This would also serve to keep her totally invested in our direction. I then made sure to secure, and then sell to the client, the right photographer for the job. The last piece was picking a model that we all loved and luckily she walked in late in the review and wowed all of us. I believe in hiring talented people and letting them do what they do best. I try to master the art of getting out of the way and seeing them do what I paid them to do, so on the shoots a lot of my job was keeping things on schedule and adding little touches, but mostly setting up an environment for my photographer and model to really shine. When it came to bringing things together, I managed the photo selection process with a firm but understanding hand, brought in someone to do the handwritten pieces of type, managed the print process (crucial), and coordinated the final delivery. Start to finish—it's the only way.

TS: When you choose a photographer, what influences that choice? Is it their style, their location, maybe their facilities?

JF: It depends on the project and its needs. Some shots can be this meticulously staged piece where lighting and poise and control are vital, others require someone who can see the soul of a person or location and needs to be more inventive or spontaneous. The key is to know your client and project inside and out as well as your photographers. After all that, I only work with people I like and respect and who are professional in their dealings. That needs to be a given.

3

4

3. Melvins

Promotional poster for a gig by
US band Melvins.
John Foster—Bad People Good Things

4. For Sale

For Sale, published by HOW Books,
written and designed by Foster,
showcases packaging designs from
50 top firms.
John Foster—Bad People Good Things

TS: **And do you like to set costs with a day rate or a flat fee?**

JF: A flat fee is always easier but it's nice to know the day rate too so we'll know what additional time will cost.

TS: **How about illustrators? Do you ever deal with agencies?**

JF: The choice is all about style and professionalism. I will use agents if needed for pricing but I need to talk directly with the illustrator.

TS: **And do you ever attempt to influence the content of commissioned illustration, or do you rely on the illustrator for concepts?**

JF: I'm always careful to allow enough space for the illustrator to contribute as much as is possible. Each project varies but generally I give as much information as I have and share the brief with them (that little piece of paper again!) and let them return with some sketches. Again, hire good people and let them do what they do best.

TS: **So roughs are obviously important?**

JF: Critical because you need them for client buy-in and for confirming composition.

1. The Sisterhood of Convoluted Thinkers

CD packaging and card inlay.
John Foster—Bad People Good Things

2. City Livability Awards

Brochure for the US Conference of Mayors and Waste Management, with illustrations by Noah Woods.
John Foster—Bad People Good Things

1

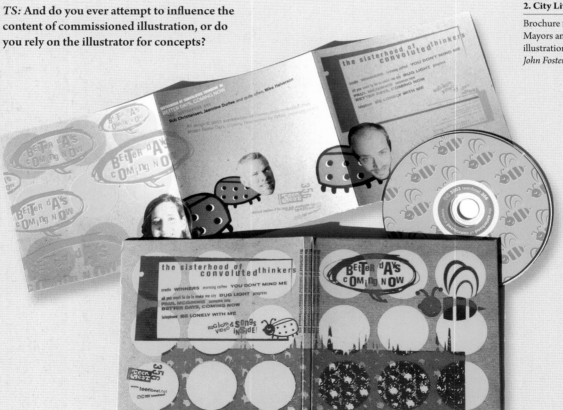

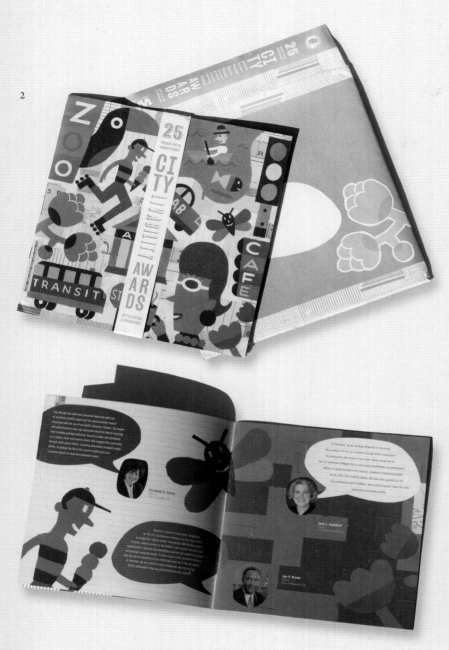

2

TS: You illustrate quite a bit yourself, so you must feel pretty close to any projects which involve illustration?

JF: I've run a project for 14 years where I hire a different illustrator each year for what is essentially the same problem. The final result depends on their skills and they've never let me down. It's also a blast for me as an illustrator, but I know my limitations, so it allows me to hire people that think and create imagery in ways that I never would. It's essential to hire people that don't do what you do—but rather complement your talents. It's a project I look forward to every year and has seen a lot of attention so now illustrators are very excited to be asked to work on it, but it's because of them that the scenario even exists.

TS: Moving to print, do you consider print specification to be an integral part of the creative process?

JF: In a word, yes. You can enhance a project by, say, 20 percent through the print specifications, but getting this part wrong can destroy 100 percent of the effectiveness of a piece. It's a vital ingredient and needs to be considered as early as possible in the process. I'm always careful not to use production tricks as a crutch or the sole solution but often they can be the deciding factor between a nice piece and a jaw-dropping one.

TS: What criteria do you use for selecting a printer?

JF: Knowing their strengths and weaknesses, and their equipment. Some jobs are placed on cost, some on quality regardless of cost, and some on schedule (too often for my liking). These days may be past, but when I was in charge of a large amount of print buying I was careful to keep feeding work to the suppliers I needed the most to keep the relationships warm.

TS: **You obviously feel that relationships with suppliers should be rigorously maintained.**

JF: Yes, it's incredibly important! It's a real partnership and the key is working with people who will do the right thing when it all breaks loose—and it always will! It's also essential to remember that the quickest way to get fired on a job is for it to not show up on time and you depend on the printer for this. It's rarely the design that causes the most chest pains—but rather the logistics of getting the final piece to arrive!

TS: **Do you have any insights into effective ways for rejecting print if it is not up to scratch?**

JF: Again, too old for all that nonsense—pick good vendors and they'll do good work. Having said that, printers are skilled people and I figured out how to maximize that. I know just enough about printing to be dangerous but not enough to tell them how to do their jobs. Explaining that you are hoping to "warm up" an image or add "intensity" or "contrast" in an area rather than barking "pump it up three points of yellow" will do wonders. So many times the pressman has pulled back on a color where I would have pushed the obvious, and achieved exactly what I wanted without throwing everything else out of whack as I would have done.

TS: **Print technology aside, do you keep up with other technologies associated with the industry?**

JF: Here is my entire take on the technology aspect—it is strictly a tool. I can't teach you creative problem-solving, but you can always pick up software skills.

1

2

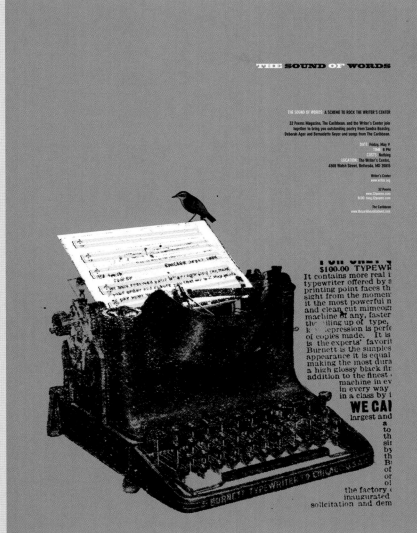

3

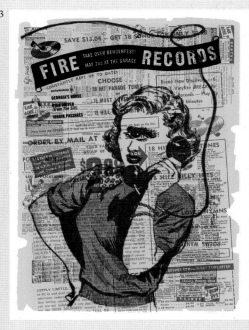

1. Sad Crocodile

Poster promoting a Sad Crocodile gig, that being John's musical alter ego.
John Foster—Bad People Good Things

2. The Sound of Words

Poster promoting a poetry event at the Writer's Center in Bethesda, Maryland, USA.
John Foster—Bad People Good Things

3. Fire Records

Poster promoting a Fire Records showcase at the Bergenfest, a music festival staged annually in various venues around Bergen, Norway.
John Foster—Bad People Good Things

Working with Printers

SELECTING A PRINTER

Deciding who you should place your high-quality, large-volume print work with shouldn't simply be a case of looking in the telephone directory for printers in your area. Nevertheless, for simple projects it's feasible to do just that as there may be a truly excellent printer only two blocks away. Don't limit yourself however—cast a wide net and look for suppliers who can meet the top three criteria for buying print: the quality of their work, the cost of their service, and the ability to work to your schedule. Unsurprisingly, most art directors I know have a couple of favored printers that they like to work with. One is likely to be a larger outfit capable of high-quality, large-volume print runs for their corporate clients. The other will be a smaller setup, probably equipped with a mixture of quality digital and small sheet-fed presses capable of economical, short print runs. The latter is more likely to be in your neighborhood, enabling you to drop round at short notice with that last minute job on a tight schedule.

1–6. Iceberg greetings card

An agency greetings card printed on Curious Skin stock from Arjowiggins. *David Sampedro and Ximena Xiveros—Iceberg*

Some printers may not have the facilities to take care of every aspect of a print job, so find out if any finishing (such as die-cuts or binding) has to be farmed out to a third party as this may add to the schedule and costs. This needn't be a deal breaker of course, but it's worth trying to locate suppliers that can take care of everything under one roof for the sake of efficiency. Most important of all, find a printer you can talk to—someone that can work with you on timings and be flexible about costs, and can advise you on the best materials and processes without bias. A trusted

print supplier is one of the best assets an art director can have, so when you find one, make sure you maintain a good working relationship with them as it'll pay dividends for you, for your business, and for the business of your clients.

6

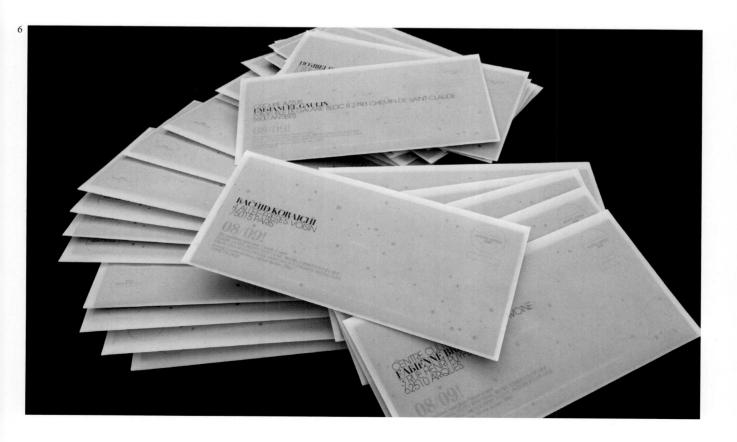

Negotiating prices

If you prefer to work with the same trusted suppliers on a regular basis, it's a fair assumption that their average prices have played a large part in your decision to continue to bring them in on projects. Providing a printer with regular work will nearly always help you to negotiate favorable and consistent prices, and sticking with the same suppliers means it's easier to spot if and when print costs start to quietly increase over time.

I mentioned in section two that it's perfectly acceptable (and expected) for you to engage in a little negotiation when commissioning any kind of work, but remember once again to be realistic about paying appropriately for the printing you're commissioning. Budgetary cuts from one project to the next will not help you to maintain that working relationship, and the cheapest quote isn't necessarily going to produce the best quality. If you're in any doubt about the competitiveness of your chosen supplier's prices, obtain an additional quote or two to confirm your position in what is essentially a buyer's market.

PRINTER RELATIONSHIPS

"We work with a print broker for specialist print jobs. He provides real attention to detail and will flag problems up as the project proceeds. We also deal with a local printer that can turn jobs around quickly and for competitive prices, which is essential for clients who demand that work is turned around quickly. Our relationships with these two people are essential to the smooth running of Crush. I consider them to be part of the full-time team."

Carl Rush—Crush

"Printing has become such a commodity that people have forgotten the art in it. Presses running 24 hours a day don't suggest quality to me. I'd only seek a relationship with printers if they really cared about what they were doing."

Mark Stevens—M-A-R-C

1–2. Iceberg identity

Agency stationery printed with fluorescent Pantone colors on Curious Skin stock from Arjowiggins.
David Sampedro and Ximena Xiveros—Iceberg

1

2

3

WENST U EEN GELUKKIG
AITE UNE TRÈS BONNE ANN
PY NEW YEAR - UGC LE DES
GC VI AUGURA UN FELICE NA
O NUOVO - UGC WENST U EE
C VOUS SOUHAITE UNE TRÈS
S YOU A HAPPY NEW YEAR - U
NUEVO - UGC VI AUGURA UN
RO ANNO NUOVO - UGC WE
AR - UGC VOUS SOUHAITE
WISHES YOU A HAPPY NE

3–5. UGC greetings card

Greetings card commissioned by
movie theater group UGC, and printed
using a silk-screen process.
*David Sampedro and Ximena
Xiveros—Iceberg*

4

5

PREPARING WORK FOR PRINT

Arguably it's not part of an art director's role to prepare images and layouts for print, but in reality this depends entirely on your circumstances. Large design studios are likely to have specialist art-workers on the staff who take care of all prepress and PDF work. However, if you're the art director of a small company with only a few creative staff, or you are operating as a one-man band, you should ensure you have the knowledge to enable you to prepare files for repro and print if necessary, and to allow you to recognize when material is prepared incorrectly. Whatever the scenario, it's the responsibility of the art director to ensure that quality is never compromised, and if you don't have the knowledge yourself it's not possible for you to brief others sufficiently well.

Before we get into any details, I can't help but mention the odd practice that I've occasionally come across when commissioning work from freelance designers, whereby they submit first layouts which are all over the place in terms of accuracy and consistency and the files are constructed in a particularly random way without any consideration for the use of style sheets or layers. When quizzed about the logic of their methods, their answer is usually something along the lines of, "Oh, I'll tidy it all up at the end." This is a terrible way to work and there's no reason I can think of for not setting files up correctly from the outset of a layout process, particularly as it takes time and therefore costs money to fix them for repro. Therefore, I think it's extremely important to emphasize when a job is briefed that you consider the quality of the files to be the responsibility of the designer, and that badly set up files will be returned or rejected. It helps to produce a set of basic guidelines outlining your minimum requirements which can be handed to designers you haven't worked with before as part of their brief.

Preflight procedures

A good repro company or printer will always check original files and PDFs before pressing ahead with color proofs and print, and will get back to you with regard to any problems they've come across, such as low-resolution images or missing fonts. However, now that a great deal of artwork is supplied in the PDF format rather than an InDesign or QuarkXPress layout with collected images and fonts, there's a limit on what can be fixed without access to the original files. Electronic delivery via an FTP server or one of the very useful online delivery services such as MailBigFile or YouSendIt means that the printer often doesn't even get a marked laser with notes, making it more difficult for them to know if the proofs they are producing are correct. This means it's more important than ever to make sure the files are right when they're sent out.

At the most basic level, a preflight procedure only involves checking that none of the images or text are missing. I don't regard this as part of a genuine preflight procedure as to me it's more a part of a well-organized layout procedure prior to any prepress checks being carried out. Therefore, encourage everyone involved in the layout process to ensure that images are always properly linked to the file, and that all fonts are loading correctly. That way, there'll be no surprises on the last day of the schedule as a result of missing material that takes hours to track down.

Large design studios are likely to have specialist art-workers on the staff who take care of all prepress and PDF work. However, if you're the art director of a small company with only a few creative staff, or you are operating as a one-man band, you should ensure you have the knowledge to enable you to prepare files for repro and print if necessary, and to allow you to recognize when material is prepared incorrectly.

1. Marie de Paris

300gsm matte coated paper stock was specified for the cover of this folder to guarantee the success of the embossed typography. *David Sampedro and Ximena Xiveros—Iceberg*

1

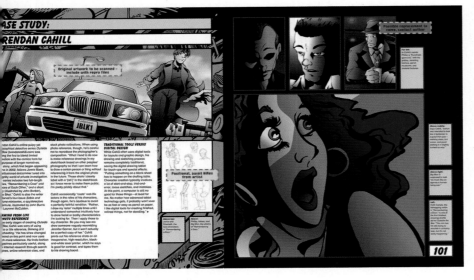

1 2

File formats and settings

If you're working with a new repro or print supplier, ask upfront for any guidelines they can give you about their preferred format for delivery of the files. They may prefer to receive original files as well as PDFs, or may have their own set of custom color profiles matched to their presses which you can embed to ensure color consistency.

Imported images

If any additional pre-press work on original files has been booked with the repro house, such as cutouts or color correction and retouching, make sure each image is flagged up on the file. I do this using a "notes" layer which can be switched off or set for nonprinting, using distinctive yellow boxes like virtual Post-it notes. Other image checks should ensure that:
• file names are not duplicated;
• images are all used at a suitable resolution and not significantly enlarged or reduced in the layout;
• all images are supplied in CMYK, unless a mixed RGB/CMYK workflow has been implemented;
• there are no images containing spot color channels that will appear as a separate separation from the CMYK standard; and
• there are no images placed on hidden layers.

Specialist preflight software

There are several software packages available that take preflight procedures to a higher level than the built-in features of InDesign, QuarkXPress, and Acrobat, the best known being FlightCheck Professional (www.markzware.com) for both original files and PDFs, and Pitstop Professional (www.enfocus.com) which is specifically for a PDF preflight workflow and can also edit PDFs. They're great products with a huge array of

features that mean your preflight workflow will be completely watertight. The built-in preflight features of your layout software may be sufficient enough for your needs, particularly if you're not sending multiple files to repro every day, so think carefully before spending your cash on additional software of any kind.

Exporting PDF files

As I mentioned above, it's now common practice to supply artwork directly as a PDF. This has produced an additional level of responsibility for the art director, where he or she must ensure that PDFs are created to the correct standards required by the repro house or printer. I can say with conviction and from experience that, as long as files are set up correctly in the first place, making PDFs is no harder than outputting files on an ink-jet or laser printer. If you've maintained a well-managed layout procedure and are confident that none of your images need any extra work prior to repro, there's no reason at all why you shouldn't be able to implement a full PDF workflow.

Using presets

I'm an InDesign user myself, but QuarkXPress is able to use a set of PDF presets that follow the same standards as the Adobe products. Skip the "Smallest File Size" and "High Quality Print" settings for repro work, and go straight to the "Press Quality" option as your first choice of built-in preset. It's a good option for any prepress workflow that will be output as high-resolution color separations or to a digital press. The PDF produced with this preset features "editable transparency," which means that the printer can "flatten" the files using their own specifications. Flattening happens when the transparent regions of a PDF file are rendered out as final separations.

1. File annotation

Post-it-style notes can be added on a separate layer to alert printers to any repro requirements such as cutouts or to low-resolution positionals.

2. InDesign preflight

Preflight functionality within InDesign is comprehensive, but not as extensive as that of specialist applications.

3–4. FlightCheck Professional

Specialist applications can preflight all kinds of files, including PDFs, and offer a much greater range of options for checking every aspect of your file setup. It's important for art directors to take responsibility for file quality, even if they are not directly involved in the checking of those files.

1–5. PDF presets

Typical custom presets used by RotoVision for the generation of all repro-quality PDF files. Note the settings in step 4 which convert all images to CMYK with an embedded color profile.

6. PDF preflight

A broad range of built-in options allow you to preflight, analyze, and fix PDF files within Acrobat prior to dispatch to your printer.

What is PDF/X?

PDF/X isn't an alternative format, it's a subset of the Adobe PDF specification. It was designed to help eliminate common problems—such as missing images or fonts—that occur when PDF files are created, and to minimize unexpected color repro results through its support for a color-managed workflow. Using the PDF/X standard ensures that your files will be output as you intended. Some repro houses or printers may insist that they flatten the files themselves, as I mentioned above. If this is the case simply use the Press Quality preset.

The PDF/X-1a:2001 preset is designed for high-resolution output. All fonts are embedded, color is either CMYK or spot depending on how the colors were specified in the original file, and all page boundaries and trapping are defined in the resultant PDF file. The PDF/X-3:2002 and PDF/X-4:2008 presets are similar in most respects to PDF/X-1a, but they support a color-managed workflow and allow a profile to be specified for the output intent. Both RGB and LAB colors can also be included, which makes a mixed RGB/CMYK workflow possible. I prefer these options and use PDF/X-4:2008 for all my reprographic requirements. I use a version of the standard preset which is customized slightly to use the color profile of my choice, illustrated by the screen shots shown to the left. It means we don't need to convert all our images to CMYK as part of our layout process as everything is accurately converted to CMYK when the PDFs are created. It's a very efficient, quick, and reliable process and it's rare that I receive a color proof which needs much in the way of color correction.

PDF preflight

Preflighting PDFs within Acrobat Professional is made straightforward by the use of the built-in profiles which include settings for Acrobat/PDF version compatibility, digital printing, PDF analysis, PDF fixups, PDF/X compliance, and standard prepress. It's always a good idea to preflight a document before sending it out as the process picks up things that are difficult to spot manually such as images that are used at a resolution lower than the minimum recommended resolution, objects that contain spot colors, and so on.

So there it is, a bit technical I grant you, but necessary to know as a part of today's digital workflow. There's no doubt in my mind that a high level of production skills set an art director apart from those with only a passing knowledge of reprographic practices. The extent of your knowledge will always be reflected in the quality of the print you commission.

6

WORKING WITH PROOFS

Most designers have their own tried and tested procedures for checking color proofs, usually learned through a combination of experience and mistakes, and there's no set method. The bottom line is, take time to check every aspect of a color proof thoroughly to guarantee that the final print will live up to your expectations.

Wet proofs

Wet proofs (or press proofs) are the most accurate type of contract proof, particularly if they're produced on exactly the same paper as the specification for the final job. They're also the most time-consuming and costly to produce, but if color consistency between print and original imagery is essential, they're still the best option. Wet proofs made with a smaller proofing press, as opposed to a full-size offset press, may be slightly less accurate because the larger machines print ink "wet on wet", whereas the ink is usually allowed to dry between colors on a proofing press.

Digital proofs

Digital contract proofs are now generally accepted as the standard proofing method for high-volume printing. It's important that a digital proof is made using the same PDF file that will be used to produce the printing plates for the final job, as proofs output from the original InDesign or QuarkXPress layout are unlikely to match accurately. Digital proofing devices are essentially sophisticated color-managed ink-jet printers where the halftone dots that will eventually produce the color tints on press are simulated by pixels. In the early days of digital proofing the process had a deservedly poor reputation, but improvements in the technology now mean that accuracy is growing ever closer to that of wet proofing.

1–3. Itoshii stationery

A combination of gloss and matte paper stocks were specified for this staionery range.
David Sampedro and Ximena Xiveros—Iceberg

4. Linen tester

The magnifying tool used by art directors the world over for checking fine detail on proofs. The name derives from the tool's original quality-control application in the textiles industry.

4

SPECIAL FINISHES

There's no doubt about it—the presence of the web is challenging for print designers as certain types of job migrate from paper to screen. On the one hand it provides a platform for parading one's green credentials in a paperless world, which is of course to be applauded. Conversely, it means that print designers have to create printed objects that are even more attractive, tactile, and desirable than before in order to set them against the advantages of online publishing. For anyone with a love of printed matter, there's still nothing to compare to a beautifully designed and expertly bound book, and special printing and binding finishes are central to this process.

Your printer is of course a key player in the development of projects that use special finishes through the use of alternative paper stocks, special inks, varnishes, die-cuts, and so on. They will advise you on what can be realistically achieved within your given budget and what will work best for the job in hand. It's possible to be overly optimistic about how distinct a specified finish will be, so encourage your printer to provide samples that are as close as possible to the final piece. This will in most cases require extra work on top of the standard proofing procedure offered by printers and may well incur an extra cost and add time to the schedule, but it's well worth the trouble. It's very disappointing to specify a spot varnish or extra spot color for a book cover or brochure, only to find that it doesn't leap out from the surface of the board or paper when you receive your advance copies.

The choices of special print finishes are numerous, but here are a few of the more accessible options.

Varnish

Probably the most basic of special print finishes, varnishing can be either matte, gloss, or silk in texture and is normally printed in the same way an extra spot color would be laid down on press. Varnish helps to protect color work so is great for brochure and book covers, and can be applied to both wet and dry ink.

UV varnish

This is a plastic-based varnish which is applied using screenprinting, and is also available in either a matte, gloss, or silk finish. It can be applied to an entire page or to certain areas, where it is commonly referred to as a "spot UV." Gloss UV varnish has a tendency to boost colors so that they pop off the page, while a matte UV varnish can mute colors a little.

Emboss and deboss

Embossing indicates a raised surface pattern, and debossing indicates a pattern that is pressed into the substrate. Debossing can also be referred to as blind embossing. The pattern is created by heat-pressing a tooled die into the surface of the board or paper.

Die-cut

This involves cutting holes, often comprising of very intricate shapes, through board or paper to reveal the printed matter beneath. Once again, a custom-made die is used to cut the shapes, but this time the die incorporates a sharp steel edge to make the cut. Die-cuts can also be achieved using laser-cutting technology, but the option can only be used on certain types of substrate that are not affected by the extreme heat.

1–2. F3asts

A collaborative project produced with the aim of showing how creatives match their client's needs with potential consumers through a beautifully designed and produced book about pairing wine and food. The tactile cover, which uses special stock and print finishes, is central to this message.
Rule 29

Foil blocking

This finish involves the transfer of a metallic foil to the printed surface using a heated metal block. Foil blocking can feel very luxurious and stylish when applied sympathetically, but handle this finish with care as it can also look rather trashy if overdone.

For anyone with a love of printed matter, there's still nothing to compare to a beautifully designed and expertly bound book, and special printing and binding finishes are central to this process.

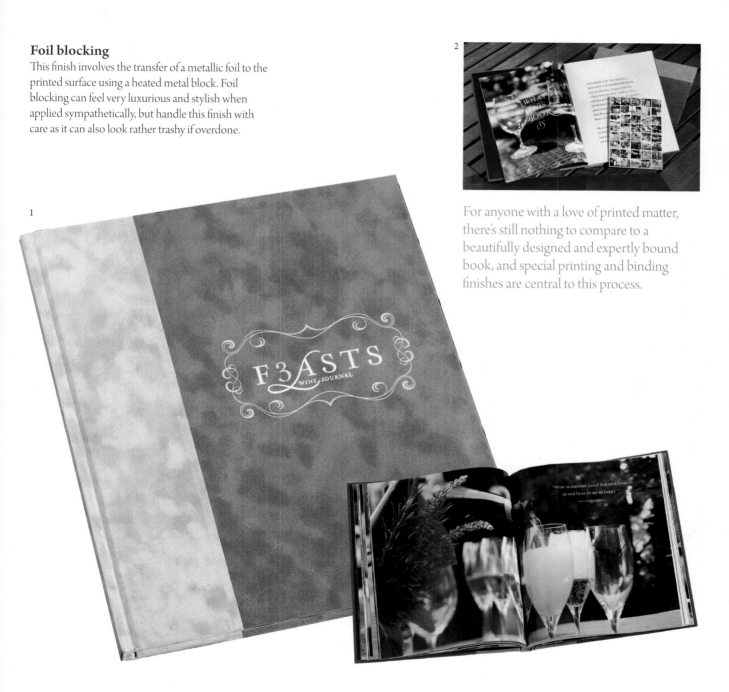

REJECTING PRINT

If you're not happy with a printed job because the quality doesn't live up to your expectations or the expectations of your client, an awkward phone call isn't necessarily the only option open to you, particularly if you've worked with the printer previously. If they've printed a job which is less than perfect, they probably already know it and should be prepared to offer the option of a reprint or a discount on the agreed price. This will depend on the degree of dissatisfaction of course, and a reprint may be the only sensible option. Besides that, you'll have viewed and approved a set of color proofs, so everyone knows what to expect. This is why color proofs are often referred to as *contract* proofs.

So, how do art directors feel about rejecting under par printing? Carl Rush of Crush says, "If you have a respectful relationship with your printer there won't be a confrontation. We have worked with our printers for many years—we have the odd cross word but we both know if something isn't up to scratch." Mark Stevens feels there is a connection to print pricing, and says, "You get what you pay for. If you're grinding down the printers on costs, and constantly seeking the cheapest supplier, don't expect much quality. If you have established a relationship with a good quality press, then things can be worked out if everyone gives a bit." Sean Adams backs up Carl Rush when he says, "You let the pressmen decide if they could do better. If they are a great printer their pressmen would never let a bad piece get printed."

So there you have it—the answer is basically pick up the phone and have a polite conversation. And remember, if you get a great piece of print delivered, let your printer know how pleased you are, as Steve Price at Plan-B Studio does. "I always make a point of emailing or calling my printers to say thank you when a good job has been done," he says. "I'm not sure how many people actually do that, but I always do."

1. Color markup

Marked color proof for use prior to final bulk production of this RotoVision title. The illustration is by Brendan Cahill.
Tony Seddon—RotoVision

Y

1

Character Design for Graphic Novels

INCREASE CONTRAST ON DROP SHADOW TYPE

A REDUCE SHADOW / BLACK OVER FACE

About this book

Character Design for Graphic Novels includes instructions and insights from some of the field's most talented creators, including Jeff Smith (Bone), Wendy Pini (Elfquest), Alex Ross (Astro City), Eddie Campbell (From Hell), Colleen Doran (A Distant Soil), Bryan Talbot (Alice in Sunderland), Stan Sakai (Usagi Yojimbo), Eric Shanower (Age of Bronze), Jenn Manley Lee (Dicebox), and P. Craig Russell (Sandman).

Also available from RotoVision:

Character Design for Mobile Devices:
Mobile games, sprites, and pixel art
NFGMan
2-940361-12-6

Digital Illustration: a master class in
creative image-making
Lawrence Zeegen
2-88046-797-7

Secrets of Digital Illustration: a master
class in creative image-making
Lawrence Zeegen
978-2-940361-56-4

www.rotovision.com
www.myspace.com/rotovision

Steven Withrow & Alexander Danner

RotoVision

CHARACTER DESIGN LIBRARY

STEFAN G. BUCHER
344 DESIGN

Profile

Stefan G. Bucher is the man behind 344 Design and the online drawing and storytelling experiment dailymonster.com. His monsters have invaded computer screens all over the world and their savage adolescence is chronicled in the book *100 Days of Monsters*. He is also the author of *All Access: The Making of Thirty Extraordinary Graphic Designers* and *The Graphic Eye: Photographs by International Graphic Designers*. He has created gratuitously ambitious designs for Sting, Tarsem, and the *New York Times*. His time-lapse drawings currently appear on the rebooted TV classic *The Electric Company* on PBS, and he is, as always, working late into the night preparing the next phase of the 344 invasion.

Interview

Tony Seddon: Our first question is, simply, what do you think an art director is?

Stefan G. Bucher: First off, you'll have to make a distinction between art directors in graphic design and in advertising. From the title of this book, we're clearly talking about an art director in the context of graphic design—somebody who either oversees a team of designers, or commissions and directs work by photographers, illustrators, animators, etc. Sadly, it seems that a bit of titular inflation has taken hold. I see a lot of designers who bill themselves as art directors, the same way that owners of one-person firms suddenly become creative directors and principals. Somehow being a graphic designer is not glamorous enough. Which is too bad. Who cares about titles? Is the work any good? That's what matters.

TS: Setting aside your aversion to job titles, do you think of yourself as an art director or a graphic designer, given that 344 Design is a one-person setup?

SGB: About 10 years ago I was a real life, grown-up art director, but these days I'm a graphic designer who also illustrates, animates, and writes.

TS: Do you think it's OK for art directors to have a signature style, or do you think it hinders creativity to the point that projects suffer?

SGB: I hear this question asked of designers all the time, usually with the bias that a good art director can change styles to suit each project. If I don't see a personal style it makes me suspect that the art director doesn't have a strong aesthetic opinion, and that the client doesn't have one either. At that point, art directors just get hired, when they should get cast as you would cast actors. Jumping from acting to music, do you think anybody asks B.B. King if it's not maybe time to mix it up a bit? "Again with the blues guitar? What about some steel drum calypso? Show them that you're not a one trick pony, B.B.!" It's simple— whether you have a style, or you're a chameleon, be very, very good at it. Produce something that's worth everybody's time.

TS: So, when you're planning a project, what do you look at first? Do you prioritize style over budget and schedule or is it the other way around?

SGB: Any complex project always involves a mix of style, budget, and schedule. I don't prioritize any of those factors. My clients do that for me in their brief. Sometimes it's "We need it in a month." Sometimes it's "We have to bring this one in under $50,000 for once." And sometimes it's "Go for broke!"

1

"I see a lot of designers who bill themselves as art directors, the same way that owners of one-person firms suddenly become creative directors and principals. Somehow being a graphic designer is not glamorous enough. Which is too bad. Who cares about titles? Is the work any good? That's what matters."

1. All Access—The Making of Thirty Extraordinary Graphic Designers

This book, written and designed by Bucher and commissioned by US publisher Rockport, tells the stories behind the careers of 30 significant designers from around the world.
Stefan G. Bucher—344 Design

1

2

3

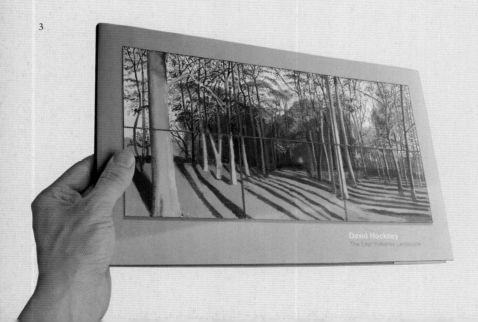

TS: **I guess the latter doesn't happen too often. Have you worked on a project recently which gave you the budgetary opportunity to produce something special?**

SGB: For the LA Louver catalog of David Hockney's exhibition *The East Yorkshire Landscape*, I was in the fortunate position of having a dedicated and adventurous client of great taste and fortitude, as well as a cache of amazing new work by one of my favorite painters. Here the edict was to make a book that would not only give a worthy representation of Hockney's monumental new cycle of paintings, but would also celebrate L.A. Louver's 30-year history with David Hockney. It was clear from the word go that this book had to be something special. While my client knew better than to say "Spare no expense," we all knew that the format had to fit the work. This was not a time to go small, and everybody from the client, to me, to the printer, went all in.

We knew that we wanted to include photos of the installed show, so the initial plan was to design everything, shoot the space a day or two after the opening, and go to press. By that time we had settled on the 12 x 9 inch [30.5 x 22.8cm] landscape format, which made it necessary to do a fair bit of retouching on the installation shots. I also needled the gallery to needle the studio to needle Mr. Hockney to write an introduction. The man is one of the great writers on the creative process—I had to at least try to get a few words from him. Luckily, everybody was patient with me, and Mr. Hockney added a beautiful page of writing. Of course, these things take time. And great printing costs money. Especially when only an out-of-state bindery can handle the oversize format. At any time in this process a less ambitious client would have reduced the scope of the project or simply said, "Let's just get this thing out of the door." Luckily, Peter Goulds and Lisa Jann at L.A. Louver like to aim for the fences.

1–6. The East Yorkshire Landscape

Catalog to accompany the David Hockney exhibition at LA Louver in Venice, California, USA.
Stefan G. Bucher—344 Design

TS: **And how do you approach the research and development side of things?**

SGB: Research and development are almost instinctual. Each information set has an inherent shape it wants to take. It's the art director's job to find that shape, and R&D is the first part of the search—a sort of visual and conceptual triage. Sometimes there's sketching, looking for appropriate formats, or just banging your head against the wall, looking for a spark.

TS: **Do you ever try to engage your clients in the creative process? How tenacious are you when it comes to fighting for your ideas?**

SGB: My relationship to my clients changed profoundly once I created personal outlets for my work—my site dailymonster.com being chief among them, but also my posters and my late column "ink & circumstance" for *STEP* magazine. Before I had those zones to just have fun, each job had to fulfill the

1

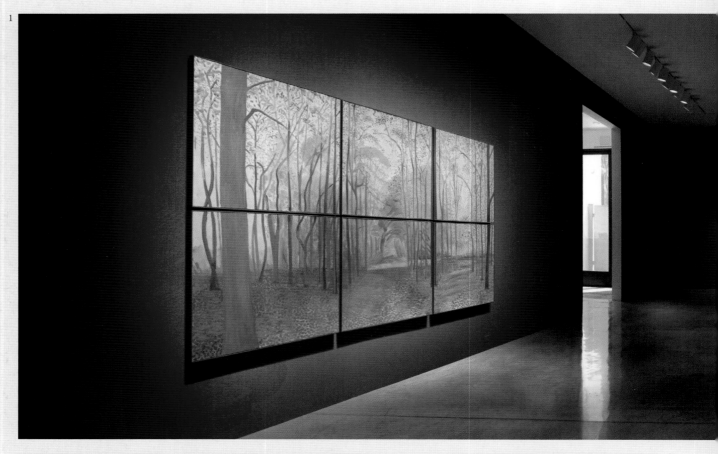

2

David Hockney
The East Yorkshire Landscape

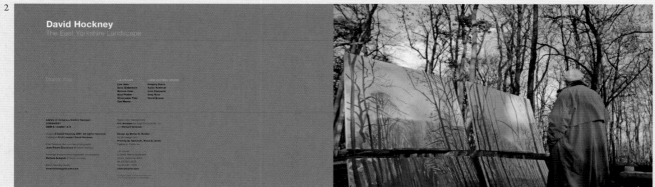

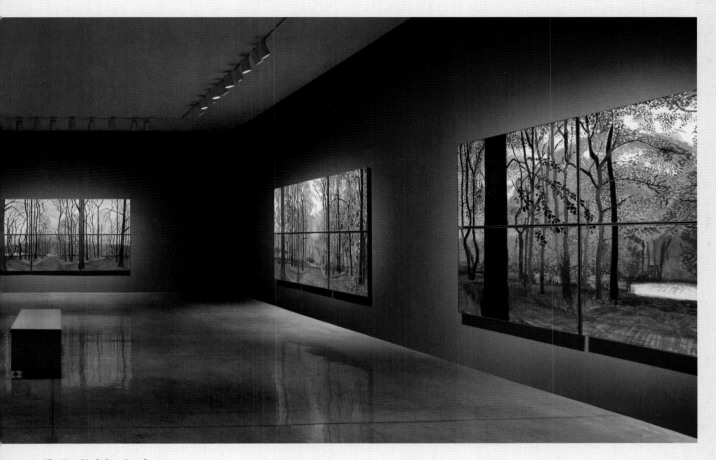

1–2. The East Yorkshire Landscape

The interior space of LA Louver
gallery and the original format of the
paintings influenced the concept for
the design of the catalog.
Stefan G. Bucher—344 Design

demands of my client as well as providing me with an opportunity to create another portfolio piece. It's hard to hit two targets with one arrow. I've always been lucky to attract clients who hire me for me, but it's not always possible to truly fulfill the brief and make a killer portfolio piece at the same time. When you try, it's very easy to slide into conflict—graphic design is an ideal environment for passive aggression. Endless discussions about type size, image crops, page sequence—each is an opportunity to fight a little fight until those little tussles pile up into serious personal resentment.

Not that it went that way for me all that much, but it still happened too frequently to be fun. Ever since I've had the Monsters and my other personal work, I've found myself much more relaxed on client jobs. Not because I don't care about the outcome, but because there is now only one target to hit. It's allowed me to ask questions of my clients that I wouldn't have asked earlier in my career, for fear that the answers would've taken me away from the project I wanted to see in my portfolio. Now I try to involve my clients in the creative process as early as possible, and of course the result of all this is that the work has gotten so much better because it's no longer tinged with the negative emotions generated by a schizophrenic process.

TS: How do you approach the ever-delicate issue of setting a fee for a project?

SGB: I wish I had an agent to do it for me. I'm such a slow learner when it comes to negotiations, and still so enamored of the work that I feel bad about having to haggle over money first. Which is an amateur attitude, I know. I'm working to get over it, because it's not about profit or ego, but about creating enough space to do the job well. If you base all your decisions on extracting the maximum amount of money from a situation, your portfolio will forcefully reflect that priority.

1

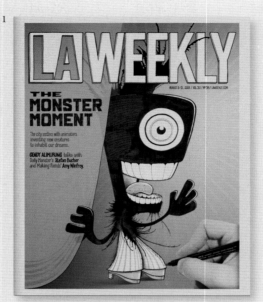

1. LA Weekly cover

One of Bucher's monsters was featured on the cover of LA Weekly.
Stefan G. Bucher—344 Design

2–3. 100 Days of Monsters

For 100 days, Bucher filmed himself creating a monster by blowing a few drops of sumi ink into a shape and working from the result. His blog, dailymonsters.com, eventually became a book published by HOW.
Stefan G. Bucher—344 Design

2

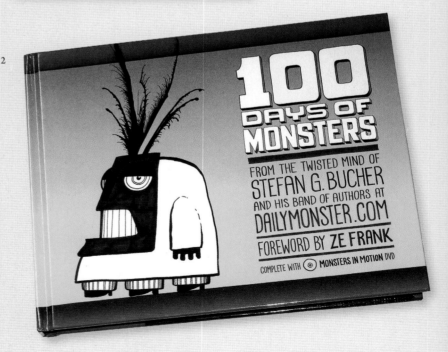

3

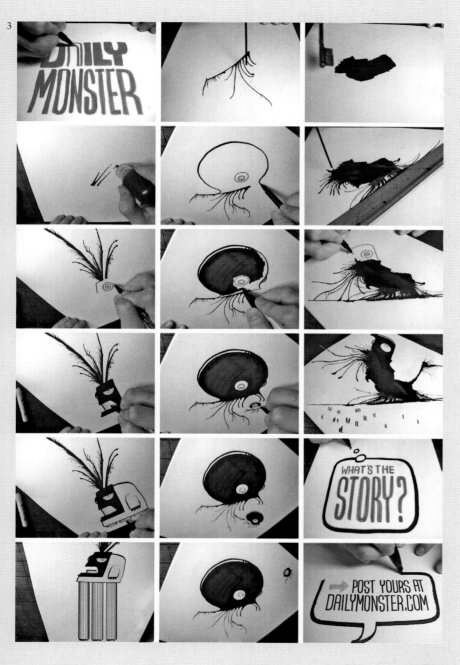

"I've always been lucky to attract clients who hire me for me, but it's not always possible to truly fulfill the brief and make a killer portfolio piece at the same time. When you try, it's very easy to slide into conflict—graphic design is an ideal environment for passive aggression."

TS: So your decisions are based partly on how much you'd like to take a project on?

SGB: I go on a lot about Greed Control®—keeping your overhead low, living within your means, and getting rid of debt. Thanks to that I'm now in the lucky position that—knock on wood—I can choose my jobs based entirely on the desire to work on a project, or with a particular client. But, as I said, at this point I'm extremely fortunate that people hire me for me, so when new clients reach out to me the call tends to make sense. I hardly ever have to scratch my head and wonder why they thought I'd be the guy for the pro-gun cigarette ads. If anything I think, "Wow! Cool! How'd they know that I love what they do?" I'm still hoping for a call to design for NASA.

TS: Do you have any tips on how best to present work to clients?

SGB: There are many valid ways of presenting work. As long as the presentation makes the work look its best, and makes it clearly understandable at the same time, I don't really have a favorite format. I set myself the Rule of Three Whys: every aspect of a design should be able to withstand a series of three why questions by the client.

TS: Your work often features a lot of illustration. Do you commission much of this or do you prefer to handle the work yourself?

SGB: This goes back to your earlier question about signature style, of course. If the job requires illustration, people hire me specifically because they know that I'll provide both the design and the artwork, so yes, I prefer to handle the illustrations myself.

1

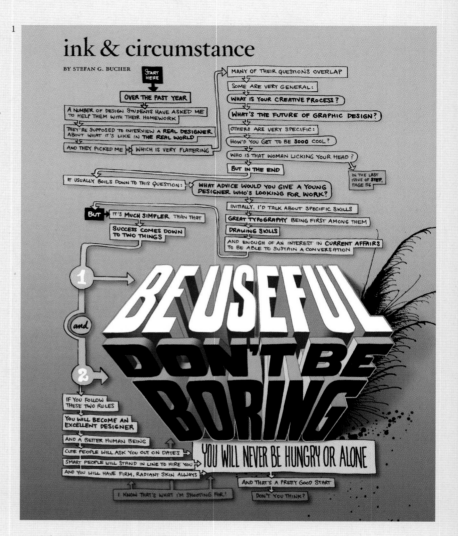

1–2. Ink & Circumstance 9 and 10

A regular illustrated column that appeared in STEP magazine, meditating on the truths of a passionate designer's life.
Stefan G. Bucher—344 Design

2

ink & circumstance

BY STEFAN G. BUCHER

"If the job requires illustration, people hire me specifically because they know that I'll provide both the design and the artwork."

TS: **And how about print buying. Do you see it as an integral part of the creative process?**

SGB: Oh yes! Print specs are incredibly important, especially if you're trying to push the format in any way, and my projects always start with a print spec. I'm a huge ink nerd. Even on my personal projects I'll often spec the printing before I ever put pen to paper. I love setting printing parameters and then figuring out ways to evolve the work within those strictures. Going the other way just becomes a matter of how much money you can spend on fancy gimmicks. Forcing myself to understand and use a limited palette is much more fun!

1

2

3

4

5

1–5. The Fall

Logo for, and spreads from, a book of
on-set shots taken during the filming
of Tarsem's film <u>The Fall</u>. The book
was used to promote the film's release
to potential distributors.
Stefan G. Bucher—344 Design

Also, let's not forget that good art direction falls apart
awfully fast if it's not backed by good communication
with your printer. All my projects benefit from the
relationship I've built with Typecraft Wood & Jones
here in Pasadena, where they are all handled by my
print rep, David Mayes. Every time I start a job, I try to
keep in mind the realities of schedule and print
production, and every time I somehow manage to put
in specs that make the job subtly but fiendishly
difficult. It's a testament to the talent gathered at
Typecraft that they manage to make these things real
each and every time.

**TS: The consistency provided by your
relationship with your printer is obviously a
very important part of your workflow. How
did you go about selecting them in the first
instance?**

SGB: Quality. The end.

**TS: Fair enough. Do you spend much time on
the preparation of your artwork or do you also
look to your printer for that service?**

SGB: I'm completely involved in all files that go to
print. In 95 percent of my work I've gone over every
placed image with a fine-tooth comb, adjusting colors,
touching up little things that bug me, or big things that
bug me. At this point I'm pretty good at understanding
what we can and can't achieve on press. But of course I
try to push that boundary wherever I can, knowing
that I can rely on Typecraft to either make it happen or
tell me when I've reached a point of insanity.

**TS: Do you like to pass work on press, and
have you got any useful advice on how to
handle problems with print in a
nonconfrontational way?**

SGB: I'm at every press check, and I definitely
tweak—the press is a great, fun instrument—but
one of the benefits of a long-term relationship with
a great printer is that they understand my level of
perfectionism. By the time my clients and I sign off on
a proof, we already know that we're in good shape.
By the time they call me to the floor to look at a press
proof, it tends to be a question of nuance and trying to
get to that extra little bit of pop.

Regarding problems on press, it's so rare that the
printing isn't up to scratch that it's almost a nonissue.
Printing technology has evolved to the point that a
bad print job is usually a failure at the prepress level.
That said, if the printing's not there, it's not there, and
plates have to be pulled. In that case, all I do is
apologize to the pressmen for making their day longer,
but I don't apologize for the decision. Clients will
forgive and forget a slight delay, but they'll always
remember a lackluster product.

**TS: So I guess you try to keep your technical
knowledge completely up to date in order to
avoid any prepress mistakes?**

SGB: Hell yes! The more time you've put in on your
instrument, the better you'll be at making music. Over
time you develop a strong instinct for what's possible
that allows you to let your hands do a lot of the
thinking for you. Unless you're intimately familiar with
your tools, all you have is your imagination, which is a
lot more limiting than you might think. Hands are
good thinkers.

Technical Concerns

KEEPING UP WITH TECHNOLOGY

The role of the art director has changed dramatically since the days when the now ubiquitous Macs and PCs first started to land on every creative's desk. I recall a good deal of resistance and skepticism throughout the industry back then from art directors and designers alike, but luckily for me I was fortunate enough to be working for an enlightened company that bought into the new technology. We all know what happened next, and I've always felt that maintaining an awareness of the latest advances in design technology provides art directors and designers with an advantage.

Many art directors lack the time needed to get heavily involved in hands-on work, which is a shame but also a reality of the role, and traditionally it's always been the designers and artworkers that need to keep abreast of all there is to know about the productivity enhancements for InDesign, the latest plug-ins for Photoshop, or the organizational advantages provided by Bridge. However, I think a reasonably current awareness of what the principal software packages are capable of is important when it comes to formulating concepts for presentation and production. If you know what the software can do, even if it's only to specify what format you prefer for the delivery of files, you can use that knowledge to help articulate your briefs more clearly from the outset. The ability to talk to designers in their own language is a valuable resource for art directors, and designers will respect the fact that you've kept your technical knowledge up-to-date.

1

1. Digital letterpress

This great product provides a number of full and partial alphabets scanned from actual printed letterpress sheets which can be composited by hand in Photoshop, capturing the spontaneity as well as the visual impact of real letterpress. It's a good example of an innovative combination of old and new technology.
*Wood Type Impressions—
www.withoutwalls.com*

2

DIRECTOR

2. Adobe Bridge

Bridge is the quickest and easiest way to browse through a large number of images. I recommend that all art directors get to grips with the organizational features it offers through the use of metadata.
www.adobe.com

I need to qualify something here—concepts and styling for print projects should not be driven by innovations or features of the software you use. Innovations in print technology, yes, but not by the latest tricksy scripts and effects. For example, some years ago a software developer (A Lowly Apprentice, ultimately purchased by Quark Inc.) launched an extension for QuarkXPress called ShadowCaster that allowed designers to add a soft drop shadow to type and objects, something which was otherwise difficult to achieve at the time. It was a great product and worked really well, but for the next six months or so practically every line of headline type in every magazine appeared with a drop shadow. The overkill didn't last of course, but it's an enduring example of how technology can sometimes entice art directors into getting a bit carried away with a neat new effect.

Joshua Berger at Plazm draws some interesting parallels between technology and the creative process. "I like to be hands-on with many things—but in art direction conceptual innovation, collaboration skills, and aesthetic understanding are more important than a high level of knowledge in every technical area. I keep up with technological developments so they can serve a larger conceptual goal. There's so much specialization out there now. I will probably never know how to design in Flash, but that's OK because there are lots of good Flash programmers out there already and the broad principles of art direction are the same for motion or print. However, it's always important to know enough to understand what it takes technically to get things done. Technology usually replaces itself, inventing ways to make itself obsolete. People yearn for connection and storytelling and beauty—they want to be surprised and amazed. They want to see themselves and their lives reflected in the images around them. That will never become obsolete."

1. Forever MTV

Promotional print campaign for MTV referencing outdated technology.
Maestro

TECHNOLOGY AND ART DIRECTION

"Design is a craft and not understanding technical issues is like a surgeon not understanding how to operate."

Sean Adams—AdamsMorioka

"Art directing for print involves less technical knowledge than the interactive side of graphic design, but keeping up with the technology is useful. The more knowledge and experience one can gather, the more creative options open up for you, but I don't believe that technology should be the answer to solving a creative problem. Technology can help a smart solution or concept come to fruition."

Neal Ashby—Ashby Design

"I don't usually get involved in the technical issues—it's more about having a creative vision and answering a brief well. Knowing what is possible and who can achieve it is more important that actually doing it yourself. It's my job to art direct—not to know the latest Photoshop trick."

Carl Rush—Crush

"I prefer to look backwards and re-examine old technologies and approaches. I'm often looking for tactile qualities and seeking to make a haptic connection with the audience. Old technology seems better for this but I'm happy to be proved wrong."

Mark Stevens—M-A-R-C

"I think it's important for any art director to have a good understanding of technical issues, but it's not imperative that you know everything. You can spend too much time keeping up with the latest software when it's better to share collective responsibility with your peers so that you inform and teach each other. It's equally important to understand technology that you don't personally use. The advances in photographic technology mean that the process, reproduction, and postproduction of photographic imagery is very different to the predigital era. There are also greater demands now on design agencies to look at new media and platforms to communicate an idea causing designers to change and adapt accordingly. However we only learn new software when we need to. It's no substitute for good ideas!"

Paul Reardon—Peter and Paul

PROTECTING YOUR DIGITAL ASSETS

If you work for a large organization you've probably got an IT department at your disposal to deal with archiving completed work, but if you're a small studio or work freelance, you're more likely to be responsible for this important task yourself. Everything you create digitally, whether it's a layout, illustration, or photographic image, is a valuable asset which you may be able to use in the future. Furthermore, a client may return to you with a request for, say, a brochure which is a revision of the previous year's edition with changes to only half the pages. It would be a shame to have to recreate existing pages all over again. So, what is the best practice for creating secure archives?

Dual locations

It's a good idea to keep duplicate sets of your archive in two different locations, both on- and off-site. It's up to you whether you use CDs, DVDs, or a portable hard drive for this. I have the benefit of an archive server with backup tapes for my day job at RotoVision, but for personal projects I have a large capacity external drive hooked up to my Mac. That takes care of regular backups with OS X's Time Machine, plus I keep a complete archive of all my projects on a separate partition. In addition to this, I archive each project onto a separate DVD and keep them off-site at the home of a friend who lives nearby.

Online archives

If you have your own domain name registered, or subscribe to a service such as Apple's MobileMe, you'll have access to online server storage. This is a good option despite the sometimes lengthy upload times for larger files as it combines an off-site archive with easy access from any location with a decent internet connection.

1

1. Physical off-site backup

Archiving projects and digital assets to DVD and storing them off-site at your home or at a friend's place is a simple and cost-effective way of ensuring that important material is never lost to burglary or fire.

2

2. Online backup

My domain host provides a limited amount of online backup as an inclusive service with no additional fees to pay. It's quick and easy to use, and you can buy additional storage space if you wish.

3

3. Hard drive storage

Large-capacity desktop hard drives, like these ones from LaCie, are still reasonably portable and can store huge amounts of backup data. I use one myself in conjunction with Apple's Time Machine for regular incremental backups, and to store digital assets I need to access regularly.
Courtesy of LaCie

"A great art director is someone who does whatever it takes to bring an idea to life."

Erik Kessels—KesselsKramer

Reference

GLOSSARY

This glossary contains many technical terms which may not necessarily be related directly to art direction, but all art directors should be equipped to "speak the language" of designers, artworkers, and printers in order to manage their teams and suppliers effectively.

A

ASCII American Standard Code for Information Interchange. A digital text file format used to transfer data. It does not include any formatting.

Achromatic A method of color correction used on a color scanner to achieve an extended degree of *undercolor removal* (UCR). In conventional UCR, most of the color and tone is still contributed by the three *primary colors*, with the black lending only deeper shadow tones. With achromatic reproduction the very minimum amount of color required is computed and the black is added to produce the required depth of color.

Aliasing When "jaggies," or visual stair-stepping effects, become apparent in an image. Caused by a low-resolution file. Can occur when an image is enlarged beyond its capacity to be viewed as smooth edged.

Anti-aliasing The addition of increasingly lighter pixels to a jagged edge to smooth the visual effect.

Aqueous coating A coating applied after initial printing, but usually in-line from a water-based solution to further enhance the visual printing effect.

Ascender The portion of a lower case letter that extends above the x-height, e.g. b, d, and k.

B

Back step (collation) marks Black numbers or letters on the spine of a *signature/section*. When the signatures are gathered, the marks appear in a staggered sequence on the spines indicating the order.

Banding An undesired printing effect when the graduation from one tone to another is not smooth, causing a band effect at the transition point.

Bitmap Any image formed in monochrome or color by *pixels* in a rectangular grid. Contrast with *vectors*.

Blad Book Layout and Design. A small booklet featuring the front cover of a book plus sample pages to provide advance promotion or sales interest at trade book fairs, and to help secure commitments for reviews.

Bleed (1) When an illustration or image is designed to run off the page. A term also used by book binders to describe overcut margins. **(2)** Ink that changes color or mixes with other colors, sometimes caused in *lamination*.

Blind (1) Book *cases* or covers that are stamped (US), or blocked/embossed (UK), or without the use of ink or *foil*. **(2)** Term applied to a *litho* plate that has lost its image.

Block (UK) **(1)** A binding term describing the impression or stamping of type or a line image on the cover. This can be achieved with metallic or pigment-based *foil*, or gold leaf. **(2)** In printing, a letterpress block *(cut*, US) is an etched copper or zinc printing plate mounted on wood or metal.

Bolt Any folded edge of a section other than the binding/spine fold.

C

CMYK Abbreviation for Cyan, Magenta, Yellow, and BlacK, or Key, used in four-color process printing. Combined, they approximate colors in the spectrum, within the color gamut of printing inks.

Book block The printed, gathered *sections/signatures* of a book or publication ready for the application of glue, prior to paperback binding, or casing in hardcover books.

Bottom out (US) The arrangement of type to prevent *widows*. See also *Orphans*.

Brightness A papermaking term to define the level of blue light reflected by the paper. Contrast with whiteness, the degree of which is achieved by varying the chemical mix in the pulp.

Bronzing A process for obtaining a metallic finish by the addition of a hand- or machine-applied bronzing powder to a wet, adhesive ink.

Bulk The relative thickness of a sheet or sheets, e.g. a bulky paper and a thin paper may have the same weight.

Bulk factor (US) The number of pages of a paper equal to one inch. (UK) Volume.

Bull's eye/hickie A printing defect caused by dust or lint, usually from the paper or board's surface causing a white spot on the printing surface that should be ink.

Bullet/bullet point (UK) A heavy, centered dot (·) used to make a piece of text stand out, or to identify items in a nonnumbered list.

Burst binding An unsewn binding method whereby the spine fold is burst with perforations during the folding, enabling the glue to adhere to each leaf without having to grind off the usual 3mm, or ⅛in.

CTP Computer to Plate. The prepress or imaging process in lithographic printing where a finished digital layout or image file is output direct to a printing plate, rather than to film. Most book and magazine publishers now use this system, which is more efficient and usually more accurate than Computer to Film (CTF), although there are some disadvantages.

Cap height The vertical space taken up by a capital letter. The top may be below the top of the font's ascender, while the foot always aligns with the baseline.

Carbonless paper (NCR) No Carbon Required Paper that has been coated with microscopic chemicals allowing the transfer, under written or typed pressure, of whatever is being written on the topmost surface.

Case In binding, the cover for a book using cloth, paper, or synthetic material, or a combination of these, over board. Can be one or three piece.

Center line/centered A line of type with an equal amount of space at each end. Contrast with *ragged right* or *ragged left*, or *justified* composition.

Chalking A drying problem with offset printing leaving a loose pigment on the surface of the paper.

Character set The complete suite of letters, numerals, symbols, and punctuation marks, plus any special characters, in a *font*.

Choke See *Spreads*.

Coarse screen A halftone screen of up to 35 lines per cm (85 lines per inch). Used to reproduce photographs on *newsprint* or similar grade papers.

Coated paper Paper that is coated either one or two sides in matte, semi-gloss, or gloss finish.

Cockling A wave effect on paper caused by changes in the humidity while in transit or storage. Can result in severe problems on press.

Cold set Printing by *web offset litho* that does not require heat for drying the ink. It has limitations on the fineness of a halftone screen and suitable paper.

Collation marks See *Back step marks.*

Collotype A planographic process of printing. Gelatine is applied to a sensitized plate onto which the type and images are exposed, and without a screen. This is a slow and expensive process. It reproduces flowers and art with a high fidelity of color balance and detail.

Color control bar A strip at the back edge of a sheet consisting of color and grayscale measurements to assist the press operator in determining a variety of controls are working correctly for the job on press.

Color profile Establishing a profile on a prepress device, or for a printing press that conforms to an agreed set of parameters.

Color separation In color reproduction the method whereby an original image, e.g. a transparency, print, or digital file, is separated into the primary colors, plus black. This can be achieved on desktop computers running programs such as Photoshop, or on high-end scanners. Once approved, the separations are converted into film or go direct to plate from the digital file.

Color swatch(es) A set of color reference guides, e.g. the *Pantone Color Matching System®.*

Comb binding A method of binding a publication. Small rectangular holes are punched into pages and covers followed by the feeding of the plastic "comb" through the holes. The spine of the comb can be printed.

Continuous tone, or Contone An image, such as a photograph, composed of graduations of tone from black to white. Contrast with line work, such as drawings.

Convertible press A printing press that can print either a single color on both sides of a sheet of paper or board in one pass, or two colors only on one side.

Copy Author-supplied text and supporting material ready for editing and production. Can be supplied as hard copy or in electronic form.

Copyright The right of the legal party in the contract (author, photographer, artist, or publisher) to control the use of the work being reproduced. International agreements exist to protect the copyright holder. However, intellectual property rights are an increasingly complex area in the internet age, with local legislative systems often at odds with the global, file-sharing impetus of the internet.

Corner marks Serve as the location in finishing for where the sheet is to be cut or trimmed.

Cromalin DuPont-patented high-quality, off-press, four-color proofing system from color separations, used to provide a good indication of final color reproduction.

Cut flush A binding style where the book block and the cover are trimmed flush to each other. Usually achieved with a guillotine, or in-line with a three-knife trimmer.

Cut in Index Also known as a *thumb index.* An index to a book, e.g. dictionary, where the alphabet divisions are cut into the fore edge of the book in a series of steps.

Cut marks (US) Printed marks on a sheet to indicate the edge of a page to be trimmed. (UK) Trim marks.

Cutoff The maximum length of a sheet that can be printed on a web-fed press and equivalent to the circumference of its impression cylinder.

Cyan The special shade of blue in the four-color process inks, known collectively by the abbreviation *CMYK.* The pigment shade may vary between countries.

D

DAM Digital Asset Management. Now print production is largely digital, DAM describes the strategy of managing these digital assets collectively and individually on central servers and in terms of version control, archiving, and easy retrieval for reprints and new editions. A logical DAM strategy can be an asset in itself.

DCS2 Desktop Color Separation. A robust format for transmitting five EPS files—one for each color image, plus a master file—from the prepress stage to the final output device, preventing any intervention or changes.

DPI Dots per inch. A measure of the output resolution of a laser printer or imagesetter. See also *pixels per inch.*

DTD Document Type Definition. A specialized coding system that prepares documents for XML searching and display. It identifies the various elements in the document and establishes a hierarchy by the use of machine-readable tags. The results are invisible to the end-user.

Deckle edge The ragged or frayed edge on the edges of a sheet of handmade paper. *

Descender The part of a lower case letter falling below the *x-height* of the character as in g, q, and p.

Descreen Removal of the original screen value on a previously printed image or film to prevent the creation of a *moiré* pattern. The image is then rescreened to the desired new halftone screen value. Can be applied to one-color or four-color images. Also see *rescreen.*

Diacritic A typesetting term applied to a mark placed over, under, or through a letter to distinguish it from one of similar form, or to indicate pronunciation or stress.

Digital printing (DP) An impression printed from a digital prepress file via plateless application of text and images using ink-jet, fused toner, or liquid ink.

Die cutting The use of a die to cut holes or irregular shapes in display work or on book covers.

Die stamping An intaglio process whereby the image is in relief on the surface of the material, either in color or blind (without ink).

Direct to plate (or CTP: Computer to Plate) The process of transmitting digital layouts and instructions from a file to the plate without the interim step of creating film.

Discretionary hyphen Also known as a soft hyphen. This specially noted hyphen in a computer file will disappear in the event of editing or reformatting.

Dot See *Halftone.*

Dot gain An on-press condition where the dot size of an illustration or text increases, making type appear heavier and images less clear. Some papers, such as *newsprint*, are more absorbent and thus can cause increased dot gain. All presses have a dot gain capacity, and software can compensate for the problem. Excess pressure exerted on the blanket, or use of an overly worn blanket during the press run can also add to dot gain.

Dry proof Any proof that is prepared off press. Cromalin, Matchprint, Epson, Approval, Waterproof, etc., all fit into this category of proof. Various systems use powders, films, ink-jet, or thermal transfer to achieve the proof.

Duotone Two *halftone* plates made from the same original image, usually a black-and-white photograph, but to different tonal ranges. When the image is printed a duotone will have a greater tonal range than is possible from one-color reproduction. One color in a duotone is usually black; the other can be any color.

E

EPS (Encapsulated PostScript) A file format often used for images generated in object-orientated drawing applications, e.g. Illustrator or Freehand, and also for scanned images. Contains a *PostScript* file, which describes the image, and a preview image for display on computer.

Em The area occupied by the capital letter M. It will be wider or narrower than square, all depending on the style of the letter in a specific typeface. An em space is twice the width of an en space. Ems and ens are referred to, respectively, as "muttons" and "nuts."

Embossing, blind The process of raising or recessing an image using an uninked block.

Emulsion Normally, a light-sensitive coating on film or a printing *plate*, but it may also include encapsulated aromas or flavors in promotional printing.

Emulsion side The matte side of a film that is placed in contact with the emulsion of another film or *plate* when printing to ensure a sharp image. As in "right-reading emulsion down."

Endpapers Lining paper used for the front and back of a casebound book. They adhere to the first and last signatures of the book and attach to the front and back covers of the *case*. Also known as endsheets.

Extenders See *Ascenders* and *Descenders*.

Extent The complete number of pages in a printed work, which will normally be a multiple of four or eight.

F

F&C/F&G Folded and Collated/ Gathered. Sheets of a book that have been folded and gathered and/or collated in preparation for binding.

FPO For Position Only. A low-resolution image in a digital document to indicate the size and placement for the eventual high-resolution image.

FTP File Transfer Protocol. A data transmission and communication protocol for sending large amounts of data between remote locations, either via a web browser, or using dedicated FTP software. (Compare with HTTP [Hypertext Transfer Protocol], used to allow remote computers to connect to a website.)

Feet/foot margin The white area at the bottom of a page between the type area and the trimmed edge.

Feint Lines, usually ruled and printed in a pale blue on account book pages and in school exercise books.

Film lamination A polypropylene or other synthetic film laminate applied in one of a variety of finishes (gloss, matte, silk, lay-flat) to the printed surface of a dust jacket, paperback cover, or item piece. Used both for visual effect and protection.

Finish The surface given to a grade of paper from calendering, *coating*, or *embossing*.

Finishing (1) All operations performed after printing. **(2)** The hand lettering or ornamentation on the cover on a handbound book.

Fixed space The space between words or characters not variable for justification purposes. Used in *ranged* left, *ragged* right, *centered*, and *tabular* typesetting.

Flat back Bound sections or signatures having a square spine, as opposed to a rounded and backed spine; normal in limp bindings, but less common in *case* binding. More common in short-extent children's books.

Flexiback/Flexibind (UK/US) A binding style with sewn signatures. Often used for guide books.

Flexography A relief printing process using rubber or plastic plates on a web-fed press and solvent-based liquid inks. Mainly used for packaging, and for some newspapers.

Flop When an image is reversed (or flipped) from its intentional appearance, usually in error.

Flush left/right Type that aligns vertically to the left or to the right. Also described as *ranged* left or right. Contrast with *ragged left or right*.

Foil (1) Film with either a metal or color pigment used to *block* type and images on book covers and packaging. **(2)** Clear film used as a backing during film assembly.

Folio (1) A page number, and consequently a page. **(2)** A large book in which the full size sheet only needs to be folded once before binding.

Font Software which contains the data necessary to generate the characters or glyphs for a particular typeface.

Footer Recurring information at the foot of a page in a book or magazine, often repeating the title, subject matter, or chapter heading. See *Headline*.

Fore edge The edge of a book or publication that opens.

Fount (1) A fountain or duct on a press. **(2)** (UK) A set of type characters of the same design, now more commonly referred to as *font*.

Four-color inks The pigmented inks used to reproduce the four-color process.

Four-color process Color separation from original art, transparencies, or files followed by printing the three primary colors, *cyan* (C), *magenta* (M), and yellow (Y), plus black (K, standing both for "key plate" and also instead of "B" to distinguish it from blue).

French fold (1) A sheet of paper with four pages printed on one side only, then folded twice with right-angle folds into quarters without cutting at the *head*. The inside pages are blank with an image appearing on pages 1, 2, 3, and 4, but actually on pages 1, 4, 5, and 8 of the

imposition. (**2**) A dust jacket that has a fold over at the top and bottom to provide extra strength. Usually reserved for large art books.

Frontispiece The illustration placed facing the title page in a book. Maybe printed on text stock or tipped in as a separate page printed on coated stock.

Full color Interchangeable term for *four-color process.*

Full out Type that is set to the specified full *measure.*

Full point/stop (.) (US) A period.

G

GSM or G/M2 (Eur) Abbreviation for grams per square meter. A method of indicating the substance of paper on the basis of its weight, regardless of the sheet size.

Gatefold Two parallel folds towards each other, in which the fold can be opened from the left and right.

Ghosting (1) When an image reoccurs in a faint appearance by mistake alongside the required image. (**2**) Due to ink starvation the image is reproduced to a lighter (and unacceptable) degree.

Grain (1) In photographic film, the structure of its light-sensitive *emulsion.* (**2**) In paper, the direction of fibers during the papermaking process.

Grayscale A line of gray tones in varying percentages ranging from white through black and used by printers as a measure to an industry standard.

Gripper edge The allowance of extra space on a sheet of paper for the grippers to hold it.

Gutter The margin closest to the spine of a publication.

H

H&J See *Hyphenation and Justification.*

Half up Art prepared 50% larger than final reproduction size. Allows it to be reproduced at 66%, thereby reducing any initial flaws in the original.

Halftone/screen An original photograph reproduced on press following the prepress application of a screen value in a series of dots varying in number per square inch depending on the paper to be used.

Hard copy Printed page(s), as opposed to digital files.

Hash Symbol used in computing to stand for the word "number," but in UK typography it is used primarily by proofreaders to indicate a space.

Headline The display line(s) of type denoting the title of a news story, article, and so on. Followed by a white space before commencement of the main text. In the US, running heads (UK) are referred to as headlines.

Head/tail band A narrow band of plain or striped sewn cotton, glued to the top and bottom of the *book block's* spine in a casebound book. They cover the ends of the signatures or sections. Primarily a cosmetic, inexpensive addition with minimal addition to the binding strength.

Head trim The usual allowance is 3mm or ⅛in (or twice this between pages) for the removal of folds and clean edges. *Bleeds* must compensate for this.

Hexachrome Also known as Hi-Fi color printing when two additional inks are used with the *CMYK*—usually a green and an orange to heighten the visual impact on selected images.

Hickie/Hickey See *Bull's eye.*

House style Standard spellings, writing styles, and abbreviations used by different publishing houses. House style guides are usually given to writers and editors.

Hue The part of a color that is its main attribute, e.g. its redness or blueness, as compared to its shade (lightness or darkness), or its saturation.

Hyphenation and Justification/H&J A system, usually software-generated, that determines the accepted end of line breaks in justified typesetting. Preprogrammed word-break dictionaries with publisher's approved exceptions or alternative are core to such a system.

I

ICC International Color Consortium. An internationally recognized and accepted method for achieving consistent color management throughout the prepress and printing stages. Scanners, monitors, proofing devices, and printing presses can all be calibrated to conform to a device-independent ICC standard.

ICC Profile When a device has been calibrated to conform to a given ICC standard and will operate with similarly calibrated devices.

ISBN International Standard Book Number. A unique (once 10- and now 13-digit) serial number that identifies a book from all others, with its title, author, and publisher, plus a check digit.

ISSN International Standard Serial Number. A unique eight-figure number that identifies the country or publication of a magazine or journal and its title, referring to the run of a publication instead of a specific edition.

Imagesetter A device using either a solid-state or gas laser to record text and images at high resolution on special paper, film, or direct to plate.

Impose/Imposition The arrangement of pages to fit the press being used and to provide the correct margins such that when the sheet is folded after presswork, the pages appear in their correct sequence.

Imprint The printer's name and location of printing. Often a legal requirement for overseas printing to comply with customs, i.e. country of origin. As distinct from a publisher's imprint which comprises their name and often a "mark" or symbol, appearing inside and on the spine of a book. For example, the imprint (UK) copyright (US) page contains the printer's and the publisher's name, an ISBN, credits, and the British Library (UK) Library of Congress (US) CIP (Cataloging in Publication) information.

Indent (1) Short line (or lines) of type set to the right or left of the standard margin, often used at the beginning of new paragraphs, and to draw attention to specific pieces of information within a larger text. (**2**) The special making of a paper order from the mill for a particular publication or book.

Inferior characters Letters or numbers smaller in point size than main text, and set on or below the *baseline.*

Insert (1) A signature/section of a book printed separately, often on a different paper—e.g. uncoated for the main text and coated for an illustrative insert—and bound into the book between signatures, as opposed to wrap. (**2**) A piece of paper or card placed loose inside a book or magazine by hand or machine. A blow-in.

Italic Letters in a type family that slope forward, as distinct from *roman* upright letters and numerals. Text or individual words are set in italic for emphasis or reference purposes, and also occasionally when foreign-language words are used during the course of a text. If the italic type formatting function (rather than the italic version of a font) is used within a page layout application such as QuarkXPress, it is not a true italic and may not reproduce. Within InDesign, false italics can be created by sloping highlighted text by a few degrees.

J

JDF Job Definition Format. An XML-based "job ticket" standard that permits easy exchange of information and specifications between the various parties involved in the production of a printing job.

JPEG Joint Photographic Experts Group. One of several bitmapped compression methods for storing images in a lossy format. In some applications, quality can be set on a scale from high (for print), to low (for web or layout positional purposes). Resaving JPEGs recompresses the file, losing further data.

Jaggies The visible stair-stepping (aliased) effect on raster images and type, that should instead appear as smooth edges and curves. See *aliasing* and *anti-aliasing.*

Justification See *Hyphenation and Justification.*

K

K (US) Key (or blacK). Indicates black in the four-color (*CMYK*) process, preventing confusion with "B" for blue.

Kerning The adjusting of the space between individual characters in a line of type, nowadays within programs such as InDesign and QuarkXPress.

Key/line (1) Any *block*, forme, *plate*, or artwork fitting into the *register* with other colors. **(2)** A line on artwork indicating an area for tint laying. **(3)** A component on a printing press that controls the degree of ink flow onto the rollers. Adjustable by the press operator, usually by computer control.

Kiss cut A light touch of a knife blade on label stock with peel-off to the required size. Sufficient pressure is applied to allow the label to easily detach from the backing sheet without cutting into it.

L

Lamination (1) The application of a transparent gloss- or matte-finish thin film from a variety of materials, e.g. polypropylene, mylar. Available in a lay-flat finish for paperback books to prevent warping of the cover. **(2)** Manufacture of paste boards by pasting sheets or reels together.

Leading The vertical space between lines of type, expressed using the point system—10 on 12 point (meaning 10pt type with an additional two points of leading added). Originally, leading was a literal term describing thin strips of metal used in hot metal typesetting as spacing. Today, leading is set within page layout programs, such as InDesign and QuarkXPress.

Leader A type character having two or more dots in line. Used to assist the eye's movement across blank space to the next type item, especially on lists and tables.

Lenticular printing A series of optical-grade, ribbed plastic lenses that sit above two or more printed images giving the impression of movement, or a 3-D effect. Also known as auto-stereo images. Not to be confused with a hologram.

Ligature Two or three letters joined together to make one typeset character, e.g. fi, fl, ff, and st.

Light fast An ink or colored material whose color is not easily affected by light, specifically sunlight. Often used for point of purchase and window display printed matter, e.g. showcards.

Linen tester A magnifying lens used to check *halftone* dot patterns.

Lining figure Numerals that are the same height as the capital letters in any given typeface.

Literal A typographical error (US/UK). Also known colloquially as a *typo.*

Lithographic printing A printing process where the image and nonimage areas are on the same surface plane of the plate. As water and grease do not mix, the surface of the plate is treated to attract ink and repel water.

Loose leaf Individual sheets of paper placed in a binder for easy removal or addition.

Loose line A typesetting term applied to a line where the space between words is excessive.

Lower case Small letters (not caps).

M

Magenta The red pigment based ink used in *four-color process* printing.

Magnetic ink character recognition A form of *machine readable* character.

Marbling A decorative multicoloring applied to book edges and commonly used on *endpapers* in bookbinding.

Mark-up Directions to a typesetter or prepress house for the composition treatment to a manuscript.

Masking The area of an illustration required for reproduction with extraneous material "masked" out.

Matchprint A proprietary prepress proofing system prepared from film, or in digital form. A *dry proof.*

Measure The length of a line in typesetting, normally determined in *picas* or *points,* but sometimes in inches or millimeters.

Medium (1) The substance (usually linseed oil or a varnish) in which the pigment of printing ink is carried. Also known as a vehicle. **(2)** The weight of a typeface midway between light and bold. **(3)** A standard size of printing paper (18 x 23in; 455 x 585mm).

Metallic inks Inks whereby the regular pigments are replaced by very fine metallic particles, typically gold or silver in color.

Micron 10 and 20 dots assigned in stochastic or FM screening for process color reproduction. 10 micron is finer, but it is more difficult to adjust color in track when on press, and special equipment is required to bake the plates prior to exposure.

Middle tone The range of tonal values between highlights and shadows.

Moiré The undesired screen pattern caused by incorrect screen angles of overprinting halftones.

N

Negative Exposed photographic film or image in which all the tonal values are reversed.

Network A group of interlinked computer or communications devices through which information can be exchanged, either via cables, hubs, and routers, or wireless protocols via a wireless hub.

Newsprint A relatively inexpensive paper made for newspaper presswork—mostly from groundwood/mechanical pulp. With its high acid content, it quickly yellows when exposed to daylight.

Notch (burst) binding A form of adhesive binding. Pages are not cut into individual leaves, but instead are notched with slots to facilitate the penetration of glue.

O

OCR See *Optical character recognition*.

Octavo A standard book format obtained by folding a sheet three times at right angles to create eight leaves. (UK) Sometimes abbreviated to 8vo or 8mo.

Offset (1) A mainly *lithographic* method of printing, in which the ink is transferred from the printing plate first to a blanket cylinder, and then onto the paper or other material—rather than printing direct from plate to surface. **(2)** When the pages of a previously printed book are photographed into bitmap form and the file is used to print a new edition. Also referred to as "shoot from the book." Often used to bring previously out of print titles back into print.

Old-style face Typefaces from a period between Venetian and Transitional, e.g. Bembo. Capitals tend to be shorter than lower case *ascenders* and slightly more contrast in the stroke weight.

Opacity A state of a material that determines its relative ability to inhibit the transmission of light. In papermaking this determines show through, i.e. whether or not text or images printed on one side of the paper can be seen from the other.

Optical character recognition The use of a scanner to scan a printed text and turn it into an editable text file.

Optical media A disc, such as a DVD, encoded by light.

Original Any artwork or copy to be reproduced in print.

Orphan An unacceptably short line length on the last line of text on a page, or paragraph, which needs correcting. Contrast with *Widow*. Also known as a club line (US).

Overmatter Typesetting that will not fit in the available type area space. Options are to edit to fit or cut.

Overprinting (UK) To print a second image (not always in an additional color) on a previously printed sheet.

Overrunning To turn over words from one line to the next (or for several successive lines) after an insertion or other correction. The opposite is to run back.

Overs The percentage of additional copies above the agreed contract quantity. The percentage is negotiable and may be chargeable. The opposite of unders.

P

PDF Portable Document Format. Adobe Systems technology that enables layouts (for example) to be viewed on screen and printed outside of the original application that created them, and without the need to have the original files and fonts. When a PDF is made of a document, by using Adobe's Acrobat Distiller on the original QuarkXPress or InDesign file (for example), all of the fonts and images are embedded into the file, which can then be published online, or sent as an e-mail attachment, or via FTP. Printers can produce separations from prepress-quality PDFs, while low-resolution PDFs have relatively small file sizes but are of sufficient quality to be viewed on screen (using the free Acrobat viewer) or published on a website. When combined with *CTP*, the workflow from origination through to printed article can be relatively swift and manageable.

PLC Paper Laminated Case. Instead of a cloth over board, paper is printed, laminated, and glued over the board.

Packager A company that sells book ideas to publishers, who will then commission an agreed quantity of the book from the packager and publish it under their imprint when the packager delivers the completed book. The packager does not publish or distribute the book, and is guaranteed the sale of the printed quantity at an agreed unit cost, while the publisher sells at the full cover price for a profit.

Page makeup The organization of text and graphics into the desired design and format.

Pagination Making a publication into its paged form with page numbers, includes any blank pages.

Pantone Color Matching System® Pantone Inc.'s proprietary check standard for color reproduction and color reproduction materials. Each color bears a description for its formulation in percentages, for use by the graphic arts and printing industries.

Pass (for press) (1) Instruction to printer approving the project for press. OK press (US). **(2)** When a sheet or roll of paper is running through the press.

Perfect binding A binding method, most popular in magazine publishing, in which all of the sections are glued into a separate cover, with a flat spine.

Perfecting The printing process whereby the sheet/roll is printed on both sides in one *pass*.

Perforation Very small holes or slots in continuous lines made through the paper or card. Can be done to achieve easy removal of part of the form or document, or to facilitate easier folding of heavier-weight paper or card.

Peripheral Any device not essential to a computer's operation, but connected to it for a specific additional function, e.g. a printer, scanner, or external drive.

Pi characters (Pies) (US/UK) **(1)** Any character such as fractions or musical symbols, not normally included in the regular *font*. Also called a special sort. **(2)** A mixed or disordered collection of printing type.

Pica A unit of typesetting measure. Twelve *points* equals one pica in the Anglo-American system with 6 picas to the inch.

Picking Damage to the surface of the paper, card, or board during presswork.

Pixel Picture element. The smallest element of a picture captured by a scanner or displayed on a monitor.

Pixels per inch/per centimeter The measure of resolution of a scanner, scanned image, or monitor screen. The

ppi or ppm system is used to describe the resolution of a scanned image to distinguish from the frequency at which it is printed. The accepted ratio for conversion is 2:1, e.g. 300 ppi = 150-line screen.

Plate Metal, plastic, or even paper, image carrier used to transfer ink to paper in letterpress and litho printing, or to the blanket in *offset litho.* In color separation for full-color or two-color printing, a separate plate is made for each process color.

Plate cylinder (1) The cylinder on a press that holds the printing *plate* in position. **(2)** An illustration in a book. Can be printed with main text, or more usually, separately on a different (perhaps coated) paper, and tipped in.

Platesetter A laser operated device that records text and images directly from the file to the printing plate.

Point (US) **(1)** One thousandth of an inch. **(2)** (US) Used to refer to the thickness of board, e.g. 98pt board.

Point system Type measurement systems; 12 points make a Pica Em.

Positive A photographic reproduction on printing film, made from a *negative,* or on a duplicating film in which the highlights in the original are clear and the shadows are deep.

PostScript The device and resolution-independent page description language, which is used to describe the appearance of a page prepared on a computer to a laser printer, *imagesetter,* or digital press.

PostScript file A data file containing all the information required to print a single or stream of pages. Contains all picture and text data and may also include fonts.

Posterization The condition of using a

limited number of gray levels creating a special effect to a halftone, i.e. reduced number of tonal shades.

Preflight Before a completed application file is sent for proofing/printing one of several desk-top programs can run a series of checks to ensure the content is correct and all fonts and additional items are included. Printers also run preflight checks prior to platemaking.

Press proof A proof prepared on a press with ink on paper, often the actual paper to be used on the final pass, as compared to a prepress proof. A machine proof.

Primary colors Used in the *four-color process* printing, comprising *cyan* (blue), *magenta* (red), and yellow, plus black, to reproduce four-color separations.

Print down To use a vacuum frame to transfer a photographic image from one film to another, or to a printing *plate.*

Printability The ability of a specific paper from a particular making to successfully accept the ink without causing on-press problems, especially *picking.*

Process color See *four-color process.*

Progressive proofs A succession of proofs using all of the inks in the *four-color process,* shown individually and in gradual combination.

Proof The representation on paper of the final printed product. This can be at any interim stage, or at final layout, showing text and images in paged form. Some proofs can be used for color reproduction checking, and others purely for positional purposes.

Proof correction marks Standardized symbols used to mark errors in text or illustrations on proofs that require correction. Usually, these are marked by hand by a proofreader or an editor, but

software exists to allow these to be marked electronically on PDFs. Corrections will then be "taken in," either by the project editor, on interim, internal proofs, or at the printer on completed layouts.

Proofreader A person who reads typeset proofs and marks appropriate corrections.

Proportional spacing System used in typesetting by which all the letters in the alphabet occupy an appropriate amount of space for the best fit within that typeface's design, with an "m" being wider than an "i."

Q

Quarto A page size typically about A4 and obtained by folding a sheet once in each direction.

R

RGB Red, Green, Blue. The additive *primary colors* used to create the image on a monitor. Most scanners capture their image in RGB values with a subsequent conversion to *CMYK* for print reproduction. A device-dependent color space with a color gamut in RGB that is greater than that of CMYK inks and, therefore, cannot be exactly matched. Used for scanning and color separations.

RIP Raster Image Processor. A computer device which converts the *PostScript* data describing pages into bitmap format for imaging on an *imagesetter, platesetter,* digital press, color photocopier, or other imaging device. Often includes specialized technology for the rendering of different types of halftone screen. Also used in phototypesetting and electronic page composition systems, processing the digital information passed to them

relating to individual letters, numerals, and images both line and halftone, before preparing pages for output in the correct position and orientation.

Ragged right/left Use of a fixed word space in typesetting to prevent the type from aligning vertically on either the left- or right-hand side. Also known as unjustified composition. The opposite of *flush left or right* typesetting.

Range To cause type or illustrations to line up on or to a certain point, either vertically or horizontally.

Raster (graphic) A bitmap. An image formed from a grid of pixels, or points of color, on a computer monitor, or printed onto a surface. Contrast with *vector graphics.*

Raster image processor See *RIP.*

Rasterize To turn into a bitmap.

Ream 500 (originally 516) sheets of paper.

Recto A right-hand page.

Register/Registration To print two or more impressions that fit together without overlap or causing a *moiré* effect. Also to backup accurately if printed on opposite sides of the sheet with the intention of maintaining register and preventing possible show through.

Register marks Marks on sets of overlays, artwork, typeset pages, film, *plates,* or formes so that when they are superimposed during printing the rest of the work is in *register.*

Reprint Any printing of a work (with or without corrections) subsequent to the initial printing.

Repro house (UK) A prepress house, which takes application files or PDFs from clients and readies them for print production, making color separations, and so on.

Rescreen When a previously printed halftone has to be treated as an "original." To avoid the creation of a *moiré* pattern with conflicting screens the image is first descreened and then rescreened. See *Descreen*.

Retouching (1) Hand treatment on litho film *negative* or *positive* to change tonal values or correct imperfections. **(2)** In a digital context the modification in Photoshop of an original image to comply with the photographer's or designer's preference for the final visual effect.

Reverse out When type or an image appears in white out of a black, or other color background.

Right reading Paper or film in *positive* or *negative* that can be read in the usual way, i.e. from left to right.

River A series of word spaces (usually occurring in badly *justified* typesetting) that form a noticeable pattern of white space down many lines of type.

Roman The standard characters of a *font* in which the letters are upright, as opposed to *italic* sloping.

Rosette The locations on a color separation where all four colors intersect.

Rough An unfinished design/layout. Also know as a comp (US).

Run on Sheets or signatures printed in addition to ordered initial quantity.

Runability The resistance of paper to curling/waving, or web breaks and other problems associated with the paper, as opposed to *printability*.

Runaround To lay out type on a page whereby the line beginnings or endings follow the shape of an illustration, which may be regular or irregular.

Running head/foot Recurring lines of text—usually a book or magazine title, or a chapter heading—at the head or foot of every page of a publication.

S

Saddle (wire) stitching Similar in effect to stapling, achieved on a saddle-stitching machine which feeds a continuous wire to form staples of the required length to be fired into the publication and folded on the inside.

Sans serif A category of typeface without the *serifs*, e.g Helvetica.

SGML Standard Generalized Markup Language. A meta language used for coding a digital manuscript to facilitate eventual searching of the document.

SWOP Standard Web Offset Printing (US). A standard for printing color on *web offset* presses. An alternative is a sheet-fed color space with more density than the high speed SWOP version.

Scale To calculate the percentage of enlargement or reduction of an image. To resize an image in proportion.

Screen (1) See *Halftone screen*. **(2)** The material used in screen printing that contains the text and images.

Screen angle When *halftones* are printed in one or more colors there is a risk of a *moiré* pattern appearing on the printed sheet. If the angle used for each screen is not correctly selected the result can create a moiré effect. In the *four-color process*, the angles are commonly black at 45 degrees (as in monochrome), *magenta* at 75 degrees, yellow at 90 degrees and *cyan* at 105 degrees.

Screen clash See *Moiré*.

Screen ruling (or frequency) A measure of the quality or fineness of the dot structure used to reproduce a halftone image or tint expressed in lines per inch or centimeter. Do not confuse with PPI.

Screened negative/positive print Any film or print of a color or monochrome subject that has been reproduced using a *halftone screen*.

Script A typeface that imitates any handwritten style.

Scumming Effect caused in litho printing when the nonimage areas of the *plate* do not repel the ink resulting in a dirty image being printed.

Sections/Signatures A folded press sheet. Paper is folded to form part of a book or booklet. Sections/signatures normally comprise sheets folded to make 4, 8, 16, 32, or 64 pages.

Self cover A publication whose cover is the same paper or material as the inside pages.

Self ends A binding in which the *endpapers* are part of the first and last *section* of the book, as opposed to being tipped in separately.

Separated artwork Artwork prepared as a series of overlays, each one providing the portion of the overall *separation* for the relevant color to be printed.

Separation See *Color separation*.

Serif The small ornamentations/terminating strokes on individual letters/characters of serif typefaces, as opposed to *sans serif*.

Set solid Type which has been set without any *leading* or line feed between the lines. The result is usually difficult to read.

Sheet-fed press A press on which the printing *plate* surface is fixed around a cylinder and is fed with single sheets, as opposed to a web-fed press.

Side sewing/stitching To stitch through the side of a book or booklet from front to back at the binding edge (spine) with a thread or wire. A method of binding leaves as well as *sections*. The publication will not lay flat and extra spine margin should be allowed for.

Signature Interchangeable term for *section*.

Signature numbering A consecutive number or letter printed at the foot of the first page of a *section/signature* to enable the binder to check the correctness of the sequence and completeness of a binding. The letter or number may be accompanied by a rule on the back of each section so that when they are folded and gathered these appear in a stepped pattern, one out of sequence indicating incorrect gathering.

Slug line A line on a color proof that indicates if any of the colors are clogged (filled-in) on the proof.

Small caps Type *fonts*, especially those used for book typesetting which include an extra alphabet whose *cap height* of the *roman* font is the same as the *x-height*, but without the strokes being thinner than the rest of the font, as occurs when ordinary capitals are reduced to their x-height. There are no true *italic* small caps.

Soft proof A digital proof for viewing on a monitor screen.

Spine The binding edge of a book.

Spiral binding A publication bound with spiral width of varying diameter and often coated with a colored plastic. Pages are punched with small holes to accept the coiled wire.

Spot color When a color is printed using a specific color of ink, usually from a special guide, in coated or uncoated version, instead of creating it via a build of percentage tints from process color inks.

Spot varnish The application of a gloss or matte varnish to a specific area on the page or cover. Can be a press varnish applied in-line or a separate pass.

Spread (1) Reproduction. A variety of terms, e.g. "lock-on," "overdraw," and "spread and choke," are used to describe the need to make two adjoining images slightly thicker than on the original artwork to facilitate *register* when printing in two or more colors. **(2)** A double-truck/page spread (DPS) (US/UK) occurs when an illustration occupies two opposing pages. Strictly speaking, this only occurs on the center spread of a signature—elsewhere it is a "false double"—however the term is commonly used in book and magazine publishing, advertising, and design

Stamping (US) See *Blocking*.

Stet Leave as set. Instruction to return to the original intention in a typeset proof and to ignore a previous correction or deletion mark.

Stock Any material to be printed on.

Stochastic screening Also known as FM, or random dot screening. Unlike AM screening where dots are placed in a predetermined line screen per inch, e.g. 150 lpi and vary in size, with stochastic

screening the microns at either 20 or the even finer level of 10 micron dots are the same size and vary where they are positioned, i.e. clustered heavily in shadow areas and fewer in highlights.

Strip and rebind To take unsold casebound books (for example), strip off the covers, and then rebind them as paperbacks to achieve further sales.

Stripping (1) To insert, i.e. "strip-in," any correction in film or paper during phototypesetting. **(2)** To glue a strip of cloth or paper to the back of a paperback book or pad as reinforcement.

Subscript/inferior characters Any letter, numeral, or character appearing below the baseline in typesetting. The opposite of *superscript*.

Substrate Interchangeable term with *stock*.

Superscript/superior characters Any letter or numeral smaller than the text-size and positioned above the *x-height* of the type body.

Surprinting (US) See *Overprinting*.

Swash characters *Italic* letters with exaggerated strokes.

Swatch (book) Samples of binding cloths, inks, *endpapers*, head/tail bands, or text papers to show the designer and print buyer the available selection.

T

TIFF Tagged Image File Format. A high-quality bitmap file format for images, especially photographs, that is ideal for print production purposes.

Tabulate To arrange type and other elements in regular columns, usually of figures.

Tailband Same as *headband* but at the foot of the spine on a casebound book.

Thermography An imitation of *die stamping*. The finished effect of a similar raised look is achieved by a combination of ink, powder, and heat.

Thread sealing A method of book binding in which the *sections* are "stabbed" with thread, the loose ends then being sealed with adhesive.

Thumb index An index where the dividers are cut into the *fore edge* rather than stepped as in a *cut in* or tab index.

To view The number of pages appearing on one side of a sheet. e.g. 16 pages to view would equal a 32-page *signature*.

Tone The gradation, usually expressed in percentages, from light to dark in ink on paper, contrasted with line work that has no tonal values. Measurable with an instrument known as a densitometer.

Tranny A photographic transparency.

Trapping The technique of slightly overlapping one image on an adjacent one thereby preventing unsightly small white gaps appearing between the two colors. A misregister will only exacerbate the problem by either increasing the gap or overlapping the trap.

Trim marks (UK) See *Cut marks*.

Turned in The cloth or other material used on the *case* of a book that is turned in round the edges to prevent the board's edges being exposed.

Type area The area on a page determined by the designer to be allocated for the placement of type and illustrations, excludes margins.

Typo Abbreviation term for a typographical error.

U

UCR See *Undercolor removal*.

USM Unsharp Mask. A photographic darkroom process, available in digital form within software such as Photoshop. It uses a blurred positive to create a "mask" of the original image, which, when combined with the negative, creates an illusion of increased sharpness. Like all sharpening techniques, it does not improve poor focus, but creates the perception of sharper detail.

UV (1) Ultraviolet. **(2)** A coating on top of a previously printed product to enhance the visual effect.

Undercolor removal A technique used in the *color separation* process that removes unwanted or excess color, either to reduce the amount of ink to be used on press (for economy but more often to reduce *trapping*), or where these colors cancel each other out in the various *achromatic* systems.

Underline/underscore A typesetting term to indicate a fine rule being placed just below the baseline and used to indicate emphasis.

Unjustified setting When lines of type align vertically on one side and are ragged set on the other. The amount of indent on the ragged edge can be specified to prevent an ugly appearance. The word space is usually kept to a constant value to enhance the visual effect.

Upper case Capital letters (caps). From the portion of the type case that held the capital letters in the days of hot metal typesetting.

V

Variable data printing When every digitally printed piece varies from its predecessor and successor. Used extensively for direct mailing pieces to target perceived individual preferences in product, but can also be just the name and address that vary.

Variable space The space inserted between words to justify them. This can be controlled with acceptable minimum/maximum amounts of allowed space, defined as being "to the em," as in "5 to the em." See *Hyphenation and justification.*

Vector graphic Graphic (drawing) format that uses mathemetical calculations to reproduce lines and curves on screen. When an image is scaled up, the calculations are redone so that the image displays without image degradation. Vector graphics are different from pixel graphics, which degrade or "pixelate" when blown up beyond the resolution and image size they were saved at.

Verso A left-hand page.

Vignette A *halftone* with etched, gently fading edges, as opposed to being cut out or squared up.

W

Watermark A design impressed by a dandy roll into a newly-formed web of paper containing a unique logo or symbol, which is visible when held up to the light. Digital files, such as images, can also be "watermarked" digitally, either invisibly, to trace the route of piracy, or visibly—such as in the widespread use of copyright messages embedded within low-resolution positional images from commercial image libraries, prior to the purchase of, and permission to reproduce, high-resolution versions for print reproduction.

Web offset Reel-fed offset litho printing. There are three systems: blanket to blanket, when two *plate* and two blanket cylinders on each unit print and perfect the web; three-cylinder systems, in which plate blanket and impression cylinders print one side of the paper only; and satellite or planetary systems in which two-, three-, or four- plate and blanket cylinders are arranged around a common impression cylinder printing one side of the web in as many colors as there are plate cylinders.

Weight (of type) In any given *font,* light, medium, black, bold, or ultra versions of the same basic typeface, affecting its overall blackness and visual impact on the printed page.

Widow A single word, or a short line, appearing at the top of a page.

Wire-O binding A binding method for publications. The pages and covers are punched with rectangular holes and a double-loop wire is then inserted through the holes. The loops are crimped to keep the wire in place. A strong, lay-flat binding. Allow for a deeper spine margin.

Word spacing The amount of space allowed between words by the typographer's/designer's specifications.

Wraparound (**1**) A *plate* that wraps around a plate cylinder. The normal condition in litho printing, but not universal in letterpress. (**2**) One sheet or *signature* wrapped around another in the binding stage.

Wrong reading Film that has been made such that it reads from right to left from the side in question.

X

XML (Extensible Markup Language) A metadata (data about data) markup language used to code and identify the different elements of text, graphics, and any other digital data within a file for searching and also for use on the internet. XML is "platform agnostic," in that any computer device can read it, regardless of the operating system it runs on. Anyone can write their own XML "tags" to describe the format of a piece of data. It is at the heart of the idea of "web services," the seamless and intuitive creation and flow of online applications and information to and from the user, and is therefore a vital tool in cross-platform publishing.

x-height That part of a letter with no *ascender* or *descender,* e.g., an "a," or a "x."

THE CONTRIBUTORS

SEAN ADAMS

Sean Adams is a partner, with Noreen Morioka, in AdamsMorioka, based in California, US. His work has been recognized with numerous awards from just about every major creative competition and publication, and he is currently the national president of the AIGA.
www.adamsmorioka.com

JUSTIN AHRENS

Justin Ahrens is the founder and principal of Rule29, a strategic design firm founded in 2000 and based in Illinois, US. His clients range from nonprofit organizations to Fortune 500 companies, and he is also involved in many design community organizations and advisory boards as well as Life in Abundance International, an organization that works with poor communities in northeast Africa.
www.rule29.com

NEAL ASHBY

Neal Ashby is the principal of Ashby Design based in Virginia, US. He specializes in work for the music industry, and for 10 years was Vice President and Creative Director for the Recording Industry Association of America.
www.ashbydesign.com

PAULA BENSON AND PAUL WEST

Paula Benson and Paul West are founders and partners of the London-based design consultancy Form. The company's expertise focuses on design and visual branding with particular understanding of contemporary culture, and their client list includes numerous major players in media, publishing, retail, events, and music. Paul and Paula pride themselves in their hands-on approach to the day-to-day work produced by their deliberately small and close knit team of creatives.
www.form.uk.com

JOSHUA BERGER

Established in 1991 by Oregon-based artists as a creative resource, Plazm is an award winning design firm led by founder and creative director Joshua Berger. The commercial arm, Plazm Design, was founded in 1995 as a conscious effort to apply their creative process and collective talents to serve commercial clients and social causes. The annual *Plazm Magazine* publishes challenging and innovative art, design, cultural, and literary works and is distributed worldwide.
www.plazm.com

STEFAN G. BUCHER

Stefan G. Bucher is the man behind 344 Design and the online drawing and storytelling experiment dailymonster.com. He is often engaged to speak on all things design, and produced a regular illustrated column that appeared in *STEP* magazine, meditating on the truths of a passionate designer's life.
www.344design.com

PAUL BURGESS

Paul Burgess cofounded Wilson Harvey in 1994 and, after a 2004 merger, became Creative Director of Loewy in London, UK. Paul works across branding, communications, and campaigns to create synergy between ideas and execution. He has authored five books and is currently in the process of establishing his own agency.

SIMON DIXON

Simon Dixon founded his London studio, DixonBaxi, with Aporva Baxi in 2001. The company provides an extensive approach to the entire creative process from strategy to the execution of print, online, and television for a comprehensive body of clients, audiences, and markets.
www.dixonbaxi.com

SONYA DYAKOVA

Sonya Dyakova is the Associate Art Director of Phaidon Press, London. Born in Russia, she lived in San Francisco before moving to London in 1999 to work with Vince Frost, and joined Phaidon in 2005. Specializing in typography, she creates bespoke typefaces, such as *Paper Alphabet*, which has gathered international recognition and numerous awards. Her approach to book design is strongly rooted in attention to conceptual and tactile details, as well as typographic experimentation developed through extensive research.
www.phaidon.com

JONATHAN ELLERY

Jonathan Ellery operates in three different arenas. Firstly there is London-based design studio Browns, cofounded with Nick Jones in 1998. Browns has an international reputation based on its ability to mix the worlds of culture and commerce. Secondly comes Browns Editions, the publishing arm of Browns. Set up by Ellery and Jones, it specializes in limited-edition, collectible art and photography books. Lastly comes Ellery's art. Working in brass, magnesium, stone, new media, sound, and film, he has had one-man shows at both the Roth Gallery in New York and London's The Wapping Project.
www.brownsdesign.com
www.brownseditions.com
www.jonathanellery.com

JOHN FOSTER

A designer, author, and frequent speaker on design issues, John Foster is otherwise known as Bad People Good Things. His work has been published in numerous books and industry magazines, and is included in the permanent collection of the Smithsonian. He has designed everything from cans of Coke to packaging for Hasbro to major arts advocacy events, but the humble poster always holds a place in his heart.
www.badpeoplegoodthings.com

MARTIN FREDRICSON

Martin Fredricson is a partner in the design studio We Recommend, established in Malmö, Sweden, in 2004 with Nikolaj Knop. Visual identity sits at the center of the company's core of expertise, and they describe their design process through four distinct phases: research, creative base, visual base, and solution.
www.werecommend.se

ANGUS HYLAND

Angus Hyland studied at the London College of Printing and the Royal College of Art before launching his own studio, based in London, UK. His work encompasses a broad range of disciplines, from print and publishing to exhibition curation, and he became a partner at Pentagram's London offices in 1998.
www.pentagram.com

ERIK KESSELS

Erik Kessels founded the Amsterdam-based agency KesselsKramer with Johan Kramer in 1996, and has gone on to produce an incredibly diverse portfolio of work for numerous international clients. The agency now has a publishing arm, and has opened KK Outlet, a multifunctional office space combining a communications agency with a store and gallery space, in London, UK.
www.kesselskramer.com
www.kkoutlet.com

ASLAN KILINGER

Aslan Kilinger is the Art Director and founder of Maestro Design & Advertising. His career has taken him from Caracas, to London, Madrid, Istanbul, and to Amsterdam where Maestro is based. His art direction for international clients has won him recognition at home and abroad, and he is a recipient of the London International Advertising Award.
www.maestro-amsterdam.com

DOMENIC LIPPA

Domenic Lippa studied at the London College of Printing and cofounded design consultancy Lippa Pearce with Harry Pearce in 1990. His work focuses on packaging, print, identity, and retail graphics, and he became a partner at Pentagram's London office in 2006.
www.pentagram.com

STEVE PRICE

Since 2001, Steve Price has operated as Plan-B Studio, which works under the adage that "it's not the size, but what you do with it." An openness for the collaborative approach to any and all design processes is central to Steve's philosophy and he works with a broad range of international clients.
www.plan-bstudio.com

PAUL REARDON

Paul Reardon cofounded Peter and Paul with Peter Donohoe in 2005. The studio is a small and highly creative communications agency, working with a broad base of clients with a particularly strong focus on arts and culture, architecture, and retail design.
www.peterandpaul.co.uk

CARL RUSH

Formed in 1998 in Brighton, UK, design agency Crush is headed by Creative Director Carl Rush. Crush works with a diverse range of clients from international names to niche markets, and their work is notable for its innovative and challenging use of illustration, much of which is created in-house.
www.crushed.co.uk

DAVID SAMPEDRO

Based in Paris, France, David Sampedro has been a partner at design agency Iceberg with Sébastien Heylliard since 2002. The agency is backed by a cutting-edge in-house production studio, creating media in all formats, optimizing the relationship between products, brands, and target audiences.
www.iceberg.fr

GREIG STEVENS

Greig Stevens graduated from London's Central Saint Martins College of Art & Design in 1991 and has since worked for magazine publishing companies in the UK and Ireland. He is currently the Creative Solutions Art Director at the New York Times media group based in Paris, France.

MARK STEVENS

Based in Copenhagen, Denmark, Mark Stevens is currently the Communications Director for Copenhagen Design Week. His own company, M-A-R-C, specializes in communications, creative direction, and copywriting. Mark is also an Associate at the Institute Without Boundaries, a combination of a school, a design think tank, and a socially and environmentally-focused design studio.

PETER STITSON

Peter Stitson was the Art Director of the style magazine *Dazed & Confused* for five years, supervising and influencing the magazine's artistic direction. In 2007 he took part in a group exhibition at the BALTIC gallery in Gateshead, UK. He lives and works in London.
www.peterstitson.com

ED TEMPLETON

Ed Templeton founded Red, a design studio based in Brighton, UK in 1996. The company is known particularly for its work for the music industry, and for its successful art direction of promotional and advertising campaigns for high-profile clients within the creative industries.
www.red-design.co.uk

INDEX

ACKNOWLEDGMENTS

It would have been impossible to write this book without the generosity of the many art directors and designers who contributed their thoughts and their work to this project. My sincerest thanks to all of them, particularly Paula Benson, Stefan G. Bucher, Sonya Dyakova, Jonathan Ellery, John Foster, Angus Hyland, Domenic Lippa, Greig Stevens, and Paul West for the interviews.

It was great to coauthor with Luke after working on many other projects together as art directors, and I remain very grateful for the shared responsibility he provided throughout the making of this book. Thanks also to April Sankey for once again putting her faith in me, and to Jane Roe for her editorial support.

And finally, I am as always indebted to my wife Sarah who has a great talent for lifting one's spirits when putting in another evening's writing is the last thing on one's mind.

Tony Seddon

Firstly I would like to thank Tony Seddon for his shared opinions and perceptions of the world of art direction. Not only has he been a joy to work with, but a great sounding board to bounce ideas off, and to clarify my own opinions and experiences of what it means to be an art director.

I would like to thank all the contributors, especially those we interviewed personally for their time and willingness to share with us their own varied and insightful experiences and personal anecdotes.

I would also like to thank the team at RotoVision, including April Sankey and Jane Roe for their support and encouragement throughout the production of this book.

Luke Herriott